"Very thoughtful and knowledgeable; pulled me in right from the start."

—STEPHANIE TAMEZ,
Tattoo artist and co-owner of This Time Tmrw
private studio in Greenpoint, Brooklyn, NYC

"Melding first-hand observation and sociological theory, Kiskaddon reveals how the act of tattooing—because its canvas is the human body—is always embroiled with culturally loaded ideas about race, gender, and sexuality. This book teaches us something beautiful about how people create meaning in an impersonal world. I hadn't expected to encounter the sacred in the tattoo shop, but after reading *Blood and Lightning*, it's clear as day."

—NEIL GONG,
author of *Sons, Daughters, and Sidewalk Psychotics:*
Mental Illness and Homelessness in Los Angeles

"In *Blood and Lightning*, Kiskaddon eloquently unfolds the skills tattooers learn to navigate work that is loaded with pain, emotion, and physical intimacy. This is truly an excellent ethnography for anyone interested in the world of tattooing, as well as for students and scholars of labor and the cultural significance of bodies."

—KRISTEN BARBER,
author of *Styling Masculinity: Gender, Class,*
and Inequality in the Men's Grooming Industry

"In this absorbing and theoretically rich embodied ethnography, Kiskaddon powerfully describes the bodily socialization, ethical quandaries, and intimate interactions with other people and their bodies he experienced through the process of becoming a tattooer. *Blood and Lightning* is at once funny and moving, a page-turner and a rigorously conceptual exploration of embodied labor."

—ASIA FRIEDMAN,
author of *Blind to Sameness: Sexpectations and the Social*
Construction of Male and Female Bodies

BLOOD AND LIGHTNING

BLOOD AND LIGHTNING

ON BECOMING A TATTOOER

Dustin Kiskaddon

STANFORD UNIVERSITY PRESS
Stanford, California

Stanford University Press
Stanford, California

Printed in the United States of America on acid-free, archival-quality paper

Library of Congress Cataloging-in-Publication Data
Names: Kiskaddon, Dustin, author.
Title: Blood and lightning : on becoming a tattooer / Dustin Kiskaddon.
Description: Stanford, California : Stanford University Press, 2024. | Includes
 bibliographical references and index.
Identifiers: LCCN 2023017188 (print) | LCCN 2023017189 (ebook) |
 ISBN 9781503635609 (cloth) | ISBN 9781503637412 (ebook)
Subjects: LCSH: Tattoo artists—California—Oakland. | Tattooing—Social
 aspects—California—Oakland.
Classification: LCC GT5960.T362 C35 2024 (print) | LCC GT5960.T362 (ebook) |
 DDC 391.6/5—dc23/eng/20230424
LC record available at https://lccn.loc.gov/2023017188
LC ebook record available at https://lccn.loc.gov/2023017189

Cover design: Derek Thornton / Notch Design
Cover illustration: Dustin Kiskaddon and Shutterstock
Typeset by Elliott Beard in Minion Pro

For Matt

CONTENTS

INTRODUCTION

The Bumblebee Rides a Unicycle

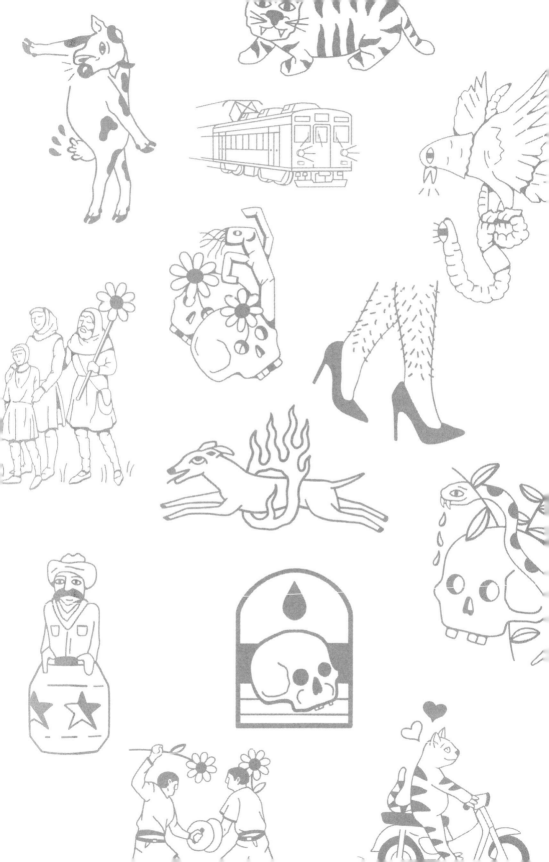

Matt drank coffee as we stood on the back patio. His red hair landed across a blue handkerchief tied around his neck. He wore vintage denim and leather boots, as usual, and we stood there talking about the day's projects. Both of us were doing two tattoos, scheduled at 12 noon and 3 p.m. They reflected the kind of work we'd grown to love doing. He—my tattoo mentor—had been at it for thirty years, I for just two.

Matt shielded his eyes from the sun, "Gonna be a solid day, my dude. That bumblebee on a unicycle is fun." A young guy requested it, the bumblebee riding a unicycle. He asked me to put it over his heart. The image reflected a cute, folk-art style I'd developed over the preceding few years. Matt dug the style, and he seemed to enjoy watching me work, even when he was in a bad mood.

Matt and I oscillated between now-predictable topics of conversation: tattooing, politics, whatever his kids were up to, and food. We also rested comfortably in silence. We had spent thousands of hours together by this point, and it was clear we'd end up on that patio come evening, enjoying the warm fatigue from a day of work. He would drink beers and smoke joints. We'd eat, share photos of the day's tattoos, and listen to music. I would head home earlier than he would, and we'd part with a hug.

Our morning routine ended as I opened the screen door and walked into the 750 square feet that is Premium Tattoo, a real-life tattoo shop near downtown Oakland, California. That aluminum screen door, as light and tattered as it was, offered a brief yet meaningful separation between the shop and the world. It kept some things out, and it held other things in.

I encountered the smell. It was mostly the green soap, a piney liquid used while tattooing. It was also the Dettol, a pungent orange fluid used to transfer *stencils* onto skin. It was the Opticide too, a medical-grade destroyer of life, as well as the bleach, glass cleaner, and hand sanitizer. It was the smell

of bodies and breath. It included remnants of the weed and booze from the night before. This last bit was a reminder that things, and sometimes the *best* things, happened after hours.

There was the music, too, most of which included '70s rock and roll, '80s punk, and '60s funk. You'd likely hear Grace Jones, Black Sabbath, Iron Maiden, Black Flag, Madonna, or Thin Lizzy during a visit to the shop.

The bumblebee client arrived just before noon. He introduced me to his partner, and I showed both of them the design. They loved it. I let them talk for a bit, and they began discussing some details, such as whether putting it over the heart was indeed the best choice. I reinserted myself into the conversation when they came to an agreement.

I had learned it was best to let people do this kind of negotiating on their own. Like many of the tattooers I met, my initial approach had me jumping in to discuss all the specifics of size and placement with clients, but it was hard to be with folks all day at that level of detail.

These two were quick and easy: they dug on the design, and they knew where they wanted it to go. It was a best-case scenario because we hit it off straightaway, and I didn't have to sit and change the design with them over and over. That design had, after all, been altered many times before they arrived.

Matt encouraged me to keep my cool when clients nitpicked the details. He knew that losing your patience in an obvious, public way had its consequences. The encouragement was welcomed and necessary, because the back-and-forth with clients could test my composure.

Matt also taught me there was some joy in doing even the most basic tattoo. That joy wasn't always easy to find, either because the client was hard to work with, your shop mate was driving you up the wall, or because you just didn't give a shit about the design.

I mean, if you had gotten good enough at the basics, how many times could you get excited about tattooing a predictable memento? Try doing the word *faith* over and over again, making sure the *t* resembles an erect Christian cross. Try doing it with excitement when the only faith you've got will never show up in the God-fearing promise of salvation. You could be too tired, hungover, or bored to feel that surge of energy that came with your early tattoos.

But there was always a chance to find joy in any project; you just needed

to know where to look. It often wasn't located in the design itself but rather in the more profound condition of your work: the client, the *person*, and the things you did with them. Even if that person was irritating, they were there asking you to change their body forever. You had to—*got* to—deliver on that ask.

So I often reworked designs with clients on the day of their appointment, even if it could be a drag. This was one aspect of the job that contributed to its intimate and sometimes messy character. It shaped me as a "tattooer," what I call people who do tattoos for money, and it helped me understand that tattooing requires much more than coming up with cool designs.

Indeed, the work of tattooing demands the management of a complex intersection, one made up of people, bodies, and money. This is because tattooers work with clients, who are people, to accomplish an intimately carnal task in exchange for payment. Tattooers dwell within this intersection daily, and they are shaped by the many things that can occur there. Ultimately, they have to keep each element afloat to achieve ongoing success in their work.

There are a few ways to visualize the situation. Maybe the intersection involves a meeting of three roads, with green street signs indicating the character of each path. Or perhaps it takes the form of a Venn diagram, with overlapping bubbles and the tattooer sitting there in the middle. Possibly it's composed of three streams that join to form a river that flows toward some destination off in the distance.

I like this vision of streams.[1] In it, the tattooer helms a thatched raft and navigates the water. They work to ensure the vessel stays its course. The best tattooing happens when the streams are easy to navigate, when each coalesces in a way that reduces the likelihood of unpredictable currents. A steady flow of each element—of people, bodies, and money—can make the navigation look easy. It can occasionally make the task even *feel* easy. But when one of the streams is out of whack—maybe it's flooding into the river with too much force—the task of navigation proves a formidable challenge.

The intersection could turn into a great, writhing ball of snakes on you, with each element taking residence in a number of serpents. They occasionally seemed to encircle me in the heat of the tattoo moment, squirming through my palms and landing somewhere just out of reach. I'd scramble to scoop them up, only to have them slither through the cracks.

Whether it was a Venn diagram, a coalescence of streams, or a ball of snakes, the whole tattoo experience was infused by the fact that every tattoo is permanent. This fact forced me—and all the tattooers I ever met—to employ strategies that could keep some difficulties of the work beyond the immediate attention of often-anxious clients.

Imagine a few nervous passengers sitting upright on that river raft. Would the navigator reveal the dangers hidden below the water's surface? In tattooing, the task of keeping those dangers at bay required the implementation of studied technique, both in doing the actual tattoo and in employing a kind of intentional performance. This necessity of performance animated my life—often in ways I didn't like.

Back at Premium with that bumblebee on a unicycle, my client stood with his partner, anticipating the upcoming tattoo experience. His partner held an increasingly less-significant role in the situation. The tattoo quickly became a thing that he and I would do together, intimately. We dove head-first, and as we did, the distance between us began to collapse.

I was like Matt and other tattooers who lived for moments when the client jumped right in. It signaled the trust and enthusiasm that made for good tattooing. It assured us that we knew what we were doing, and this was key, because tattooing can be nerve-wracking. It demands you change a person's body through pain, and, again, each mark you make is going to be there forever. The whole thing freaked me out, especially at the beginning. But when it was good, and it often *was* good, it was one of the best things there was.

The bouts of nervous energy weren't so prominent on that day of the bumblebee. I stood calmly in the face of my task because I had figured out how to navigate many of its nuances by that point. I knew I would make each mark well enough and that I'd give the client a good experience. My attention even seemed to drift away from the moment and toward other things. This was a luxury, as any comfort found within the tattoo process was new and very welcome.

I asked for the client's ID and copied it across the bottom of a waiver he would fill out. I used a device to make a stencil from the printed design. This device is like a small copy machine. It transfers the design onto a thin sheet of "stencil paper" that feels like rice paper in your hands. Tattooers apply it

to the dampened skin, being sure to avoid wrinkling or distorting the design in the process. Temporary purple lines imprint on the skin when the stencil is peeled away, and tattooers use those purple lines to guide their machine across the body.

With the waiver signed and the stencil done, I invited my client to move from the shop's waiting area and back toward me, further into the depths of our building and our experience.

He and I encountered a kind of transition as we pursued the course— moving from a state of being total strangers to a different, more intimate condition. I would soon be shaving hair from his chest. He'd be telling me about his love life. I worked to ensure this transition went off without a hitch, attending to the tiny details that I knew could make a difference, including my posture and the speed of my language. I also put the physical features of the shop to work.

The first thing you'd encounter upon entering Premium Tattoo is a small waiting area. The area is demarcated from the rest of the shop, extending straight ahead, by a three-foot wall. That wall serves many purposes, one of which is to provide counter space for the shop's main computer, printer, and a tablet used for payment processing and music selection. There's a spot just right of that computer where the wall is broken up by a set of black saloon-style doors.

We at the shop used that wall and those doors to separate clients from ourselves, our equipment, and our work. Clients would be invited to pass through the doors and move back toward the "booths" in which we tattooed once we knew it was time—that is, when we felt ready to bring them into a more advanced phase of the tattoo process, as was the case with my unicycle-bumblebee client, whom I invited back after he'd signed the waiver.

Sociologist Erving Goffman famously meditated on the meaning of separate "regions" of space, with boundaries encouraging a particular set of expectations for thought, feeling, and action.[2] At Premium, those saloon doors separating the waiting area from the rest of the shop helped establish two distinct regions and, therefore, steps in the tattoo process. There was another region, one just past the booths, that functioned as a space for us to draw, eat, and play Dungeons & Dragons. Clients could pass through the space on their way to the bathroom, but they couldn't hang around. On

their way through, however, they might have noticed an elaborate terrain for D&D campaigns along with carefully painted miniature figurines: wizards, dwarves, thieves, and dragons preparing for epic adventure.

The last region, and the ultimate "backstage" of our shop, was the patio. It was a small rectangle of concrete on which to stand, partly covered by a wooden staircase leading up toward a couple of apartments above the shop. There was an old, chest-high cabinet to hold your beer and a long wooden bench. It was on this patio that we let down our performance. People talked shit, drank, and smoked. Bottles could pile up back there, and we could let it all hang out. Being backstage meant we could do things we otherwise could not, or at least *would* not, do in the purview of public attention. We let our faces look sad, angry, or nervous. Most important, we talked.

It was often benign talk, but when it wasn't, it was the juiciest stuff we had. We stood on that patio and discussed everything about our work, especially the constellation of things we tried to keep beyond our clients' hearing. We'd go out there after a tattoo that we weren't especially proud of and discuss it plainly—pulling up the photo and digging into the details.

We would critique the linework, the sections of solid fill, the shading, the design itself, or its placement. We'd identify the ways it could have been better and, if the tattooer was up for it, we gave them shit. Something like "You fucking know better than to try *that* on that part of the body" would do the trick. We would even complain about our clients back there. Who wouldn't?

The backstage of any social world has its allowances and restrictions. We, being the central members of our scene, were allowed to go back there and break from any performance we'd otherwise produce while in the more "front-stage" regions of the shop.

Those who were not central members of the scene were restricted from entrance. They were the ones that were being *performed for*, even as we also performed for each other and ourselves. There's often a physical barrier between the front and backstage of any scene, like our large, back door. But when that door was open, as it often was, our tattered aluminum screen door stood in as a barrier. It was lite, porous, and still powerful.

There were some exceptions, because a few people transitioned from the state of being standard clients to something closer to us. Matt called these

folks "baseball fans" because they, as he explained, "are always rooting for the team."

I had a great baseball fan, someone who began as a client but who hung around long and deep enough to join us backstage on that small patio to hear it all. He wouldn't go back there on his own, unlike the truest, deepest, baseball fans who would just show up and walk back there. These special folks, numbering two during my time, were such a part of the team that they occasionally contributed to our broader performance for clients, complimenting them on the tattoo they were getting and adding to the fun atmosphere.

Now, this isn't to say that they, or we, would fake around, playacting. It's to say that we all knew we had a role to fill and that our roles changed as we moved through space. We went about filling our roles most often from an authentic posture.

Most clients understood the regional character of the shop. They would wait by those saloon-style doors as if they were made of concrete. They knew intuitively that the doors amounted to an important, social boundary. The rare one who passed through without invitation seemed to *barge in*. They appeared to be *barging in* because their actions offered a contradiction in the "definition of the situation," to return to Goffman, or the shared understanding of the social scene and its related expectations.[3] While those doors could be opened by a toddler, their strength was great in the eyes of people who understood their context. Same went for that tattered screen door.

I invited my bumblebee client to join me near the tattoo booth. It was in the booth that we prepared our "setups," the material we used while tattooing. This material was carefully arranged on top of a plastic film that covered a black, waist-high toolbox on casters. The setup included a tattoo machine, small plastic "caps" for ink, needles of various sizes, and plastic-wrapped squeeze bottles of green soap, alcohol, and Dettol. It also included a small blob of Vaseline-like jelly, a blue disposable razor, and a stack of white paper towels.

My client stood near me, and I asked him to take off his shirt. He paused with a nervous smile, "I've got a weird belly button." He elaborated, "It's an outie." It was an outie, indeed, but his belly button didn't concern me. We wouldn't be tattooing in that area. I was rather busy assessing the thou-

sand things I needed to consider to give this guy a decent tattoo. That belly button wasn't among those thousand things. His comment about it, though, prompted me to offer him reassurance. I knew he wanted it.

Such moments of intimate, carnal interaction could reveal the deeper challenges of tattooing. It was my paid job to ensure the client and I would properly navigate a series of complex moments involving the human body. My best work would render these moments invisible—transform a set of carefully managed events into a straightforward, seamless experience. Tattooers who do this well are good at their jobs, even if their tattoos aren't the best. I and many of my clients would prefer to get tattoos from someone who's good to *work with* before booking an appointment with some asshole who does great tattoos.

But, of course, the nicest tattooer in town still needs to be good at doing tattoos. Importantly, they need to be continually *perceived* as good. They have to pull off an authentic performance of proficiency, no matter how good they are, and they have to do this under the watchful gaze of nervous clients and their curious, often-critical peers.

During my time at Premium, I saw how much tattooers think about and work on producing such a performance. They do so as individuals, and they often work in "teams." They employ shop mates and various attributes of the setting to convey a perception of cool mastery. These attributes include music, furniture, and even the architectural features of the building. Producing the perception of cool competence is an important feature of the quick trust-building that needs to occur between tattooers and their clients.[4]

We at the shop worked together to accomplish this performance for clients and for ourselves. It helped my bumblebee guy, for instance, bathe in eager enthusiasm for the piece rather than wonder why he ever signed up for it in the first place. His enthusiasm spilled outward so that it entered my own experience. His excitement heightened my attention, brought us together, and made me focus on the interaction we were having. It was intoxicating, making me remember just how special tattooing could be and just how lucky I was to be doing it.

As we were already in the booth, I stood before him and asked him for consent to touch his body. I said what I always said: "Can I touch and work with your body today?" He thanked me for asking, even though it was obvious I'd be touching him. Most of my clients offered a similar thanks. The

majority were women, queer folks, and young men dedicated to a politics of bodily autonomy. They approached the world with heightened attention to the relationship between power, language, bodies, and action. They often voiced appreciation for my request to touch them.

I put on some black gloves before selecting a paper towel from the stack on the toolbox. I used a plastic-wrapped squeeze bottle to dampen that paper towel with alcohol. I then touched my client for the first time, wiping his chest with the alcohol-soaked paper towel. I threw the paper towel into a black, foot-operated, trashcan before picking up another plastic-wrapped squeeze bottle, this one filled with green soap.

I squirted some soap directly on his chest. I caught the drips before they ran down his torso with the edge of my gloved hand. I lathered the soap by rubbing my hand in circles against his body. I then reached for a razor, removed its clear plastic guard, and shaved a few dark hairs from the skin. I noticed his chest had that firm consistency of youthful skin wrapped across a muscular body. My hands felt cool against its warmth.

I applied the Dettol, a stencil-transfer liquid, and hovered the stencil above his skin while lining it up. I set the stencil against his body with the hope of landing in the right spot. I carefully peeled the paper away to reveal the purple lines I would follow with the machine. I then directed him to walk over to his partner and ensure it was in the right place, saying what I said a few times a day: "We can't move it once I tattoo it!"

A little humor could soften the nerves for my clients and sometimes for myself. Quick statements at the beginning of our tattoo sessions could have a huge, positive impact. We at Premium all had our go-to quips or, as Matt called them, "bits."

My client and his partner looked into a floor-length mirror and agreed the stencil was in the right spot. I guided the client back to the booth while his partner stayed in the waiting area. I asked him to lie on his back across a massage table that was covered by a large, medical-grade bib. I sat on my stool, adjusted its height, and began preparing my machine. I poured ink of many colors out of small squeeze bottles and into the plastic caps on my setup. I then changed my gloves and leaned over the client to begin the tattoo.

The most intense thing was his breath on my face. I could smell it and feel its warmth. It's not often you feel a stranger's breath on your own face, even as a tattooer. I bent over his body as he closed his eyes, and I began

tattooing—which was, of course, a mere extension of all the work I'd been doing for him up to that point. Our faces were sometimes inches apart. Our inhales drew from the same volume of available air, which became, over time, increasingly saturated by our exhales.

I always exhaled slowly while pulling the machine across someone's body. It helped ensure the smooth movement of my hand, wrist, and arm. If they weren't breathing erratically, my clients often exhaled with me in concert, using their outward breath to manage the pain. This could produce a deeply satisfying effect, breathing together in close proximity and often for more than an hour. It also made me warry. I wasn't always excited about sharing the same air with strangers all day at work, especially if they were exhaling toward my face.

This was March 11, 2020. We closed the shop three days later because of the COVID-19 pandemic. I worried about my shared breath with this client for days, watching the news and considering the degree to which the bodies of tattooers and their clients overlap. I wrote that evening, "The entire world is absolutely stressed out about the new Coronavirus, and I felt scared because a guy was breathing in my face all day, one of my clients. I presume that if he had a virus I would surely have it by now."

The repetitive overlapping of bodies in tattooing—the sheer demand of carnal comingling—made it so that my body would be shaped by the bodies I encountered at work. My clients and I would *both* be different after the tattoo was done. We were usually improved, with them getting a new tattoo and I some cash, along with a little more experience under my belt. But there was always a chance we would be worse. Our individual, communicable baggage could leap across the tiny space between us.

I pursued the bumblebee piece confidently, engaging the pink tattoo machine with its foot peddle so as to leave saturated lines in his olive skin. That machine was a "rotary" style tool, one that was much quieter and lighter than the "coil" variant I'd built a few months earlier.[5] While the machine didn't make much of a sound, it still *told* me things. Small changes in its vibration and sound let me know, for instance, whether the needles were in the skin deep enough. Like anyone who grows to hold deep familiarity with a tool, I developed a relationship with this machine through repetitive use.

The client's body also conveyed information. His skin tone informed the choices I made when it came to the colors of ink. The beads of plasma and

blood oozing from fresh marks told me that they—the marks—would stay there forever. And there was the smell. A client's fear-sweat and its accompanying odor would tell me they were undergoing some bodily stress.

Matt had an incredible nose, detecting tiny changes in a person's body odor; more important, he was able to *use* these changes in odor to assess the state of his clients. Too much fear-sweat and its pungent smell would have him checking to see if the client was about to puke or pass out.

I'd learned to approach these new smells, sounds, sights, and feelings with heightened attention. Over time, I could translate these elements into useful, even necessary, traces of information. This process of "sensory socialization" helped me become a more competent tattooer.[6] It was satisfying, like learning a new language. And like language learning, the process required direct exposure.

The technical aspects of it all were enjoyable—the tools and the satisfaction that could stem from their proper use. Even if running the tattoo machine for a long time caused discomfort, I learned to love the feel of it in my hand. I also appreciated the interpersonal exchange with clients, which was often rewarding even if it could be the source of great trouble.

My bumblebee client shared his life with me, including that the tattoo marked a new romantic relationship. We talked childhood, grad school, and parents. We became close through talk and touch, closer than I'd become with most people outside the tattoo shop in such a short time.

I also yelled across the shop with Matt and two other tattooers, Pauly and Karime, although Karime was rather quiet. We often sang to the music when not holding our breath to steady our hands. While we had our own struggles, we all worked to solve the same problem—performing the intimate, carnal labor of tattooing. Among other things, we wanted to avoid the terrible stress and guilt that came from making mistakes.

The bumblebee was going great. The black lines were finished, and I moved to add color, proceeding through an order of operations conventional to tattoo production. I made sure to move from the design's lower corner, in this case on the right, to the opposing top corner. This was done to avoid smearing the purple stencil with my gloved hands, which had, by this point, a bit of ink, blood, plasma, and a Vaseline-like jelly on them. Touching that stencil with those gloves could cause it to blur, morph, and eventually disappear. That would be a serious problem.

Matt had *lost the stencil* a few times in his early days of tattooing, during the 1990s. This meant he had to improvise and sometimes on the bodies of large, tough guys. The risk that you might just ruin any tattoo increases in relation to the amount of unsupported activity you do. I never lost a stencil because we used better technologies of stencil transfer than had tattooers in the '90s and because I'd gone through a more supportive apprenticeship than Matt. I was taught to keep the stencil intact.

My client *sat well*, meaning he remained calm and still. Lots of people twitch all over the place when you tattoo them. Imagine trying to draw straight lines across a piece of paper while seated in a bumpy train. Then bend that paper around a flexible tube—because the body isn't flat—and render its surface stretchy. Tape a vibrating rock to the end of your pencil, and, of course, make sure each mark would impact a person's life forever. Now, turn that paper into a nervous stranger who is paying you good money and watching your hand while talking your ear off. That might be a little bit like tattooing.

With the bumblebee client, it helped that I was working at a good pace, not lingering and fussing with nervous hands as I had during my initial tattoos. I moved through the piece, wiping the blood, plasma, and excess ink off his body with paper towels and being careful to put the right color in the right spaces. I finished and sat looking it over, assessing my work with a gaze shared among tattooers—one characterized by special attention to details only we likely noticed.

The crew at Premium called this gaze "micro vision." It could reveal the slightest variation in a line's thickness or a tiny gap between lines that should have been connected. I saw a few mistakes like this in the bumblebee, but I knew they were so small that my client would likely never see them, especially once the hair grew back. I worked to keep a neutral face so as to avoid exposing my slight disappointment, part of the emotional labor of the job.

People are sensitive to such things when they get tattoos, often looking toward their tattooer's facial expression for any indication of their assessment of the work. Clients are often in a rather vulnerable state after the piece is done. We at the shop knew this, and we knew that our clients may question the work's quality if they saw their tattooer wince at the completed piece. So, we actively displayed excitement over new tattoos, even if we sometimes knew they could've been better. It was just part of what we did for money.

I asked my client to sit up slowly. He looked around like he had been

asleep before stepping down from the table. He stood in front of a mirror while I stretched my arms, watching. I wanted him to light up with enthusiasm. I yearned for it, even. This was because I anticipated feeling a bit awful if he didn't love it. His big smile sent comfort to the tension in my shoulders (see fig. 1).

My client walked across the black-painted floor in his socks to show his partner, leaving damp footprints because of the sweat. She smiled. He turned to me, "I love it, man!" I felt happy. More than happy, though, I felt satisfied. We had done something important together, and now I was sure we had done it right.

I took my gloves off, washed up to the elbows, and asked my client to put on his shoes. I met him near his partner and led him outside for photos. Motivated by the anxious desire to get at least one good picture, I took far too many. This impulse revealed itself every time I opened the photo app on my phone to see great blocks of nearly identical shots. But with tattooing, it was likely I'd never see the piece again. It was my work, but now it was his—part of his body. Even if I chanced on him and his body again, the tattoo would never be the same as it was then, on its very first day.

I would use these photos to critique the work later on. The best two of them, along with a quick video, would be posted to Instagram within a few days. Like many of the tattooers I met, Instagram functioned as my primary source of marketing. We used the platform to get clients and to gain any attention we could get.

Still guiding our experience, I directed my client back into the shop and toward the booth. I sanitized my hands, put on fresh gloves, and dabbed his chest with a couple of paper towels. Tattoos tend to bleed, and tattooers have to clean up the blood. I described aftercare techniques, applied a flexible bandage for proper healing, and took the gloves off before washing my hands and accepting his cash. He gave me more than I had asked for.

Like others who left pleased, he seemed sure the process went as it always did. The tattoo looked good, and I had presented a legible confidence throughout our time together. We'd shared just enough about ourselves to forge a powerful connection. He had let me do something rather profound to him and in the meantime enjoyed the opportunity to become close with me. It was a professional intimacy that was nonetheless powerful. Of course, the process didn't always go so well.

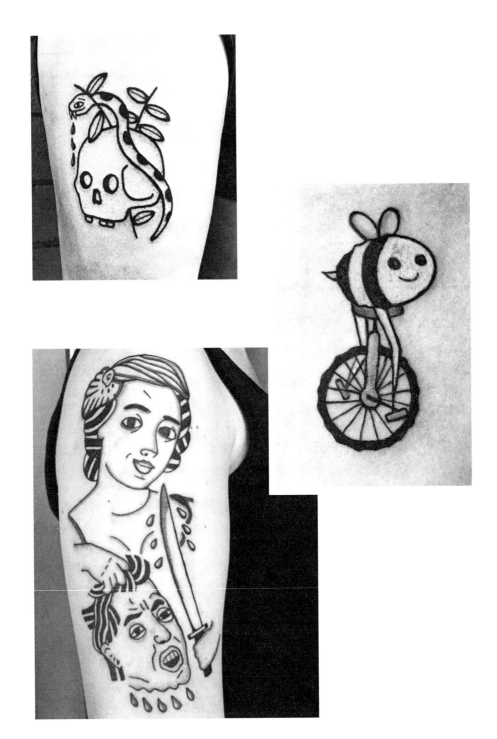

FIGURE I. *Three of the many tattoos I did, with the bumblebee on a unicycle in the middle.*

The pain I had put him through inspired a flood of endorphins throughout his body, and he seemed to float away from me out toward the world. The distance between us—both physical and emotional—grew as he moved through the saloon-style doors, across the waiting area's painted floor, and toward the shop's front door. He fumbled with the doorknob. His airy speech and movement gave away the fact that he was high as a kite.

We transitioned once again but this time in the opposite direction, moving apart rather than together. It felt good, though, because we'd done it right.

"I felt great, too," I later wrote in my fieldnotes. "That kind of thrilled elevation I've come to expect from my days in the shop." I only hoped the day would stay on its positive course. I had an awesome piece coming up—a vintage light rail train with pastel highlights. I was pretty sure the client would be easy to work with, too, as our exchange over Instagram had been easy.

I got some tacos from down the street and ate them fast while drinking two glasses of water. All of this while talking with Matt on the back patio. He was pacing while taking a break from the rather large tattoo he was doing. He circled his arms overhead to relieve some of the tightness that came from hunching over clients for thirty years. He was also giving this particular client a break, as they were growing fatigued from long bouts of tattooing.

Matt looked up to the sky. He appeared introspective, perhaps thinking about the fact that his shop was running smoothly. Things were going well in large part because he had taught Pauly, Karime, and myself how to do tattoos and how to *be tattooers*. He seemed proud and optimistic.

On this day and at this moment, the *glamour* of our shop was in full effect. Stemming from the Scottish word *glamer*, glamour has the effect of casting a spell or charm "to blur the eyes."[7] It usually works by making things seem a little better than they really are.

The glamour we produced would impart a sense of confidence on those who entered its presence. Clients under its charm would feel that everything was under control. They wouldn't likely think about the fact that we, like all tattooers everywhere, could easily make permanent mistakes on their bodies. And we did make mistakes, some more noticeable than others.

The glamour of tattooing was a collective production, achievable by a team.[8] Our teamwork was evident in our shared banter, which was often light and fun. It could be seen—if you were in on it—by paying attention to

how we used our bodies and voices in time and space. Take, for instance, the way we publicly praised each other's tattoo work.

If Pauly had just finished a tattoo, for example, I would ask the client if I could see it. I would look at it and say something like, "Pauly knocked it out of the park!" To be sure, I would say that even if he didn't knock it out of the park. We simply wanted our clients to love the work. We put on a show.

The glamour was in full effect the day of the bumblebee. I moved throughout the shop while digging on the tattoos being done. I took pictures to share on social media, and I chatted with anyone who would listen. I encouraged clients to "hang in there" through the pain, and I joked with Pauly.

Pauly's gregarious talk provided a light touch to the atmosphere, as did his disarming banter with anyone who wandered into the shop. He was great with people. "That bumblebee was sick bud," he said to me with kind sarcasm. "Watcha gonna do next, a giraffe on a Ferris wheel?!"

Meanwhile, Karime sat drawing nearby in silence. They (Karime) almost always sat drawing while not in the throes of actual tattooing. This was because they loved drawing but also because they had a hard time interacting spontaneously with strangers. This offered a challenge to their success as a tattooer. They were technically gifted, but they weren't the best with people, and you can't do tattoos without interacting with people in a rather deep way.

With the floor covered, I turned my attention toward the day's next project. I printed out its design while our new apprentice "flipped" my booth, which means they cleaned everything and set up the equipment I'd use for the next tattoo. My client walked in with a loud greeting, and I showed him the design. He loved it, and I began guiding him through the experience. We were tattooing in fifteen minutes, and I fell into a process of self-reflection while working.

It was clear that—while I changed the bodies of other people—I was changed along the way. I increasingly *embodied* what it meant and what it took to tattoo strangers for money. By "embodied," I mean to suggest the "experience of having and using a body," because people don't just *have* bodies. People *are* bodies.[9]

The change in me had it so that I could alter my internal and external states to meet the demands of tattoo labor without much conscious effort. In my own small way, I'd made it. This was a relief because, like many tattooers

who struggle through the early days, I often *knew* that making it just wasn't in the cards for me.

This Book

This book is about tattooing, of course, but, more so, it's about what can happen at the intersection of people, bodies, and money. Tattooing is, after all, an intimate (think people), carnal (think bodies) job (think money). Most directly, this book is about what the people who labor within this intersection often think, feel, and do.

It turns out that tattooers navigate complex arenas of physical and cultural experience. These arenas are themselves organized by ideas related to the body and the life course. As I found out over time and through experience, what tattooers think, feel, and do is shaped by what people think, feel, and do in a more general sense.

And the stakes are always high. That's because tattoos inspire a visible and permanent change to the body. These high stakes are exactly what make tattooing what it is: awesome and terrifying, risky and rewarding, fun and a lot of work.

The best tattooers render their navigation of people, bodies, and money unseen, making the whole gig seem easy. Their clients will likely never consider how quick it could fall apart—how a slip could cause a permanent mistake and how a tattooer's bad mood on one day could be felt for decades, retained within the tattoo itself by the memory of getting it.

Now, there is a little wiggle room here, a number of opportunities that exist in the space between great and terrible work. When one element of the people-bodies-money intersection does break down, when the intersection itself begins to take on the energy and terror of balled-up snakes, a tattooer can save the day. They can, for example, give someone an awesome experience and make up for the fact that the tattoo itself isn't as good as it could have been. They can give someone a great deal, moneywise, and perhaps correct for their grumpy attitude. There's no guarantee this will work, though.

Luckily, this book isn't the first to approach this intersection and its frontline workers as a site for social research. Indeed, sociologists have studied manicurists, hairstylists, massage therapists, sex workers, surgeons, elderly care providers, therapeutic spa workers, and even nightclub bouncers.[10] As

different as these workers may seem, they all participate in something called "body labor"—paid work to change, sustain, or even control the bodies of other people.[11]

Tattooers are body laborers *par excellence*. Explaining how they think, feel, and act helps reveal, among other things, just how complicated it can be to work with bodies. After all, bodies are always two things: physical and cultural. On the physical front, bodies are things that can be touched, moved, and changed. They are the vehicles through which people experience the world, and they can be difficult sites to work *from* and *on*. Tattooers face and eventually master this physical difficulty. The cultural front is a little more complicated.

Consider, for instance, how bodies seem to carry and convey *meaning*. There's a great deal of sexual meaning ascribed to bodies and to certain areas of the feminine body in particular. There's also a great deal of racial meaning ascribed to bodies and especially to skin tone, although racial significance has been applied to facial features, bodily shape, and even demeanor through a process called "racialization."

Tattooing demands a person bounce between the physical and cultural body on a daily basis. Tattooers touch strangers, and at least in some cases, they have to approach sexual features as though they're just physical qualities. And because they produce colorful designs within skin—a medium of various tones—tattooers often work to approach racial features as though they're only technical components of the job. There's a tension here that might be irresolvable: you can't fully separate the physical from the cultural body. Tattooers have to try, though. It's a central characteristic of their labor.

Of course, tattooers aren't alone in dealing with the gap between the physical and cultural body. Hairstylists, for instance, work with *hair* as much as they may work with *gender* or *race*.[12] But tattooing is unique among other types of body labor. Its major distinction involves time; tattooers proceed into the work knowing that tattoos are forever.

While the issue is complicated, this fact saturates every crease and corner of what it's like to be a tattooer. It mostly raises the stakes. And while the stakes are high for people who *get* tattoos, they're also high for those who *do* them. Indeed, tattooing can scare the shit out of people, especially at first. It gnawed at me during the early days and nights.

Tattooing is also distinct among other types of body labor on account

of its masculine character. As sociologist Carrie Purcell puts it, a "defining characteristic" of body labor is that it involves modes of attention, care, and touch that are coded feminine.[13] Researchers have mostly explored the experiences of women who work in feminized body-labor environments, and for good reason. Women, and women of color in particular, have been relegated to the performance of bodily care for those with more relative power.

Men have mostly figured out how to bolster their masculinity while tattooing. This might not surprise most people, but it surprised me after I began doing tattoos. This is because tattooing is, at its core, an intimate, delicate type of bodily work. While there are some clear exceptions, and while the process is rather complex, men have *masculinized* tattooing by preventing women from gaining significant status in the mainstream tattoo world. They've also kept tattooing masculine by approaching the feminine body as a site of potential purity—that is, one that's less markable or suited for tattoos.[14]

An example of this is found in the writings of "Phil Sparrow," a mid-century queer tattooer in Oakland, California. He refused to tattoo women "unless she were twenty-one, married and accompanied by her husband, with documentary proof to show their marriage."[15] In his memoir, he describes the women he did tattoo as "large lank-haired skags, with ruined landscapes of faces." The exception were butch lesbians, who were "usually fat as a pig" and who "bruised so easily" because the "feminine flesh was so delicate." This language and its associated practices can help remind us of the central position played by men and the masculine body in the history of tattoo production. But this book is not a history of tattooing.

Broadly speaking, I approach the intersection of people, bodies, and money with lessons from sociology in mind. The *people* element is explored with help from research on social interaction, mainly the work of Erving Goffman. The *bodies* element is informed by research on emotions and embodiment, which necessarily delves into matters of gender and race. I approach the *money* segment by drawing from economic sociology and largely that which illustrates the power of money to organize our intimate social relations.

The book is also informed by the work of scholars from smaller subfields of sociology and anthropology, including sensory studies, sex and gender studies, theories of race relations, queer and feminist studies, and ethno-

graphic methods. A key lesson of pragmatist philosophy and the work of French sociologist Pierre Bourdieu are brought into the mix as well. While these last two schools of thought differ, they both approach knowledge and a person's more general disposition as an outcome of direct experience with repetitive problem solving. This stuff is useful for describing body labor.

I develop some of my own concepts along the way, partly because this book is the first formal, peer-reviewed ethnography about tattooing to have been written by a tattooer. Some new words were needed to explain what I found, especially because studies on tattooing have been done from a distance. It is very hard to know what it's like to tattoo strangers for money unless you do it.[16]

In Blood and Lightning

Matt would try to communicate his profound appreciation for the basics, but tattooing is hard to talk about. The challenge of talking about tattooing stems from the fact that it's such an embodied thing to do.[17] It's like trying to explain the details of riding a bike or walking in a straight line. Matt seemed to know he couldn't communicate the complex thing that was tattooing, but he'd try.

He spoke in sober and instructive terms by day, but he took on the language of epic adventure come nightfall. He would bring captivating passion to the near-impossible task of communicating the gravity of what he did— what *we* did—with people, *to* people, and to ourselves.

Pauly and I came to describe Matt's most earnest of "lessons" by its broad theme, "blood and lightning." Matt would look into my eyes with an intensity seldom experienced among men in public. He would lean so close I could smell the vodka, which is a hard thing to smell. He'd stress, "We deal in *blood*. We brandish *lightning*."

He'd curl his left hand into a fist and wrap his right around an imagined tattoo machine held midair, "Understand what I'm telling you!" he would command. "Blood and lightning!" He'd catch my eyes darting across the room. "Blood and lightning, my dude." He would pause and sigh, especially in the early days, as if no amount of him repeating this crucial fact could impart its significance. We'd stand on the back patio, and he would look off into the distance, drunk on the moment if not on the vodka.

It got me later on as I navigated the intimate work of tattooing clients. I would sit sweating while changing the body of a stranger, wiping their blood away from a fresh mark and doing my best to steady the machine. I would try and keep my shit together so the client wouldn't recognize just how easy it was for me to make a permanent mistake. I'd pause and look over to Matt, who would sometimes return a glance of profound recognition.

That glance said more than he often tried to say with words. It could send a vibration through my body and remind me that we were part of something big. Something important.

I would move through the piece, pulling lines and filling sections,[18] often blown away by what I was doing to someone else. The stakes were so high, the terms complex. Those terms could move around, shift with the flow of work and in response to the conditions of a person's body, and of my own body, too.

What Matt and other tattooers often tried to describe—the great task of navigating the intersection of people, bodies, and money—began to make sense over time. I hope to communicate that description in this book. That is, I hope to express, describe, and otherwise make sense of what it's like to deal intimately, as Matt might say, in blood and lightning.

Tattoo Worlds

You probably wouldn't look at Premium Tattoo and guess that profound things happen inside—that, for instance, Matt would be gripping my attention with his talk of blood and lightning. The shop is nestled between buildings that stand alongside a busy street. It's called Broadway Avenue, and it stretches down a series of very long city blocks just north of downtown Oakland.

The street's four lanes are divided by a thin strip of patchy grass, trees, and cigarette butts. It's populated by auto dealerships, restaurants, old bars, and a tattoo shop. The shortest walk can feel like a haul, with the passing cars and sparse shade making the whole scene a bit of a drag.

I often ate from a burger restaurant across the street, one of the newer places catering to a growing set of residents who couldn't afford the million-dollar bungalows in a nearby bastion of prosperity, the small city of Piedmont, which is actually surrounded by Oakland.

Premium always looked small from that burger joint and not just be-
cause it sat on a long city block. The building just didn't convey the sub-
stance of what occurred inside. Perhaps it couldn't.

The word *TATTOO* was painted across a series of small windows above
the front door. Those small windows spanned the building's facade and
sat atop larger windows that made up the shop's storefront. It all screamed
tattoo, especially as those larger windows had a bold, decorative pattern
across them. You could tell that the interior featured black-painted walls
littered with tattoo designs and you could occasionally hear the rock and
roll from the sidewalk.

But however isolated the shop might have seemed from across the street,
it was actually one feature in a wider *world* of tattoo production. As with
manicurists, fashion models, and jazz musicians, the process of creative pro-
duction among tattooers is the outcome of cooperative effort.[19] These people
who make things might appear to be working alone, but they aren't; they
exist in and, indeed, rely on a constellation of others to make what they
make, often for money.

Tattooing is cooperative in the sense that it involves more than one
person, as its results are achieved between tattooer and client. But it's also
cooperative because tattooers rely on others to accomplish their daily work.
They need help, for instance, from those who make machines, inks, power
cords, foot pedals, tables, stools, razors, ink caps, paper towels, and the
green soap. They rely on these artifacts of tattoo production, and they even
riff on each other's designs. Then there is the team effort of constructing and
maintaining the shop's glamour—that work to manage impressions that can
coalesce into an overall performance and scene.

To be sure, though, early twentieth-century tattooers in the US worked
mostly alone, even if some upheld correspondence through the mail. They
operated in conditions far different from those I experienced. I, for instance,
was able to order premade rotary-style machines, premixed inks in an in-
credible array of colors, and anything anyone could ever need for tattooing
over the internet. I was able to meet and learn from tattooers living across
the world, all from my phone while sitting at Premium on Broadway Avenue.

Old-time tattooers did almost everything themselves, including conjur-
ing up aseptic techniques that would scare nearly anyone getting a tattoo
today. As people who built things, these tattooers hovered over workbenches

as often as they tattooed clients. They had to learn how to build, maintain, and improve basic equipment, including the "coil" tattoo machine.

I learned how to build these machines as part of my apprenticeship and research. They have a bunch of specialized parts, and people nerd out on the details. While I could've dedicated myself to the making of tattoo equipment, I didn't have to. I eventually landed on a pink and beautifully designed rotary type of machine called the "Anvil," built by a UK machine builder.

Regardless of a tattooer's relationship with machine building, the tattoo world in which they operate mostly resembles a "craft world." By *craft* I mean a commercial enterprise among people who seek mastery over an aesthetic, physical type of production.[20] The association between tattooing and craft reflects a sixteenth-century split between the "artist" and the "artisan." It was during this time that *artisan* began to suggest technical mastery and *artist* began to suggest novelty.[21]

Many tattooers, like other craft workers, associate mastery with wide-ranging technical skill. They appreciate tattooers who can do clean tattoos in a variety of styles, because each style relies on a unique set of techniques. But I stress here that the tattoo world *mostly* resembles a craft world because tattooing is hard to pin down as one thing. While there is a mainstream tattoo world, the larger constellation of tattoo work takes place within many smaller worlds.

Groups of people have their own approach to tattooing. Among many lines of distinction, including the ideals of ethical treatment, there's a rift between those who approach what they do as *craft* and those who increasingly approach what they do as *art*.

There is a growing world of artistic tattooing, built on a "renaissance" effort by tattooers like Ed Hardy of San Francisco and Spider Webb in New York City, who brought art inspiration into tattooing during the 1970s. Whether they are familiar with these figures or not, contemporary tattooers and their clients who approach tattooing *as art* appreciate the work on the basis of its conceptual novelty and sentimental expression.[22] They base their design work in art-historical concerns and often talk about their tattooing like a painter might talk about their painting.

There was some great and rather strange tattooing going on while I was in the game, between 2018 and 2021. There was a guy in Europe who tattooed as a form of performance art, for example. He once attached a battery-

operated tattoo machine to a small drone, which enabled the machine to scratch permanent marks all over someone's back from midair.

Any tattooer hoping to earn a living through this kind of artistic practice has got to secure a sizable reputation, something that could be done over Instagram. Some folks jump into tattooing from other art mediums, bringing a style, a reputation, and an established social media presence along with them. But many tattooers develop a style while satisfying walk-in requests in a "street shop" like Premium Tattoo or one that remains open to the public for same-day pieces.

The lines of distinction that separate some tattooers, and tattoo worlds, from others exist on the level of *conventions*, or established modes of thinking, feeling, and acting by people who pursue a similar goal.[23] The conventions of tattooing guide how folks understand, experience, and accomplish their work. They encourage people to talk in similar terms, and they even contribute to how they *feel*. Conventions inform ethics, too—informing the decision, for example, of whether to give someone a tattoo on their face. Looking toward tattoo worlds can reveal conventions that are local to shops and scenes.

So, this book isn't about *all* tattooing. It's good to remember that it's like any ethnography: it explains what the researcher found. It doesn't even explain the full complexity of my own experience. Ethnography narrates many partial truths, and I account for what I don't know when necessary. I ultimately try to do what a good tattoo does in skin: deliver a clear and impactful story—one that has been radically distilled from the messy, laborious, and painstaking process through which it was produced.

Premium Tattoo and Its People

The great bulk of my life in tattoos happened at Premium alongside Matt, Pauly, and Karime between the years of 2018 and 2021. My relationship with Matt is foregrounded here, while one of Matt's earlier apprentices makes an appearance, a shy white guy named Jesse. There were a few other people involved with the shop during my time who didn't make it into this story.

Matt owned the shop and was my mentor. His fantastical language was inspired by a lifetime of Dungeons & Dragons. He animated tattooing's bloody reality through conversation. He also loved to talk fashion, architec-

ture, and ancient warfare. His dream job as a youth involved painting castles in Europe. He wanted to paint in situ and sell the work to whoever would buy it. He always sought to make art for a living, and he found his chance to do so as a tattooer.

Matt was endearing: well-meaning and hotheaded. He was charismatic and a great storyteller. He also had a lot on his mind and would allow this to be seen in moments of acute stress. He had to ensure the bills were paid and, because he took on apprentices, had to teach other people to become tattooers. He tried to solve both problems daily while keeping up his own tattoo practice. He drank a lot, which helped him in some ways and burdened him in perhaps more.

He was only twelve years older than me, but as a father of two toddlers and as my mentor, he could be very paternal. We rarely admitted as much because, at least to me, it seemed too strange to say out loud. I brought it up once, and he pressed his hands against his face: "Sometimes you wake up and you're forty-six." According to my records, we spent more than three thousand hours together at Premium. Maybe it just made sense for us to be family. It sometimes seemed we could read each other's minds.

Like many who began tattooing in the 1990s, Matt was caught amid change. He negotiated the fact that tattooing was less punk rock than it used to be. He celebrated this fact and grappled with its effects, namely the onset of sophisticated marketing and communication. He hated computers, social media, and really anything that required a username and password. In this respect, he wasn't someone that an apprentice could lean on when it came to how they might best market themselves and their work. He also disliked cars, cops, and Republicans. To be sure, he'd probably give a cop a cop-themed tattoo. But that was tattooing, his job.

Pauly was another tattooer at Premium. He was a white-passing Argentinian with a head of dark hair. He grew up in the tough, flat landscape of West Oakland, although he was educated in Berkeley's public schools. He had this strange habit of buying things from people in public. He bought a hand-knitted sweater off a guy in the bar down the street, for instance. It was knitted by the guy's grandma. Pauly took to wearing it as though it were just another item in his wardrobe. Once, while we ate in a busy restaurant, he handed me a hubcap he found on the street. He loved music and VHS tapes, and he drank a lot.

Pauly was Matt's confidant, and he was quick to challenge me early on. For example, I once found him standing with a giant wooden sword on the back patio. He looked at me through bleary eyes: "You're a *spy*, man. That's what I'm going to call you, the spy."

His suspicion was warranted, given that I was there to watch and that the decision to allow a researcher into the backstage world of tattooing could bring heat to Matt and the shop. Established tattooers hoping to defend their often-secret world lash out at people for revealing insider information, a task increasingly difficult and even a bit embarrassing given a decades-long proliferation of useful and creative skill-sharing among tattooers online. I knew Pauly wouldn't hit me with the sword or anything else, but the moment had its effect. I often worried that I would bring harm to these people by writing about their lives.

Pauly might have been suspicious of me, but we grew to appreciate one another. His enthusiasm for tattooing was notable. But Pauly had a hard time finding enough success as a tattooer to quit his day job, where he worked under a licensed electrician.

He struggled to develop a recognizable tattoo style even though he had a preference when it came to design work. He didn't have a strong style partly because he didn't work at it enough but also because he was prone to self-doubt. Developing and advertising your take on tattoo design requires a level of self-confidence that Pauly couldn't always access.

He was also attached to a working-class critique of the more artistic kinds of tattoo work. He didn't like the idea of a tattooer who created and then stayed within a particular style. Pauly's goal in tattooing was to *do well* whatever walked through the door. He wanted to be what some call a "walk-in-wizard" and would dig into me about being what he once described as a "prima donna" (read *feminine*). Pauly's theory was that I only wanted to do my designs on my clients, and he might have been mostly right. I tried my damnedest to create a style and to foster a clientele. It was, as I saw it, the surest road toward good tattooing, even if it could pigeon-hole someone over the long haul.

Karime was a young, queer person of color with parents from Mexico. They lived at home and didn't own a car when they joined us at Premium as an apprentice. But Karime came equipped with some skill, having bought

ready-to-use tattoo equipment online while still a teenager. They learned techniques from YouTube and found quick success doing tattoos on people.

Karime produced solid work. Most of it reflected a style popularized by Chicano artists in Los Angeles, although Karime applied the style to designs more reflective of their everyday interests, such as anime, and caught the attention of people like them. The work was made by using thin lines and light shading, often accomplished with small needle configurations—or even a single needle—and various shades of black and gray ink. This kind of tattooing is hard, and Karime was good at it.

Most tattooing is done with larger bunches of needles, ranging from five to more than eighteen needle points attached to a single bar. The more needles there are, the more tattooing feels like drawing and the more likely your lines will appear to be free from little wobbles. Here's an exercise: Try drawing a straight line across a sheet of paper with a very sharp pencil. Don't go super-fast; remember, you're working on a body here. Now try to do it with a fat sharpie marker. Which line looks straighter? Which was easier to make? The logic applies.

The biggest struggle in tattooing for Karime involved the *people* side of things. This was a serious problem. The best illustrator can fail as a tattooer if they can't handle strangers effectively. It meant Karime faced a barrier that I and many other extroverted chatterboxes often didn't. They were at the beginning of things, though, which meant they had plenty of time to develop the skills (and the savings) they would need to stake it out on their own.

Matt was our boss, in a sense, but he was a bit more than that. He was our mentor, and in some important ways, the shop was a physical reflection of his spirit. A change in his mood could shift the atmosphere of the entire building and everyone inside. His good days were good days for all of us, and this meant his bad days could drag us down. I always knew it would be a blue day at Premium if Matt started playing Simon and Garfunkel, for instance. He was aware of this, and he worked to keep an even keel, but it often proved a challenge.

While this story is mainly about us at Premium, it is born from deep engagement with more than fifty tattooers. Many of these people tattooed me for hours, but I only briefly met some of the others. I did twenty-three formal interviews, mostly with women and folks who identified as queer

or trans. While some of the people I met were very successful, the majority were carving out a living in the Bay Area cities of San Francisco, Oakland, and Berkeley. I detail participants, method, and the ethics of ethnographic writing and research in the appendix.

Cracking the Code

Matt warned me that tattooing would consume my life. This warning was extended to Pauly and Karime, and it was repeated by tattooers I met. These tattooers assured me that they, and eventually *we*, had discovered a gripping vocation. They promised it would be something I could never walk away from. One of them told me that tattooers had "cracked the code," in that they'd figured out how to have fun, make art, and make money all at the same time. They were locked into the best gig there was. I paid attention to this warning.

The sentiment of discovery, and its association with a calling, is echoed in phrases such as "Tattooers are born, not made." I appreciated this phrase's romanticism, especially as expressed by Faith, a trans woman of color who describes her experience during a podcast interview with Andrew Stortz.[24] It conjures a sense of purpose. It made me feel like I was somehow and maybe for once on the right side of history. But as much as I enjoyed hearing it, my sociological imagination had me questioning its truth from the start, especially in the face of what I observed and went through.

Tattooers, it seemed to me, are indeed *made* over time. They're shaped by the conditions of tattooing as they encounter them. People grow into themselves *as tattooers* while working with clients' bodies for money. They are often socialized into what it means and what it takes to tattoo while working alongside other tattooers in shops. This is a kind of molding, and it's simultaneously intellectual, emotional, and physical. The demands of tattooing can change how a person thinks, feels, and acts.

The fact that tattooing shapes a person might appear obvious to a new tattooer. They are in the throes of actively attuning themselves to the many demands of tattoo labor. This process of attunement slides beyond the range of perception eventually, as people begin to embody tattooing.

And while it might seem like tattooers have a great gig, the daily life of tattooing is often fraught. I occasionally hated it. Tattooing is, after all, a

precarious service-oriented job. It's hard on the body, and the money only flows in response to the desire of a consuming public. That public is reached by the hustling tattooer, who must, day in and day out, match the emotional and bodily needs of clients who can be hard to work with. And in the age of social media, tattooers have got to develop a vibrant online presence to fight for the attention of potential clients. This often felt like a second job.

So, we spent a lot of time on our phones. We filled days with other activities, too, as there was quite a bit of downtime at Premium. We would draw "flash"—designs developed without the guidance of a client's "custom" request—either with ink on paper or with a digital touchpad, and we would take up other projects. There was always the opportunity to tattoo each other and ourselves, play Dungeons & Dragons, talk politics, and watch professional sumo wrestling. We often grabbed lunch before growing especially hungry. It often seemed like Matt and Pauly were just waiting for the shop to close so they could have a drink and crank up the music. I would go on walks, or "strolls" as Pauly liked to call them.

The work of street-shop tattooing can fluctuate daily, but it's also seasonal. There's a yearly lull during the winter months. Tattooers call it "painting season" because they paint flash designs while they'd rather be tattooing. They hope the flash will eventually be tattooed on people.

We weren't alone in the necessity to fill downtime. You could notice the onset of painting season across the Instagram accounts of local tattooers. "Got time to tattoo you next week!" or maybe, "Itching to do some of this flash, check it out!" They would offer discounted rates and cook up schemes. Some tattooers I met did paid work beyond tattooing to fill the gaps. Matt occasionally did package design for a marijuana company. It paid well, and its total compensation included products that would get most people very, very stoned.

While it's easy to see how someone could dislike the touch-and-go character of tattooing, it's still a risk to admit I sometimes hated it. This is because tattooers are supposed to love what they do. The assumption is built into the relationship they're supposed to have with their work—a relationship often cultivated through socialization during the apprenticeship process. The idea that tattooers are supposed to live and breathe tattooing is a hallmark trait of its *vocational* quality. Tattooers who say they dislike tattooing or their clients are like teachers who say they dislike teaching or their students.

Of course, this expectation that you should love the work is also wrapped up in a broader impulse of capitalist enterprise. The great "spirit" of capitalism, founded in an ethos, ethic, and duty toward industry, encourages what Max Weber described as "an ethically coloured maxim for the conduct of life."[25] Whether people have a Protestant religious background or not, a capitalist mentality motivates them to produce and otherwise dedicate themselves to constructive activity. Tattooers aren't spared here.

Despite its many challenges, though, I loved tattooing. It blew my mind and became a major source of my life's animation. I mostly loved my clients, too. They were fascinating people who often showed up on time. They appreciated my pricing, tipped well, and got rad tattoos. Some of their ideas were incredible, too. There was that "crab holding a lighter in one claw and a piece of broccoli in another" request, among others. Their concepts gave merit to one of Matt's lessons: "Your clients will give you your best ideas."

The majority of my clients were young, queer, and college educated, which meant we spent hours discussing pop culture, sociology, literature, and our pets. They taught me things.

I once tattooed a young seminary student who was trans. They had me tattoo a pangolin surrounded by the phrase "Trans is Divine" on their upper left thigh. They taught me about the religious qualities of trans experience and its relationship with the divine, pulling out quotes from scripture and digging into the details. All of this while I worked over the piece on their leg with my machine. It was just another profound experience with someone at the shop.

But some of my clients could be flaky, unorganized, and difficult. Many were prone to processing—discussing their thoughts and decisions with me and for a long time. They wanted the boundaries between us to disappear, and I wanted, even needed, to uphold at least some of them. I'd learned how to "process" through therapy and by living in leftist housing cooperatives, but I didn't want to do this with clients at work, and it wasn't just the processing. Some folks were simply rude. I wondered how Matt had been able to do it for so long, and I wondered how Karime would hold on over time.

Some people hang on because they're able to make a lot of money. It's also the case that people hang on because they don't have anywhere else to go. Even as tattooing offers plenty of opportunity to develop transferable skills, people can get stuck. A lot of long-haul tattooers wouldn't frame their

experience as "being stuck," though. This is because tattooing is far more than a *job* for many who do it. It was this way for Matt.

Matt maintained an enduring love for the work, even in its most basic forms. Tattooing the word *faith* or a quick name on someone's arm could mean the world to Matt, even if he lived for the chance to do bigger and more stylistically signature stuff.

One afternoon, he seemed to delight in tattooing the Macy's logo on some guy who had just retired from thirty years with the company. It turns out that the red star in the Macy's logo was inspired by a tattoo on the arm of Macy's founder.[26] That original tattoo came from the late nineteenth-century days of tattoo collection, when men brought tattoos home from their travels on wooden ships. I told Matt about this, and he gave me a look of curious surprise. How was it that one of the strangest, and perhaps most benign, tattoo requests was so deeply ingrained in tattoo history?

There were surprises like this all over the place.

ONE

Enter the Apprentice

My apprenticeship began the day I did my first tattoo. It was December 8, 2018, and the whole day had a big mood. I knew it was coming because Matt had said so two days before, when I wrote in my fieldnotes: "I am absolutely beside myself with excitement about this idea." Becoming an apprentice never really seemed like an option. I was at the shop for research and too nervous to ask for a real apprenticeship. Matt laughed when he heard about this, telling me he'd been thinking about it for months.

I had a hard time with sleep the night before. The time I did sleep involved a kind of waking dream state—just waiting to see that dark purple of a day on the cusp. There was a newfound sense of purpose attached to my whole endeavor with tattooing, and on my arrival at the shop that day, Matt confirmed that it would actually go down. The day had to be waited-out, though, so I busied myself with cleaning that didn't need to be done. We had two cancelations at the shop, which meant there was way too much time to fill.

Matt and Pauly were in good spirits. Matt's other apprentice, Jesse, was, too. They all knew something important was about to happen to me—and to all of us. They ensured that it would *feel* important by overseeing what amounted to a ritual. It was this day that Matt said one of the most sociological things he ever said: "These kinds of rituals keep tattooing sacred."

He could have been reading from Emile Durkheim's *Elementary Forms of Religious Life*. Durkheim was on a quest, seeking to answer an enormous question: What accounts for social cohesion? Why, that is, do social groups seem held together? For the record, he argues cohesion is an outcome of a process—found in every society—where people separate special objects and practices from the throes of everyday life.

Distinguishing "sacred" things, or those held apart from the everyday, can promote a sense of oneness. So can the vibrant feeling that often accom-

panies intense group experiences, what he calls "collective effervescence."[1] I always imagine the group enjoying a communal champagne bath, rising out of it buzzed and involved.

Matt *sacralized* my entry into his world by involving me and his crew in a sacred process. Part of the process involved a kind of stripping-down: Matt requested we no longer talk about my research project. He wanted us to be mentor-and-apprentice *only*. I was cool with that, partly because I had no choice but also because I wanted to be there with Matt on his level. I wanted to go through this thing and for real.

I was excited, and I was also grateful to have learned some details about this first tattoo ahead of time. I knew what the design would be, and I knew where I'd have to try and put it. Matt had all of his apprentices tattoo, or at least try to tattoo, a triangle on his right thigh. He showed them to me one afternoon, months before I knew I would ever be adding to that collection. He dropped his pants to reveal a few wobbly triangles, each with three dash marks extending from the right wall to the center. I saw them, but I didn't know what it *felt like* to put them there—that is, until I tried myself.

Matt, Pauly, and Jesse began gearing up by heading to the bar. It was roughly 3 p.m., and they left me in the shop for more than an hour. I stewed there in a soup of my own nerves, all by myself. I took out two sheets of printer paper to draw on, but I just left them there, blank. I jotted fieldnotes into my phone to capture the feeling. Rich notes like this one, "Incredibly nervous, feeling anxious, pacing. Just finished the set up . . . ate handful of cold French fries, loud music."

The crew eventually burst through the shop's front door, making me notice how dark it had become on that December afternoon. They set the stage through big, jovial talk. That collective effervescence started swirling all around us. They began poking fun at my obvious anxiety, and they stretched out the time by going to the back patio for a smoke. Things got more serious, though, when we set out to do the thing.

Matt had me put on a thick, vinyl apron, one that would be mine as a tattooer. He approached the booth with confidence. He unbuttoned and then pulled down his black pants before sitting there in front of me in short, black briefs. I put on gloves and sat before him while looking over my readied equipment. I failed to note who did the shaving. I did note, however, that Matt drew the triangle on his leg with a ballpoint pen. He did it with ease,

as though he had been drawing on and otherwise marking the human body for decades.

I was nervous as hell, and he knew it. I wondered if he noticed my shaky hands. I was awkward with my body and eventually with his, unsure how to sit and how to reach out to touch him. I'd never touched him there before, on that pale space above the knee, and I had never used a tattoo machine on a human, either.

This tattoo was like all tattoos in that it was intimate. The touch and the closeness were new to me, even if Matt had done plenty of tattoos on my body by that point. The intimacy grew when one of his testicles plopped out from his underwear's outer seam. I paused, wondering if I should say something while Pauly's head flew back in laughter. I sat frozen. Matt tucked himself back in casually, as if it was just another thing to have happen that day. He said, "You've gotta get used to bodies my dude. We're talking smelly feet and farts and, yes, sometimes balls. Part of it."

I started the machine by pressing lightly on its corresponding foot pedal. I steadied my hands against his leg and moved the vibrating needles toward his skin. I made contact, only to see and feel the needles bouncing around with astonishing speed on top of his leg. They actually made a flabby sound. Matt sat, knowing he would have to teach me about this sound.

I pushed a bit harder and began making some headway. Matt continued firmly over the music: "You think what we do is *easy*? You think what we do is *nice*? You thought you'd be good at this?" I believe those questions, or rather statements, were intended to prompt me. I was in a vulnerable spot, and it was clear to Matt that I could probably use a jolt of humility when it came to tattooing. He was right, I *did* think I would be good at it straightaway.

I thought I would nail the whole tattoo thing when given a chance. I had this vision of picking up the machine for the first time and offering some evidence of an inherent aptitude toward its use. This whole story of mine dissolved real quick, as did its related vat of optimism. Tattooing, and everything about it, proved to be much harder than I had ever imagined. Maybe I was overly confident, but it was more than that. I was like anyone else with no experience tattooing—ignorant of its true difficulty and surprised by the trouble I'd face on trying it.

So I sat there trying to tattoo him, only to hear this flabby sound. I knew

the sound didn't happen when he tattooed me, but I didn't how to use the sound to change anything about what I was doing. I didn't know, that is, what this sound and its related vibrations *meant*. It was one of the many sounds and feels in tattooing that my senses would have to be tuned to appreciate over time. I would later experience them as crucial bits of instructive information.

That day, and for many days to come, Matt would act as my translator. He relayed the sound's meaning so that I could respond to it accordingly. This flabby sound told Matt that the needles weren't going into the skin properly. He explained this and encouraged me to stretch the skin harder so that its surface could be more easily penetrated. The sound also suggested I could angle the machine further and add a little pressure.

I eventually calmed the flabby sound and moved the tip of that strange machine across a small patch of Matt's thigh. The movement wasn't as much "across," though, as it was *through*. I could tell I was dwelling in some sort of medium. That machine wanted to move around on its own as soon as I sank the needles into Matt's skin. "The thing wants to take off on you," I wrote in my fieldnotes, "like one of those spinning, floor buffing machines in movies." I couldn't believe anyone could tattoo a straight line. I sat back, though, to see that I might have made one.

I only saw what I'd *actually* done after I wiped the area with a damp paper towel, removing *excess* ink and some blood from the skin's surface. Tattoo machines leave excess ink around their marks, such that you've got to wipe the area between marks to see what you've actually put into the skin.

That seemingly straight line was actually the squiggled mess I thought it had to be, given what it felt like to put it in there. It undulated in direction and width, starting thinner and growing fatter before turning all thin again. I stared at it fretting the fact that I had put it in Matt's leg and that it would be there forever. I thought about this for a moment before Matt interrupted, "Put it in there, bud. Let's go."

I finished the piece and sat back in amazement. I couldn't believe it was so bad. It was, and it still is, a triangle tapped of its potential vitality (see fig. 2). Only the bottom line would pass as straight, but even it nearly disappears at one point. The triangle, or the pyramid as I later began to imagine it, doesn't even have a solid point at its top. It's missing the most crucial feature—the capstone, the pyramidion.

FIGURE 2. *Matt demonstrates how to dip the machine into the ink cap before I tattooed his exposed thigh. The second photo shows the tattoo after healing.*

I wiped Matt's leg once again with paper towels made damp with green soap. I took one rushed, blurry picture before wrapping his leg with a thin layer of clinging plastic. I secured the plastic with some medical tape, catching a few leg hairs while I was at it. Pauly reached over and slapped the covered tattoo while laughing. Matt slapped it a few times himself. The vodka they'd just drunk was having its effect. The Thin Lizzy blasting in the background was doing its job, too. Most important, though, we were absolutely drenched in that sweet effervescence. A pink aura grew across Matt's thigh.

The tattoo vanished beneath his rising pant leg. I stood while Pauly paced around. He had tears welling up, and I heard him say, "I'm fucking *crying* over here, bud." Matt gave me a hug and spoke into my ear, "Welcome to the fold." He projected a sense of pride. Jesse invited me to do my second tattoo near his knee a few days later, this time a simple skull. He was so taken by the aura of the shop and by Matt's program that he had his own ritual of collecting the second tattoos of Matt's apprentices, right there on the same upper thigh.

While I didn't drink so much, I wanted to go down to the bar for a beer in celebration. Matt quickly corrected the plan. He said, "We do that *here* my dude. In this shop. We do that here together." He had Jesse grab a six-pack of Anchor Steam lager from the 7-11 just four doors down. We raised our bottles, I offered thanks through a toast, and I gazed through the bottom of that bottle as it tilted toward the shop's ceiling. We talked and enjoyed each other, showering ourselves with an electric sense of optimism and ambition.

I eventually made my way to the train station, walking in absolute awe of what had just happened. At the least, I felt initiated into a new scene. At the most, I felt like I had changed.

"This situation of it all is crucial," I reflected in notes later on, "with the people all gathered around and emotions high." It was that night that I began to appreciate something new—something about tattooing that wasn't plain while interviewing tattooers, by that time fifteen, and by getting more than ten on my body. This something new involved the great, emotional forces that can surround and organize the experience of tattooing another person.

All of this and I felt heavy the next day. By tattooing Matt, I had made a promise. He was assured that I would dedicate myself to becoming a tattooer and for years. I had agreed to work in his shop, too, which was the source of his family's livelihood. This meant that whatever tattoo I did out of the

shop could be tied back to him and eventually to his kid's dinnerplate. There was a deep sense of responsibility, as I knew Matt took a risk every time he let someone into his world. But this was before I realized the real gravity of what I had done. What tattooing strangers would demand of me was still a mystery. I didn't suspect that my effort to change other people would change me.

I was also ecstatic. It was easy to dream up a new life for myself. The drudgery of grading and teaching part-time at community colleges was front of mind—as was the challenging prospect of seeking tenure in some university after my PhD. I put on music and sat drawing, wondering whether I'd ever tattoo the drawings. It was clear, later on, that I would never *want* to. They would have made for bad tattoos, even if they were decent drawings. I didn't know the difference then.

Getting In

I first encountered Matt in 2012, back when you learned about tattooers through word of mouth, magazines, rudimentary websites, or by flipping through printed portfolios at shop counters. A neighbor of mine in Oakland suggested Matt after hearing me describe a tattoo idea. I rode my bike to Premium for the first time, and set up an appointment to have him tattoo my inner left forearm. To be sure, I was the kind of client I would grow to dislike—someone who showed up with a list of emotions and thoughts that I wanted him to capture.

That was the first one. It set off a course that neither Matt nor I anticipated, one that had me remain his client for six years and that later had me become his apprentice. I eventually approached him with the idea of conducting a research project about tattooing, and after I asked a few times, he begrudgingly said I could "follow his apprentice around for a day or two." I just kept showing up.

We developed what he'd later call "our rapport" during those initial years when I was his client, not a researcher or an apprentice. This rapport—a legible and mysterious affinity—proved crucial in my ability to thrive in his shop. We shared a somewhat preconscious understanding of one another, partly because we both came up through small and rough punk rock scenes: mine in Bakersfield, California, his in Socorro, New Mexico. We were both

white, straight, cisgender men who enjoyed similar types of music, food, and tattoos. We were political leftists, and we were both redheads, too.

There were moments when the positive role of this rapport became clear, one of them on my first day in the shop as a researcher. I had sat near the shop's music control tablet, not knowing so, and began searching the room when the music abruptly stopped at the end of an album. There was a sense of urgency in the air, as both Pauly and Matt looked up from their work and over to me. Pauly even said, "Don't fuck this up, pal."

I chose the punk rock group Black Flag, specifically their early work as captured on a 1983 compilation album with the descriptive title "The First Four Years." On hearing the jagged guitar that opens the album's first track, "Nervous Breakdown," Matt yelled across the room, "He passed the test!" I knew Black Flag would work, and I knew any Black Flag album led by their last front man, Henry Rollins, would *not* work. That Matt and I shared an appreciation for music from the 1980s punk scene—resonating partly because it was so often characterized by white, male, working-class anger—mattered.

Premium *could* be a masculine scene, especially when I first arrived. This was partly an effect of aesthetic choices. The floor was painted black, for instance, and it had more than a few noticeable scratches on it from the near-constant movement of furniture and people.

The bathroom was painted black, too, but clients were always drawing on the walls with large sticks of available chalk. Their marks offered a chaotic, if also cohesive, sense that the shop wasn't so precious. While that bathroom had a visible supply of tampons, the tiny room had a tough feel.

The aesthetics of space contributed to Premium's potential to masculinize those within it—inspiring them to feel more masculine in the shop than elsewhere, whether they were men or not. The "deeply sensed" nature of gender allows it to be motivated by aesthetics.[2] People *feel* more butch, fem, queer, or manly across different environments.

These feelings can be cranked up or down by adjusting the way an environment looks, sounds, smells, or feels.[3] Retail store designers are masters of this trick. Tattooers are pretty good at it, too. While those at Premium might have wanted to avoid the toxic implications of "manning up,"[4] the sights and sounds could impart on those within it a motivation for manliness. I, at

least, often felt more man-like in the shop than I did outside of it, especially at first.

At the same time, Matt railed against the "white-straight-fucking-bro-shit" or "douchebag-fucking-bro-club" that was tattooing as he often found it. He celebrated the chance to apprentice queer women of color, and he re-designed the shop in 2021, painting it white and adding plants to produce what he described as an "inviting" experience. Matt told me early on, "We absolutely have to break up this bro club." We held benefits for indigenous peoples and for abortion clinics in the American South. The shop held a benefit for abortion pill providers shortly after the Supreme Court struck down *Roe v. Wade* in 2022.

He wanted to put Premium on the right path, even if he often seemed stuck in what he knew best. And what he knew best involved ideas, prac-tices, and objects appreciated most by people like him: straight working-class white guys who loved Dungeons & Dragons, rock and roll, tattoos, and drinking. There was an unresolved tension about his life, as Matt straddled the world of his youth and the more middle-class and middle-aged life that he, his spouse, and their two kids enjoyed. The tension impacted his work, and, with the booze flowing, I always feared it could threaten the success of his shop. He often seemed on the verge of tearing it all down on purpose, if only to taste that vibrant and destructive passion of the pent-up energy, anger, and angst of his youth.

There were times when the tension in his life clashed with my own, when my struggle to balance the role of researcher *and* tattooer seemed insur-mountable. Matt was frustrated by this, and it contributed to the two mo-ments when I thought we might be done for good—moments when Matt, in the early morning after the fact, would apologize through text message.

He was also surprised I ever wanted to be involved. He once looked at me while I mopped the floor and said, "What in the hell are you cleaning my shop for? Go clean a beach man. . . . What are you *doing* here?" I occasion-ally wondered what I was cleaning his shop for, too. I did it, though, and it paid off.

Ultimately, I tried to become an asset. I arrived on time, mopped the floor, and cleaned the toilet. I redesigned the shop's website and took over its Instagram account. I promoted the shop by posting pictures of tattoos and

by sharing videos taken of the day's work. This had a noticeable impact on our business, and Matt thanked me each time a new client referenced our Instagram account as their source of motivation for coming in.

There were times that I would also get him coffee from down the street, but he was a bit shy in asking me to do things like get him coffee, or even mop the floor and clean the toilet. I was, after all, a balding thirty-four-year-old community college teacher, and here I was doing what a lot of people do, or at least try to do, before they can legally buy beer.

As short-tempered as he could be, Matt was very thoughtful. He took everything about my life into consideration when he tried to make sense of my desire to be there and to eventually become a tattooer. He used things about my past to construct his approach to my learning experience.

He knew, for instance, that I'd traveled extensively, would soon get married, and would secure a PhD within a few years. He knew I had spent more than a decade in the service industry and had grown accustomed to the demands of catering to strangers. Matt also knew I was good with people. He called this last bit my "superpower," and he said it would serve me well in tattooing. He likely knew I could be an asset to the shop in this regard, helping produce an inviting front-stage atmosphere for clients.

Matt proceeded like he *had* to make me get him coffee, as though it was a built-in feature of the deal we'd made. He would say people have to earn tattooing. "It's not some casual thing. You can't just *have* it." He would get loaded, though, and openly question whether making me do menial tasks made any sense at all. "You mopping the floor is a fucking waste of your time," he told me, "You know how to mop a floor, to deal with people, to do this stuff right." He'd suggest I could run a business—maybe better than he could.

But I would get him coffee, mop the floor, and clean the toilet anyhow. We went through the motions, carried by a commitment to the process. While I didn't experience what many tattooers might describe as an especially "hard," "old-school," or "traditional" apprenticeship, I was nevertheless enveloped in a life that gave value to sacrifice. There was menial work to do and without pay, but it *was* reciprocal. I gave him my time. He gave me tattooing.

Matt's Program

Matt's program was flexible, but he generally asked people to show up for a few months before offering them a structured apprenticeship. During this initial period, those working toward an apprenticeship cleaned the shop, prepared and disposed of tattoo equipment, answered phones, and ran errands. They would draw, too, so as to improve design skills and develop style.

These tasks weren't especially challenging, but Matt's apprentices encountered a situation that could be demanding. For one, any apprenticeship involves a financial challenge. Matt encouraged people to hold paid jobs outside the shop but not ones that could interfere in their tattoo path (like mine). The financial burden was located in the missed opportunity for more wage earnings elsewhere. For this reason, the apprenticeship was most available to young people who had access to stable transportation, housing, and enough secondary income to get by.

It was mostly hard, though, because Matt's apprentices had to make sense of unstructured time under the watchful eye of someone whose assessment of them could be obscure. Matt was often hard to read. It was difficult to know what he wanted to see from people, too, because he didn't always express what he wanted.

Matt explained to me that he wanted apprentices to show initiative and interest, but he didn't tell these folks *how* they might do that. They could impress him by interacting smoothly with clients and by contributing to the glamour of our shop experience, but they didn't know Matt wanted to see this from them. He'd notice if an apprentice raised their head to greet clients, and he would pause in the middle of a project to assess the way they answered the phone. Karime's reluctance to greet strangers and their blunt, nearly incomplete interactions with people over the phone made him worry about their longtime success tattooing.

His apprentices could also impress him by designing a tattoo that had been requested by a walk-in client, but they definitely didn't know they *could* do such a thing. They could blow his mind by doing what I did: pick up and try to use a tattoo machine against a stack of napkins while cleaning up dirty equipment. It wasn't clear that doing so was okay. In fact, I tried to hide the habit, sneaking in bits of the practice while Matt was on the back patio with

Pauly or whoever happened to be around. Matt caught me in the act, though, and approached it as a sure sign of eagerness.

There was also the issue of style. Matt could tattoo almost anything, and he taught people who work in a variety of styles. His better tattoos, though, involved bold linework and black sections (see fig. 3). He had a great eye for texture. His apprentices were best suited to work with him if they dug on his style and wanted, at least to some degree, to incorporate aspects of it into theirs. "They need to know what kind of tattoos I do best," Matt would tell me one afternoon, "I have my weak spots like everyone. Apprentices should study my work to make an informed choice."

Importantly, Matt considered how they asked for the apprenticeship in the first place. While some people showed up in person ready to display their drawings to whoever would look, others asked through a phone call, email, or direct message on Instagram. Matt was dismayed by these casual requests.

He was at the shop's computer one morning looking through the small batch of emails that had come in overnight. He turned to me and said, "These fucking people have no idea what they are asking for." It was another quick request for an apprenticeship. Matt's reaction was familiar, as was the request. The person who sent it didn't seem to realize that they were, after all, asking Matt to teach them lessons he had gained across *thirty years* of work. They didn't seem to notice they were also asking to ride out the daily ups and downs of tattooing with Matt for years.

"It can be a very hard gig," Matt told me. "And I could be an asshole. I mean I *can* be a *complete* asshole! (laughter)." The email was like the others—sent from someone he'd never met. It was also short, and it likely didn't include attached drawings. It was probably written on someone's phone. The emailed request upset him, and I only really understood why after having gone through the experience of becoming his apprentice.

That night of the triangle, with all of its sacred qualities, wasn't something a person could just ask for through an email. But, of course, these people didn't know such things happened. Indeed, these types of rituals, however they may occur among tattooers, were intentionally kept beyond the view of strangers.

Other tattooers I met expressed similar offense toward the casual ask for an apprenticeship. "It's like someone wanting to walk into your home and

FIGURE 3. *Three tattoos by Matt Decker reflecting a style developed over thirty years in tattooing.*

just expecting to be able to sleep in your bed," one of them told me. "Why the hell would I just give my home to some stranger? And to ask me over the phone?!"

Matt wanted people to show up in person, get tattooed, and otherwise learn about the scene. He wanted them to *be there*—to dig in and encounter the whirlwind of intimate experience that separates tattooing from other things. He wanted them to see what tattooing really was: both what it demanded and what it offered.

Some veteran tattooers don't take on apprentices, partly because they'd never bother with the work. One shop owner told me, "Why anyone would go through all that trouble is beyond me." He added, "I mean, trying to manage the tattoo artists in this shop, keeping it all afloat, and continuing my own tattoo practice is enough!" Another said they avoided the "ton of work," while yet another asked rhetorically, "I mean, how do you even teach this thing to other people, really?"

That question is a good one, especially because tattoo-specific skill reaches beyond that of drawing and into a world of other matters. The design stuff was, in some respect, the easier part. The crux of it all involved the strange cauldron of demands that could arrive while working with any client. The back-and-forth that could accompany the booking process, their nervous requests, and their sweating, bleeding bodies offered profound challenges. You put them through pain, too, so you had to deal with that end of things. And if you didn't do as well as you could've, you would lie awake thinking about the mistakes you made. You also had to keep them and yourself safe, because, after all, tattooing is a pretty dirty gig.

Learning to See in Red and Green

Pauly would burst into the shop after some drinks down at the bar, "Gotta remember bud, green and red." He would repeat, "Once you touch something with a contaminated glove, that thing's *red*; anything you haven't touched is *green*." He and I learned this *red* and *green* thing during our apprenticeships.

While Matt received a little help from the state's mandatory guidelines on safe practices,[5] he was essentially in charge of ensuring we learned how to tattoo safely. He taught us techniques, but his most powerful instruction encouraged us to develop a new quality of awareness. We'd been encour-

aged to *see* the world as cluttered with objects belonging to two categories: dirty (red) and clean (green). This encouragement ushered in a fresh type of attention—one that coalesced into a newfound perception of risk.

Tattooing requires the rupture of bodily tissue. The machine sends a group of needles into the skin roughly one hundred times per second.[6] This poses a health risk to everyone, the most serious of which involves the potential for cross contamination. Hepatitis B, hepatitis C, and HIV transmission could occur between client and anyone handling their related tattoo equipment. The potential for cross contamination requires the tattooer to approach the bodies they work with, and indeed their entire work area, as potential sites of disease transmission.

Matt's red and green program worked if we began to *see* this invisible fact across our workplace procedures. This was great in the shop, but it followed you out into the world beyond. Fueled by heightened awareness, every door handle turned red. I began wanting fresh gloves for the grocery store, and I wondered if Pauly, in his drunken diatribes, hadn't just come from the bar's bathroom. Was he self-soothing in the face of a world rendered full of contaminated matter?

Matt made me learn how to mitigate cross contamination before he let me deal with tattoo equipment. I would drape a medical bib over the toolbox he used to store tattoo equipment and on which I would arrange his machines and related tattoo material. Everything was wrapped in plastic, and the single-use components were staged, including the Vaseline-like grease, ink caps, and a stack of fresh paper towels on the toolbox. I would slip a disposable cover over the furniture, too, including tables, chairs, and pillows. I'd wash my hands throughout (see fig. 4).

Matt's program made me realize that tattooing is a dirty job. Now, whether it's "dirty work" in the sociological sense—work seen as undignified or repulsive by outsiders—is up for debate.[7] Tattooers, especially those doing more unique, artistic stuff, can carry relatively high social status among people interested in art, design, and fashion. People who do "dirty work" in the classic sense, like grave diggers or sewage workers, don't. Regardless of whether tattooing is *perceived* as dirty by outsiders, tattooers themselves have come to understand their work as dirtier—and, as such, riskier—over time.

We at Premium followed sanitary practices unheard of in early twentieth-

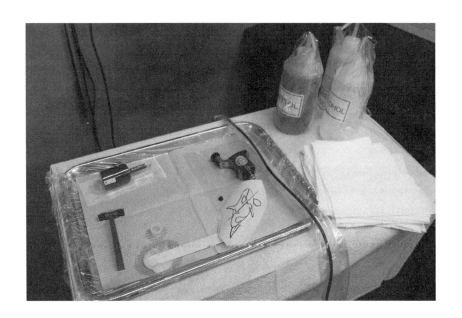

FIGURE 4. *Wrapping everything in plastic and arranging it on disposable bibs and barriers to Matt's aseptic standards at Premium.*

century tattooing. Those old-time, bare-handed tattooers worked out of arcades, traveling carnivals, and "sponge and bucket" shops.[8] They were largely unaware of, or otherwise uninterested in, the risks of cross contamination.

The name "sponge and bucket" comes from a practice: tattooers wiped multiple clients with a sponge they dipped in one bucket of water all day. Ed Hardy paints the scene: "Tattooing the guy: ink, blood, wipe off, squeeze it out, throw it in the bucket." An early twentieth-century tattoo artist, "Tatts" Thomas, is said to have had a client ask if the needles were clean. Ed Hardy describes that Tatts "took the ever-present cigarette out of his mouth and dunked it in the bucket. 'See,' he said, 'that sterilizes it.'"[9]

Tattooers don't work like this anymore. They've changed their practices in tandem with historical developments and mostly without state-sponsored oversight. I interviewed a woman, for instance, who described herself as the "unlikely founder of this country's first full-on dyke shop." She tattooed gay and lesbian folks through the 1980s HIV epidemic in San Francisco, interacting with each client "as though they were positive." She told me, "We became the cleanest shop in town because we *had* to."

Matt didn't tattoo through the AIDS crisis in San Francisco, but he was very serious about safety. He had me complete an online bloodborne pathogens certification course, one mandated by the state, before handling any tattoo equipment. He then taught me his cleanup technique, how to properly "break down" a station. I could now do it in my sleep.

I sanitized my hands before putting on gloves, and began the breakdown process by placing spent needles into the large, red, sharps container located in the booth. I removed the bib from the clients' table or chair and carefully unwrapped bottles of green soap, alcohol, and Dettol, being sure to avoid touching those bottles with my gloved hands. Those would be placed bare on the furniture that would later be sanitized. I wrapped soiled paper towels, rinse cups, and ink caps in one of the bibs.[10] This burrito-shaped ball of contaminated matter would eventually be jammed into a station's foot-operated trashcan. There were many steps in between these major movements.

"Feeling the weight of paper towels soaked in blood and ink," I wrote in my fieldnotes one day, "makes me want a hazmat suit." I always removed the gloves properly, ensuring skin-to-skin and glove-to-glove contact, before washing my hands. I then put on fresh gloves and sprayed everything down with a medical-grade disinfectant. We also used presoaked wipes for the job.

Matt would say, "That stuff kills living things, and you're a living thing." I held my breath.

I was often struck, while tattooing, by my own desire to skirt the rules. It seemed easy enough to reach over and almost touch something with red gloves. Rationalizing such a shortcut could be easy in the heat of the tattoo moment, with my whole being poured into the process. I didn't take these shortcuts, for the record, but really that's not the point. The point is that tattooers, at least those I met and those who I'd get a tattoo from, have a heightened awareness of contamination and risk. Their ability to smoothly operate within the intersection of people, bodies, and money depends on it.

I learned this stuff in my apprenticeship, and I began noticing my hands, in particular. I would ask myself: Can I touch that light switch? Should I handle my phone? Are these gloves that I'm wearing even clean? But like nearly anyone itching to tattoo, I wanted to dive in and make some ink-filled, bloody rags of my own.

Getting to Tattoo

Matt invited people into a formal apprenticeship by having them put that triangle on his thigh. For folks like me, it would be their first tattoo. If they seemed up for it, Matt would have them secure a license with the county before doing ten free tattoos on shop mates and friends.

That licensing process involved completing the bloodborne pathogens certification course—something his apprentices will already have done— some quick paperwork, and a nominal fee. A county representative would then call the shop to confirm with Matt that the applicant worked there and had received training.[11]

The apprentice would follow their initial ten tattoos by doing forty more at forty dollars each. These are indeed cheap, as the going rate for a standard tattoo with an established artist was between $150 and $200 per hour. While they may have been a bargain, they often added evidence to a folk saying: "Cheap tattoos aren't good, and good tattoos aren't cheap."

Apprentices raise their prices over time, choosing to charge per hour or per tattoo. I always priced my work by the piece rather than the time spent doing it. This pricing scheme reflected a way of thinking about the tattoos. It said, at least to me and some of my clients, that I sourced the value of

what I did in the design end of things. This differed from the hourly pricing of Pauly, for instance, who approached his tattooing as a kind of working-class labor. He clocked-in as a tattooer, calculating a wage out of the time exhausted.

On the client side of things, it was clear that many people who got cheap tattoos by apprentices could often afford more expensive ones done by seasoned tattooers. They got these cheaper tattoos because tattoos aren't just designs in the skin. They're experiences.

My friends jumped at the chance to get my early work and not because they thought it would be good. They wanted to get tattooed by me. They knew the product of our interaction could be better, but that wasn't what they were there for. It was the interaction that counted.

The tattoos themselves were mostly of animal design. They were made of lines and small sections of fill, done in black. They were usually cute and inspired by illustrations in vintage books for kids. Many of them were straight-up clipart. People liked them, and as simple as they looked, they would take me a very long time to complete. Matt could do one in ten to fifteen minutes. They sometimes took me an hour.

These tattoos *looked* simple, but they're actually hard to design and execute. It's easier to make a tattoo look decent if you add a bunch of detail and shading because you can use the extra stuff to obscure mistakes you made in the linework. Those mistakes can include lines that squiggle, lines that waver in thickness, and lines that "blow out"—that is, contain a fuzzy shadow around them.

In tattooing, the small minimal stuff is often harder than large complex stuff. It's similar in other fields; just look to the minimalism of architecture and design to see the challenges associated with reduction. I chose to do it because I knew people would get the tattoos and because I wanted to learn linework before anything else.

It was a good thing I had friends who wanted the work. This allowed me to gain direct exposure to tattooing's challenges—and pretty quick. People with a bunch of willing friends can get better at tattooing faster than those with few friends, generally speaking, because they have more immediate access to practice. I imagine the same could be said for hairstylists and manicurists.

There's a luxury to tattooing your friends and to be doing free or cheap

tattoos. That luxury has its source in lower stakes and in the ability to break from the typical performance of competence required while tattooing strangers at a higher price. You can allow more cracks to grow between the front and backstage. I could even mess up on a friend and say with a smile, "Hey I fucked up a little but don't sweat it because you can't really tell." If I was up for it, I could add, "It's only gonna be there forever."

I rarely had the confidence to actually put down statements like these, though, buried as I was in the desire to tattoo the best I could. I hovered nervously over their bodies while dithering with the machine. I would press too light before ramming the needles too deep into the flesh. But we would occasionally joke and have fun along the way. The fact that we could openly admit to my incompetence was something I'd later regard as a privilege.

Doing cheap tattoos would lighten the pressure because price helps organize collective expectations when it comes to things like technical mastery in tattooing. It was more acceptable to do a quick job if the person wasn't paying you so much. In this way, price managed the "definition of the situation" and to such a degree that, if a client expected perfect work at a cheap rate, they'd disrupt the scene. The *money* segment of the broader intersection of people and bodies could be appreciated in such moments.

But regardless of the relationship one had with a client and the price they paid, the tattooers I met worked toward perfection. "I need my tattoos to be good for *me*," someone told me over a cup of coffee. I mostly felt the same. This only means that tattooers are like other people who find motivation and even joy from the pursuit of mastery. If you weren't getting a bunch of money for the work, though, the horizon of perfection—what counted in its overall calculation—could shrink a bit. "Perfect-enough" might slide into "good-enough," and the pressure could ease off a little.

I began almost every piece hoping it would be my first "perfect" tattoo. I would ditch the daydream after about five marks. I'd more likely sit there with a knotted stomach looking at what I had signed up to do while feeling a tinge of shame from ever acting like I could pull it off. I just couldn't move my body the way it had to move, especially at first. The tiny, crucial movements were in my head but not in my hand. I usually stayed cool enough to get through the early pieces. Many were fun, but I'm glad I'll never have to do them again.

The direct exposure to tattooing bolstered what I had picked up by

watching Matt work. I stood over his shoulder for months, watching his every move. He'd ask me to notice his body and pay attention to the edges of his palms or the tips of his fingers. He would tell me to watch his feet, posture, and elbows. While I was an eager student and tried to remember these lessons while tattooing later on, I didn't really get it. I had to do the actions repeatedly to figure them out.

Matt could be rather hands-off, which surprised me, but he could also be a thoughtful teacher. We would stand on the back patio, and I would show him photos of a tattoo I just did. He'd begin with a positive comment, follow this with a point of critique, and finish by offering a proposal for improvement:

"Look at those lines my dude, solid and nice edges.
Now I will say, that shading is a bit patchy right?
You can make it more consistent. Take your time, let me show you . . .
But overall, this is a strong piece. Real improvement from a few weeks ago my dude!"

Matt's feedback contributed to the overall positive feel of my apprenticeship, as did his promoting the development of my own style. Sure, I had to clean the toilet, but the experience was different and perhaps better than many tattooers call a "traditional" apprenticeship.

The Traditional Tattoo Apprenticeship

Tattoo apprenticeships can be more or less traditional, hard, or old-school. Tattooers know what a person means when they say, "My apprenticeship wasn't old-school," or, "My apprenticeship was pretty traditional." They put the hard or old-school apprenticeship at a "traditional" end of a spectrum and place the soft, or new-school one at a "nontraditional" end.[12]

Any apprenticeship will land someplace on this spectrum as evaluated on many fronts, including the amount of time spent gathering experience, the duties required for progression through the learning process, and the character of mentor-mentee interactions. The traditional apprenticeship, for instance, is said to last two to five years. It's said to require the study of tattoo history and is to be pursued with humility and a great deal of gratitude. And, yes, it's supposed to be tough.

I met tattooers who had gone through more traditional apprenticeships.

Some expressed gratitude for the process. "I hated it back then," one told me, "but I really see the logic of it all now." I also spoke with some folks who were currently in somewhat-traditional, very good apprenticeships. They seemed to have access to a complex education, one that just might set them up for success in the effort to manage people and their bodies at work over the long haul.

These apprentices were painting good flash and doing some solid tattoos. They had active mentors, and I was sure they would thrive, especially because they worked under accomplished tattooers and, as such, had access to an influential network of people. I was also a little surprised they weren't experiencing the toxic hazing I heard so much about.

People assured me there was a great deal of hazing "back in the day." Matt's mentor made him catch a large monitor lizard with his bare hands each morning, for example. She yelled at him, "Don't let it get yer hands!" She screamed and called him a "piece of shit" during his first tattoos. Matt would tell me, especially in his nighttime mood, "I mean what the fuck good was any of that? It didn't make me a better tattooer!" I'd also heard of an apprentice who was forced to convince a drunk guy off the street into being tattooed. He worked on this guy while shop mates threw beer cans at him.

One afternoon, I stood talking with an established tattooer and shop owner. We hit it off right away. As this was before my apprenticeship began with Matt, he seemed ready to have me around his shop. We spoke about apprenticeships generally:

"The old-school way," he said, "had it so that the apprentice should be kind of humiliated."

I asked, "What do you mean by that?"

He added, "You know, to be humble, a person *needs* to be humiliated."

We talked about this for a while, and he compared tattooing to martial arts.

"Many people come into tattooing from broken homes and no structure," he said.

He took a deep breath, "We need structure and discipline to survive, you know?"

He was like other tattooers who celebrated the traditional apprenticeship while bemoaning its bad reputation.

These tattooers seemed ready to defend a set of practices—a way of doing

things that amounted to transferring skills and knowledge to the next batch of people who just might succeed at the intersection of people, bodies, and money. They also appeared bent on supporting an *idea*. Because while the apprenticeship model of training might involve a series of exercises, it's also chock-full of meaning. Many tattooers spend time and energy debating the proper mode of apprenticeship training because it is a thing of cultural significance.

Some of them take a more hardline stance in defense of the traditional model. They worry about its demise and stress that too many new tattooers teach themselves or experience cursory training.[13] Some scholars have even joined the chorus.[14]

There's a notably *gendered* thing going on here. The notion that "hard" apprenticeships are disappearing suggests that "soft" ones may be on the rise. This softening echoes the process of feminization, when the kind of hypermasculine practices of Matt's mentor, who was a rather masculine woman, are subverted by an impulse toward feminized concerns of fairness, safety, and equality—itself wrapped up in fears of deskilling.

Many tattooers I spoke with framed the traditional apprenticeship in gendered terms. Some claimed its defenders just wanted to keep tattooing as heteromasculine as possible. One called these defenders "hardliners," and a very established tattooer, one who described himself as "just another straight white guy," told me the hardliners "just want to keep the bro-club alive." He referenced then-President Donald Trump's campaign slogan and said, "This whole thing is a *make tattooing great again* effort."

The hardliner position is definitely conservative, and it wasn't something I encountered at Premium. It's conservative in the sense that the beliefs, attitudes, and values wrapped up in the stance find their authority through a celebration of tradition, even an imagined tradition cultivated through contemporary, real-time talk. The tattoo hardliner relies on a shared version of the past deemed worthy of conservation—the good old days when things were tough, ragged, and free.

The tattooer I was talking with, the critic of conservative hardliners, mocked the very idea that new tattooers need to variously "respect" or "honor" what came before them. He told me it was "bullshit." He then made a connection between tattooing and the politics of immigration, telling me that while a political conservative may believe the US is the best nation and

that newcomers should only join "legally," the tattoo hardliner may believe tattooing is the best job that newcomers can only obtain through a "traditional apprenticeship."

As self-appointed protectors of tattooing, hardliners also seek to keep tattoo-specific information beyond the reach of outsiders. Tattooers in the US have often worked to obscure what they do, not only for the sake of their clients' comfort but for the sake of preventing others from learning how to do tattoos, build machines, or find any success in things related to tattoo production.

Ed Hardy recalls an early tattooer, Chris Nelson, who would put a brown paper bag over the heads of curious clients. "That's how tattooing was," Hardy describes, "a secret world."[15] The paper bag has, however, been lifted. Those trying to keep it on have an increasingly desperate look to them.

Karime nearly exemplified this development. At the age of eighteen, they learned about tattooing on YouTube. They bought reliable-enough tattoo equipment on Amazon and began tattooing without having ever been in a tattoo shop, working on friends and family from their bedroom.

A tattooer once told me, "People trying to keep tattooing secret, they're like fighting a basically impossible battle." They *do* fight the battle, though, and often in sprawling comment sections on the internet or in conversation. People like Karime, who despite the apprenticeship was initially self-taught, are framed as being part of a problem. I wondered what hardliners would make of "community taught" queer tattooers who, in the face of an exclusionary band of brothers guarding the gates of mainstream tattooing, were amassing their own knowledge and networks during my time in the game.

I met plenty of tattooers, though, and not just the feminist folks, who openly questioned whether the traditional apprenticeship *has ever* existed. An established tattooer told me it was "more like an ideal, or even a myth." They added, "Almost everyone I've ever talked to who argues for the traditional apprenticeship didn't go through one themselves." And maybe it was just that, a utopian product of a past made desirable through an intoxicating blend of hindsight and nostalgia. It was, perhaps and after all, part of what sociologist David Lane calls tattooing's "occupational folklore."[16]

This isn't to say it's not real or that the people who celebrate the traditional apprenticeship are liars. It's just to say that it works as an organizing principle of thought and action. It helps people locate themselves in a wider

set of values, practices, and beliefs. It guides them while they try to navigate the intersection of people, bodies, and money. Whether it actually existed is, at least for me, not all that important.

It is true, though, that tattooing used to be more tough and ragged . . . if not more "free," at least more free to those who find independence and self-determination in masculine scenes. Matt worked in some rather wild circumstances during the 1990s, when tattoo shops were often at the center of a drug-dealing and fistfighting world. The shop was open all night, and they mostly tattooed bikers, people in street gangs, and those on the fringes. While there are tattoo shops like that today, tattooing as a whole has entered the mainstream. As you may expect, this change prompts changes in apprenticeship training.

I interviewed a seasoned tattooer who told me, "I used to have to train apprentices to deal with tough-ass bikers, and to make their own needles, and all sorts of things like that." She added, "I just don't have to do that anymore. I mean, tough-ass bikers don't come into my shop, and we buy very good needles." She was like other shop owners—like Matt—in that she tried to assume an agile posture toward a changing world. She reminisced of the "old days" while nearly confessing that she was happy to see new ones on the horizon. She added, "Apprenticeships change as the world changes, right?"

But changes inside the broader, more mainstream tattoo world are contested. The position tattooers take in relation to change places them in wider struggles that can shape their working lives. Conflict arises when someone subverts conventions in a big enough way, one that might reach beyond their own tattoo practice and into that of others. Matt did such a thing in the fall of 2016. It nearly sank Premium Tattoo for good.

Near Banishment: The Tattoo School Thing

Matt received an offer that promised he could help bring diversity and competence to tattooing. It also told him he'd make some real money. Matt responded positively, asking for more information and later getting on the phone with people. He did what many established tattooers would see as a blatant assault on tattooing as a whole. He agreed to transform his shop into a "tattoo school."[17] I was his client then but on a break from getting work. I

didn't learn anything about it until two years later.

The idea was that his shop would become an educational space. It would still offer tattoos to the public, although it would be staffed by people who had gone through a new training process. Matt would facilitate this transformation, operate as a teacher, and stay on as a consultant for other such endeavors across the US. Students paid for the experience, and although I never got an exact amount, I was assured it was steep.[18] The details of the private school organization remain murky, even as I got to interview its cofounder and two of its students. What was clear, however, was that Matt made a mistake in getting involved.

Through squinted eyes, he saw a rad gig. It paid very well and ensured a break from the daily hustle of tattooing. He was flown to the East Coast and given a walk-through of two such schools. He told me, "They were filled with black people, fat people, queer people, and shy people . . . people who'd likely be turned away from so many of the shops out there." It's a familiar daydream: help others while helping yourself. The catch, and there's always a catch, was that all the money came from *somewhere*.

In this case it was pulled from the pockets of eager students who might not reap benefits from the investment. For one, they would be stigmatized through tattoo school participation. "People who attend tattoo schools," David Lane suggests, "struggle to earn equal status among established tattooers." They've "paid money to learn the craft, instead of honorifically earning that right."[19] The cofounder of the school network even told me during our interview that many students keep their participation a secret. He understood why.

Matt arrived to Premium one morning and was met by tattooers protesting in front of his shop. He knew they would be there because the event was shared all over Instagram. The group included one of the most famous figures in the history of US tattooing: Lyle Tuttle of San Francisco. It was also made up of contemporary tattooers with wide acclaim, including San Francisco–based Grime and Oakland's Freddy Corbin. To those in the know, it was a big deal that they were there.

Matt recoils while reflecting on an interview he did for a local news station during the protest.[20] In that interview he described himself as a "maverick." He told me this while cringing, "A fucking *maverick*?!"

His opponents had been sharing images of terrible tattoos on social

media and claiming they were his. Matt even had people calling his shop from other countries to yell over the phone. It was a wide-reaching shame campaign with a notable following. "That's what we had," one of his major opponents told me. "We had his reputation." The death threats to Matt and to his family—his spouse and their two toddlers—came over the phone, too.

Matt was haunted by the experience. He would warn me about the "internet monster," telling me one day, "Strangers, man, people who have no idea who you are, or why you're doing what you're doing, will try to fuckin' ruin you, man. It's a total nightmare."

When they weren't bashing him personally, the opposition argued that such a school couldn't train anyone to tattoo. They said it threatened the apprenticeship model and that it exploited people.[21] One queer tattooer told me, "The schools profit on the backs of queer people of color." Tattooers rally against such schools to prevent exploitation but also because the schools seem to threaten tattooing's more working-class character. Tattooing, as a guy told me in his shop, "isn't something you can just buy a piece of paper for."[22]

Matt pulled out of the deal and began to rebuild his shop. He did so to protect himself but also because he began to more fully appreciate what his opponents were trying to do. Most of all, though, he didn't want to have young people paying him money for something he often argued should never be bought.

His most outspoken critic sent him an apprentice two weeks later, a guy named Jesse, on whose knee I did my second tattoo. "They were all about 'no new tattooers,'" Matt told me, "and they send an apprentice?!"

Matt and I would talk about all of this while standing on the back patio at Premium. He would recount his prior thinking with embarrassment. He had, after all, convinced himself that he was part of a solution rather than a problem. He said the whole episode inspired him to be a better person, but he didn't always take it in stride. Matt was prone to bitterness, anger, and frustration. He would say people didn't actually give a shit about the morality involved and argue, instead, that established tattooers just didn't want competition from newcomers.

And Matt was right in some respects. An Oakland tattooer, one involved in that protest at Premium, told me, "More tattooers means less tattooing for me." An East Coast tattooer said, "The root of all this is we don't want more

tattooers." This guy added, "We need to just be straight with it instead of like beating around the bush like a little pussy." He seemed to regret saying "like a little pussy" afterward, but he didn't correct it.

Whether any tattoo school fails to teach, exploits the marginalized, or threatens business is up for debate. What's clear is that they threaten conventions of the wider tattoo world to such a degree that people spend a ton of time and energy fighting against them; at least, they did in 2016. This time is definitely unpaid, unless you count the kind of reputation-building it might afford someone who gains clout through the process.

The fuss around tattoo schools and the apprenticeship is complicated, but it has a solid foundation in the desire for occupational control. In this way, tattooers are similar to nearly anyone else who tries to lay claim over a job, both because they seek power within that job and because they genuinely care. Like doctors, professors, or lawyers, they want to have a say in who gets in and who doesn't.

In tattooing, it's about who gets to occupy that special place in the intersection of people, bodies, and money—who gets to helm the river raft and who might have a chance at taming that ball of snakes.

While some tattooers want to be able to shape their world, they don't have the institutional levers that are available to people like lawyers. A lawyer can be disbarred, while a tattooer can, as Matt has demonstrated, weather a shame campaign. Talking with an old-school tattooer who desired the ability to govern could be a little sad. They seemed to stand at the edge of an ever-shifting ocean, piling up handfuls of sand in the face of an encroaching tide littered with debris. They placed their dying dream there, on the cusp of an unorganized and unruly force.

Matt's tattoo school blunder meaningfully shaped my experience with other tattooers. Some of them stopped our conversation once they learned I worked for Matt, as he had been so stigmatized. Matt's stigma rubbed off on me by way of association, something Goffman calls "courtesy stigma."[23] The use of the word *courtesy* here can be confusing. It's not meant to suggest politeness but rather that something is given or offered by something else. Stigma, courtesy of Matt.

Many tattooers I met would caution me, though, in a way that was kind. They seemed to be trying to help me out. One said, "You know about that whole tattoo-school thing, right?" Some wouldn't say anything until I

brought it up. A tattooer working on my leg sighed when I mentioned it. He said, "Yeah, I was wondering if you'd heard of all that." Of course I had. In fact, I made the whole thing more visible by publishing an article about it for the San Francisco Museum of Modern Art.[24]

Other tattooers didn't care, and a handful of them had never heard about it. Even across my short time in tattooing, the whole antischool thing seemed like a fading concern. While I knew the subject was important, its relevance to my life as a tattooer decreased over time. It often seemed like a background distraction from the work—the actual work—in front of me there with the client on the table.

An Apprenticeship Won't Save You

Just because I got this apprenticeship didn't mean I was in the clear. Anyone trying to tattoo must go about learning how to navigate the intimate, nuanced, and bodily exchange that is required among strangers, and this takes years. That is, they have to become someone who intuitively manages the intersection of people, bodies, and money. Like most tattooers, I gained skill in doing so from within the heat of the action.

The fact that I didn't know what I was doing helped. While Matt knew my history of work in the service industry prepared me for some of tattooing's demands, he considered my lack of direct experience with tattooing to be a good thing. He said he didn't have to "break any bad habits." I was a clean slate of sorts—a body and mind ready for proper molding. This meant I had a lot of ground to cover, but Matt did a lot to help me gain new habits so that I could cover that ground in a way that would be good for both of us.

He also appreciated my lack of experience because he wanted to test whether his mentorship mattered. His effort could be more easily seen in my development than in someone who already had skill tattooing. He would say, "It's not like I can take the credit, but *MAN* is it cool to watch you pick up what I tell you and find success." He told me it was important for him to have "something worthwhile to give" and that he was giving it to me. He knew I'd struggle along the way.

Matt warned me before I ever tattooed that poor triangle on his thigh: "This *thing* will wring you ragged." It often did. Because no matter how much I wanted to be good at it, I'd have to do bad tattoos before I could do

better ones. This meant I spent a lot of time worrying. Because bad tattoos are just as permanent as good ones. Matt would say, "This will scare the shit out of you sometimes." He was right.

I was freaked out, but no one around me was surprised. I was just another person trying to do my best with a body that would need years of training.

Now, some people *do* get good at tattooing quickly. Karime did so and to Matt's amazement. I loved seeing it happen even if I occasionally envied the development. Matt would notice my envy and general frustration with the learning process and say, "It's like learning to play violin. Think you could pick up a violin and play it?" My desire for quick success revealed an arrogant assumption—that I could easily do what Matt did. It showed him I didn't recognize the depth of his skill and experience. It told him I didn't notice his journey.

I had gained access to an apprenticeship, though, and I thought this would be the hardest part. Actually, I never thought I would get an apprenticeship in the first place. But all of that was before. It was only later that my concerns over access seemed less relevant for me and my situation. What would soon amount to an incredible challenge struck me. I only realized I had an immense problem to solve after I began tattooing strangers.

I had to routinize a messy, intimate type of work. This required me to adapt to a new framework of thought, feeling, and action. I had to manage the risks and rewards of interpersonal involvement, including how to touch bodies, produce appropriate emotional states/displays, and perform competency in front of nervous clients. All of this demanded I learn how to notice and talk about variations in skin tone, and it meant I would face difficult, moral decisions. I mean, would *you* tattoo a young person's face? Ultimately, it would be one of the hardest, scariest, and most rewarding things I ever did.

TWO

You Should Be Scared

I walked to San Francisco's Asian Art Museum on a cold summer afternoon. This was in 2019, about six months into my formal apprenticeship, and met my soon-to-be spouse near the entrance. She'd just finished another day working at the San Francisco Museum of Modern Art. Having grown accustomed to institutions of fine art, she and I often approached their expansive halls casually despite their being profoundly incongruous with the spaces of my childhood and the tattoo scene I was growing to know. We met at the museum to view an exhibition and panel discussion on Japanese tattooing.

This exhibition was curated by Sarah E. Thompson. Its roughly one hundred *ukiyo-e* prints featuring tattooed characters were on display.[1] The panel discussion included Don Ed Hardy, Junii Salmon, Mary Joy Scott, and Taki Kitamura, some of the most prominent tattooers alive. While someone in the crowd heckled them, nearly everyone was there to listen and enjoy the experience. These were respected pros talking about their work.

My partner and I walked into the exhibition after leaving our jackets with coat check. We eventually joined about two hundred people sitting fifty feet below a Beaux Arts rotunda for the panel discussion. It was freezing, and I broke from the group to retrieve our jackets. Those waiting at coat check looked the part. They wore stylish clothes and seemed comfortable in the space. You could assume their evening included good food and a drink from some nearby restaurant.

They weren't in the majority that night, however, as the place was packed with tattooers. Some were aging pros in slacks, others were bubbly queer folks in patterns, and many had what Matt called a "tattoo-bro" vibe.

The tattoo-bro vibe included a defensive, closed-off demeanor. It was made possible through a manipulation of bodily adornment, movement, and speech. The presence of this vibe remained a facet of tattooing's het-

eromasculine character—building fraternity among those with it and likely inspiring anxiety among those without it. The vibe was among the several aesthetic features of tattooing that made it such a masculine thing.

I wasn't a tattoo bro, that night or ever. In fact, I couldn't successfully come across as one when I tried, and I did try because I wanted to interact with them. That night, though, my comfort in the art museum helped level the playing field. They were in a different scene, one that felt more like "mine" than theirs. The fact that I was a white guy over six feet tall, and one perceived as straight, helped, too. If the bros had some romantic attraction to me, they did a good job hiding it.

Watching them in the museum revealed something about their relationship to the fine art world. They fit right into the flash covered walls of their tattoo shops, but they were a bit out of place in the museum. They weren't at coat check because they hadn't checked their coats.

Their working-class masculinity likely inspired them to refuse waiting in line to have someone else hold their jacket for them. The intellectual, highbrow mentality of many fine art appreciators frames the request as a desirable, if not obvious, thing to make. I imagine some of the tattooers were much like I was before I began going to a bunch of art museums—unaware they could check their coats and that it would be free. The framework through which they approached the world didn't include things like that.

Back at the museum, I quickly introduced myself to the guy seated to my right. He shook my hand with a firm grip. He seemed comforted by having something to do while waiting for the panel to start. He'd been tattooing for ten years, many of which were spent alongside the four guys seated to his right. They all worked in a shop just south of San Francisco and seemed to be in their thirties. They wore flannel shirts, jeans, and leather boots. Their appearance—being the culmination of masculine dress, defensive bodily posture, neutral facial expression, and something as mysterious as a *vibe*—placed them in the tattoo-bro category. At least it did for me.

I was only a couple of months into doing tattoos at this point. They smiled with a sense of familiarity when I told them I was an apprentice. One leaned forward to ask, "And how's *that* going?" Two people seated in front of our group craned their necks to join the conversation.

I told them all: "Tattooing is terrifying." One guy in front of us chimed in, "You *should* be scared, man; tattoos are forever." The group described

what I'd begun hearing from many tattooers: that they faced considerable bouts of fear in their work.

These tough-looking guys opened up about it and not timidly; it was as though they were proud to have been afraid. They wanted me to know just how scared they had been, or at least their enthusiasm over the subject made it seem that way. While I had initially felt separate from the tattooers around me, it turns out I was in good company. At the very least, we had all faced the same fear.

Beyond that museum experience, those who had been tattooing for decades assured me they still experienced some fear. A woman I interviewed—one who had been tattooing for twenty years—told me one afternoon, "It *still* freaks me out sometimes." She paused for a moment before adding, "You've got to respect what you do to people." These tattooers almost always qualified their fear with statements about the outcome of their work—that what they did to the bodies of other people was *permanent*, as difficult as it was to fully appreciate the fact.

They described scenes I'd come to know well. They tried to steady their nerves before a tough project, knowing that a quick slip of their arm could ruin a tattoo and scar-up a person's body. They, like me, often held a white-knuckled grip around the machine. That tight grip *never* seemed to help anything. Some had nightmares, and one had panic attacks. None of them offered these descriptions shyly.

There was a degree of pride involved in the experience of being a bit freaked out by tattooing, especially when you were new to the job. I came to understand this pride over time, although it seemed really strange at first. Why would people, and especially the tattoo bros, commend the state of being-afraid in the face of tattooing?

Fear Is a Feeling Rule

The idea that a tattooer *should* be scared isn't so strange, though. It only suggests that there's a proper way to *feel* when working as a tattooer—that there's a right and wrong emotional response to what can happen inside and around the intersection of people, bodies, and money.

This type of emotional expectation amounts to a "feeling rule."[2] The idea is that we as social animals encounter situations that demand from us a set

of site-specific emotional experiences. The rules of feeling help establish a framework for situations. They guide people toward a fitting emotional state (internally) and a proper emotional display (externally). We learn these rules as we become socialized into our cultural environments.

Think about the feelings people in the US are generally *supposed* to have while attending a wedding or a funeral. People should feel happy at a wedding and sad at a funeral. They are supposed to feel these feelings on the inside and express them to some degree on the outside. Indeed, these events might deteriorate if enough people don't fulfill their associated emotional expectations.

Imagine a wedding full of people who felt resentment or a funeral full of people who felt relief. Now imagine they felt this way on the inside and openly expressed it on the outside. The scenes likely wouldn't live up to our shared, more general expectations—expectations that are partly managed and accomplished by rules of feeling.

This kind of collective mismatch between emotional expectation and experience doesn't happen often, though, because people generally feel how they're expected to feel. They correspond to the moment in an emotional way that seems, at least to most of them, a commonsensical response to the moment. This means they likely don't notice "feeling rules" because they're fully integrated into the scene.[3]

Just as people seemed to understand intuitively the social purpose of those little saloon-style doors at Premium, the ones separating the waiting area from our booths, people often respond to a scene's emotional quality in a seemingly natural, taken-for-granted manner.

Researchers do find that people occasionally don't experience the emotions demanded by their situations. These people work to conjure appropriate feelings if the expected ones don't seem to arrive on their own. They do emotional *work* to gain alignment with the rules, and they do emotional *labor* when their effort toward this alignment is done in exchange for money. Noticing all of this helps explain the central role of the body in social relations: people don't just put on a performance with their face; they bring their complete physiology to the task.

Tattooers do a ton of emotional labor, including suppressing a visible expression of fear if they encounter it within the front-stage region of the shop. And the amount of emotional labor they do changes throughout the

tattoo session. I and those around me found that it seemed to peak near the beginning of the interaction. It's near the start of things that tattooers have to work up excitement over a dull project or conjure compassion for a client who's getting a memorial piece.

Tattooers are like other body laborers and most service workers, generally, in that they have to conjure some emotions and repress others. They summon confidence for their clients and for themselves when they're new to the trade, working at the edge of their established skill set or just having a bad day.

Tattooers also know they shouldn't feel frustrated when clients are nervous and nitpicky. At the very least, it is clear they shouldn't allow the frustration to be seen by clients. Like hairstylists, barbers, or a barista at your local café, tattooers may go backstage and let the emotion rise within them before allowing it to spill out all over the place. They might even do that to prevent such a thing from happening front stage. Matt, Pauly, Karime, and I did all of this at the shop. We talked about it, and we tried to get good at it.

I once sat to do a tattoo on Jesse, for instance, and got explicit training in how to prevent my future (paying) clients from noticing my fear. "My hand was shaking uncontrollably," I wrote in my fieldnotes that evening, "not very big shakes but definitely there." I added, "Matt told me repeatedly that I needed to gain a sense of confidence, and that my clients would need to see my confidence and not my fear." I was taught to "reset" if I began feeling afraid—standing up from the stool to stretch and gain some temporary distance from the task at hand. Pauly chimed in to say that I needed to breathe. I was told that I'd have to manage my face, my body language, and otherwise do what I could to make sure my clients wouldn't get a whiff of my nerves.

What's curious about fear among tattooers, especially the idea that a person *should be scared* from time to time, is that fear doesn't help tattooers make money. It's not like the "service with a smile" mandate among food service workers. Matt, Pauly, Karime, and I never waved a flag of fear out on the sidewalk, hoping it would draw attention from people cruising down Broadway Avenue. Fear just isn't commodifiable in the same way that a happy face might be. In fact, fear can damage your chance at doing a good tattoo. It can wedge between you and the client, such that tattooers work against its presence and display.

To prevent the formation of such a wedge, tattooers do more than work

against fear. They repress anger, self-loathing, or embarrassment. They also try to avoid getting turned on while viewing or touching the bodies of other people. Alternatively, they conjure the feelings that make for trustworthy intimate relations. These can include happiness, optimism, confidence, and those feelings that promote a sense of calm professionalism. They don't need to be outwardly happy, especially because this risks the chance of an inauthentic performance, but those who care enough to offer their clients a good experience know they shouldn't be in a bad mood. They know this especially because they know tattoos are forever.

What We Do Is Permanent

Tattooers know that what they do matters. They recognize the fact that their work can have a prolonged and powerful impact on the life of their client. They know this impact can be positive or negative, depending on how the client experiences the tattoo process and the tattoo itself. They learn this stuff through the act of tattooing but also through more instructive moments of an apprenticeship, if they have had one. Regardless of how they get it, they eventually learn that everything about tattooing, including its related emotional quality, is shaped by the longevity of the work—by the fact that tattoos last a lifetime.

Tattooers know they should (occasionally) be scared because they forever alter the bodies of other people, no matter how hard it can be to fully imagine the life course playing out there in front of you while you work. It makes tattooing what it is. It freaked me out, and it made me focus. It made Pauly pace up and down the shop. He often used humor to try and smooth over the nerves. The fear made Karime get so silent that they would nearly disappear, even if they often seemed cooler than cool when it came to tattoos.

I sat with a tattooer one afternoon across a metal table behind their shop. We were in San Francisco and it was cold. We'd been talking a while before I hit the record button on my phone, and I asked them to repeat a phrase which caught my interest. They said tattooing was "freaky," and I asked them to tell me why.

"Tattooing's freaky because, you know, you are changing the person's body forever." They paused before adding, "I mean that's terrifying in some ways." Another tattooer on a different day and behind a different shop said,

"Tattooing should be a bit scary. . . . It's a pretty serious thing to do with someone, *to* someone, you know?" And another told me, "It's scary because it's permanent. That's the whole thing."

I had spent weeks coming to the same conclusion. This was near the beginning of things, just after having done my first tattoos and around the same time I sat with the bros at that art museum. Those first pieces and the anticipation of doing more kept me awake at night with a sense of dread. I would make the motions of a tattoo machine across my upper thigh while staring up at the ceiling. "If only it wasn't permanent," I wrote in my field-notes, "it wouldn't be so damn draining." The words of sociologist Sara Ahmed rang truer than ever, that "emotions are the very 'flesh' of time."[4] In tattoos, you feel time's staying power right there on the body—in the flesh and blood—before you.

I had begun to realize what I'd gotten myself into—begun to see what I would have to deal with and overcome, during my first few months of tattooing. A similar thing happened to Karime, but less about the act of tattooing itself, and more so about the people involved. They told me it was a matter of time before they realized they would have to deal with "characters." And when I asked them, "What's the hardest thing about tattooing?" they replied, "The clients." That was their struggle but seldom mine. Mine was the fact that the marks I made would be on people forever—and, specifically, the fact that some of these marks would be mistakes.

I developed a routine to calm my nerves before getting to the shop each morning. It involved avoiding too much coffee, getting some exercise, and eating a substantial meal. I listened to uplifting music and tried to choose an outfit that invoked optimism and confidence. There was an additional routine to follow before doing the tattoo itself, once arriving at the shop. It involved retreating into the tiny bathroom with chalk-covered walls. I would stand there in the small space trying to slow my breath, knowing the client was waiting nearby. Tattooing would change for me in these moments: its rock and roll would nearly vanish. It was hardly fun, and it was barely cool.

I almost puked once. There was some relief about this fact later, when a tattooer told me they threw up before their first piece. They recounted a scenario I'd played out in my mind: puking in a dirty toilet before bending over a small sink trying to rinse their "barf-breath" away with water. I imagined the scene while laughing with a tinge of embarrassment. We both, it turns

out, considered how barfing would impact our breath. We both feared the inadequacy of water in trying to hide it. We both knew the breath might blow our cover and that if this were to happen, we may as well have just left the shop forever.

This particular tattooer became quite good, and rather quickly, but another I interviewed said she was "a nervous wreck" for the first two years. The statement struck me as a near-warning. Imagine being freaked out for that long. I knew I wouldn't make it two years. This tattooer said, "I'd probably had suicidal thoughts—only slightly kidding (laughter)—after each piece because I really took it so intensely serious." She added, "I took the gravity of what I was doing to people so heavily," and "I was really tumultuous inside." Maybe these tattooers were especially susceptible to the anxiety I knew quite well, but they weren't the only ones I met who dealt with a lingering taste of dread when it came to their work.

My fear was substantial, but a similar type of fear proved insurmountable for another apprentice in the shop, Jesse. He got more freaked than I ever did. A palpable anxiety would pulse through his body. It seemed to gather in his shoulders and amass in his grip on the machine. His fear had a sound to it—a kind of rattle from the machine that nonetheless seemed to emanate from his shivering body.

I would watch with uneasy suspense while he tattooed my leg in jerks and starts. He would gain control over the situation and ride it out for a while, making the moves and doing them with a sense of buoyancy. But he always lost that brief spell of authority over the process, over himself, just when I thought he was sure to keep it. He never did keep it.

Jesse witnessed my growth in tattooing, noting especially my ability to overcome the initial shakes. He tilted his head down one afternoon before quietly saying, "You got over the shakes . . . those damn shakes." I could control my hand, wrist, elbow, and shoulder. This was as much an emotional feat as it was a physical one; and, in this way, it added evidence to my growing suspicion that the whole of a person's bodily experience is employed in the task of tattooing.

And while tattooers assured me the fear was predictable, even necessary, they also said it would grow less substantial over time. "It never goes away completely," a tattooer of more than twenty years told me, "but it does get a whole lot better." Matt would say, "Reps, man, you've got to get your reps

in. You'll get comfortable; you've got to just keep doing it." Pauly told me he stopped "sweating little bangers," or small tattoos, "after a bit."

It's true though, and to my dismay, that some people find quick success with tattooing and don't seem scared by it at all. There was a twenty-four-year-old guy who was becoming very skilled after having done tattoos for just *six months*. When I asked him what tattooing felt like, he simply told me, "It never really gets to me. I mean, I don't know why, but it's chill." He seemed to approach lots of things with *chill*, including his distractingly dirty shoes and his wild, absolutely fascinating tattoo style. Another tattooer—one with an impeccably clean shop and a disciplined style—told me they knew they *should* be a bit nervous but they weren't. I responded to these statements, at least privately, with apprehension. It seemed they were in the wrong, or at least edging toward some level of irresponsibility.

The feeling rule of fear among tattooers was like any other social norm in that it was most noticeable when it had been broken. It was also like other social norms in that it is learned over time. I learned a great deal about what I should feel as a tattooer during my apprenticeship. It was merely a part of becoming socialized into the tattoo world, or at least into our scene at the shop. This learning wasn't always direct, but it was there. The people around me responded to broken rules, and their responses taught me things.

For instance, I once asked Matt if he ever had an apprentice who didn't face some fear while doing their first tattoos:

"Yeah man, I had this one guy like that for sure."

I asked him, "What was that like for you?"

"He didn't make the cut, but you know, he seemed to approach his whole life like that . . . not a good sign!"

"Not a good sign of what?"

"A person should absolutely be a bit freaked out," he told me. "If they aren't, they really have no idea what they are doing, no idea what they *could* do to someone."

I asked another tattooer the same question later that day. He paused before explaining: "If that person isn't scared, they're probably a sociopath, like, they have no feelings or care about other people." We laughed before he took on a serious demeanor. "Tattooing is a huge responsibility, knowing that should make anyone scared." He added, "If they say they're not, they are either lying or just kinda fucked up."

These people who didn't experience fear—one real, the other hypo-thetical—disrupted the expectations of feeling. They broke the feeling rule.

I heard these statements and, maybe unconsciously, decided I wasn't going to be seen as "just kinda fucked up," which meant I learned about the proper state of emotions in tattooing through conversation, through so-cialization. Of course, this isn't to say that I *tried* to feel afraid or that any tattooer is expected to feel terrified. It is to say, though, that a nonchalant attitude toward the practice might signal to others, and perhaps to yourself, that you didn't fully recognize what you were involved in—what you did to other people and, to echo Matt, what you *could* do to them.

But what you did was often hard to appreciate. I would sometimes see a client of mine out in the world some days, weeks, and eventually years after our tattoo. We would encounter each other in a public place, one far removed from the situation of the shop, and they would raise their sleeve to show me the healed piece. Occasionally, especially at first, I was surprised to see that it was still there.

But What Is Permanence?

Tattoos can remain embedded in the skin of a person—of a body—beyond that person's lifetime. Tattooers and their clients don't, however, often think about tattoos in relation to the corpse. Even if the sixty-one tattoos across Otzi the iceman's body stand visible more than five thousand years after his death, it's unlikely Otzi appreciates the fact. Is he still a tattooed person?

Tattooers often use the lifetime as a landmark to guide how they think, feel, and act toward their work. The trajectory of a client's life—always a projection—and its eventual stopping point determine the spread on which the tattooers' impact on the world is most realized.[5]

I once asked Matt what tattooing would be like if tattoos didn't last a lifetime. He quipped, "It just wouldn't be tattooing." Their lifelong character makes them what they are. It makes everything about tattooing what it is, including the fact that it can be so damn scary to do.

I would sit at Premium, looking toward the barbershop across the street, recalling with noticeable envy something a barber there once told me while cutting my hair: "When I don't do as well as I want, I gotta just remind myself that it's not a permanent thing." I ran to my notebook that afternoon.

"Hair grows back, man. Fingernails grow back, too." I added, "Barbers and manicurists have it easier due to the temporary nature of their work. Tattooers are absolutely screwed in this sense." Tattooers are "screwed" because they can't rely on the idea that a small chunk of time will fix their mistakes.

This only means that tattooers occupy a different position than do hairstylists when it comes to that Venn diagram of people, bodies, and money. The permanence of tattooing separates them from others who do similar types of body labor, and this source of their distinction occasionally reared its head in conversations at Premium.

Matt, Pauly, myself, and the owner of that barbershop—a trans guy who was a true baseball fan of Premium—stood on the back patio dozens of times talking about our work:

One night, the barbershop owner said, "We go to school, we do all this training, and you guys just run in here. I mean, do you know how many damn haircuts we'd have to do to make $600?"

Matt replied, "I know man; it's not fair, and maybe we should be going to school, too, but hair grows back." He added something like, "Our shit is on there forever; *think about that!*"

The guy reluctantly agreed: "I mean, I wouldn't want to ever give someone a permanent haircut."

We appreciated his grievance. We also knew that our work was inherently different from his. While the difference in price between a haircut and a tattoo may have many sources, this matter of permanence was key.

There are tattoo removal techniques, but we didn't work with them in mind. People can have tattooed ink broken down by lasers so that the ink particles become small enough to be absorbed into the body. It is an extremely painful, expensive, and time-consuming process. There are also other attempts at making tattoos less permanent. A journalist covering a business trying to popularize temporary tattooing interviewed me in 2020. The business claimed to have invented a vanishing ink, such that a person could be marked by real tattoo equipment and yet get a "tattoo" that would fade over the course of a year.

This business was in New York, although it later tried to recruit me as a "tattooer" for its San Francisco venture. I told the journalist and recruiter that the business was sure to make money, and that I knew someone would figure out the vanishing ink trick eventually, but that the business wasn't a

tattoo business. That's because tattoo-like things that don't last a lifetime will never be tattoos. Putting them on people will never match what it's like to do the real thing, either.

The relationship between time, tattooing, and the body is nuanced, though, because while tattoos are forever, they will always be temporary.

All Tattoos Are Temporary

I got a tattoo on my leg one afternoon. It features the phrase, "All Tattoos Are Temporary." The words encircle a 3 × 3 Rubik's Cube. Each block on that cube has a stick-figure face on it expressing a human emotion. The tattoo is still there, but the process of getting it ended an hour after it began. The tattooer and I talked while he did it. He said something that turned my attention away from the pain and back toward this issue of permanence:

"Tattoos are permanent," he said, "but they're also temporary."

He went on: "They're understood by people to be permanent, but, like, nothing's really permanent you know?"

I said, "No, I don't know."

He added: "But that doesn't mean you can just treat them like they *aren't* going to be there forever."

He finished the piece, took a dozen pictures, and gave me a great deal. We were both tattooers, and, as he said, "I don't tattoo other tattoo folks for the money." We learned from one another and built a quick friendship. He shook my hand at parting.

I sat one month later with a different tattooer whose work now sits parallel to the Rubik's Cube—similar spot, different leg. It's packed neatly among the twenty others around it, many done by apprentices. My spouse calls it my "junk leg" with affection because it's tattooed with abandon. The leg looks cool, though, as the many novice tattoos make for an overall pleasing scene. It's often a decent idea to pack amateur tattoos together so they coalesce into a larger aesthetic feature.

So, I was at this tattoo shop wincing yet again while trying to talk with a tattooer. We spoke of tattooing's emotional quality. We shared stories, and I asked him why he described tattooing as "emotionally intense." He said to me, "Well, you know, tattoos are 'permanent' and all." He placed air quotes around the word *permanent*. He added, "Nothing is permanent you know.

Our bodies will dissolve." I asked him to explain. "Tattoos definitely aren't *permanent*, but they are in a way."

He exuded a youthful nihilism of which I was suspicious, but he and the guy who tattooed that Rubik's Cube definitely had a point: tattoos aren't *actually* permanent because bodies decay. Nothing sticks around forever. Matt knew this, too. He often told me, "You know, my dude, those paintings I make will outlast every single fucking tattoo I ever do." He reminded me that we'd all be dead someday.

All of this to say that, as much as tattooers know their work is permanent, they and many of their clients approach tattoos, and bodies generally, as temporary events. The life course that I claim dominates the tattooer's relationship with their work is mysterious . . . landing somehow beyond comprehension. It could be difficult to appreciate the scale of time involved. I could always imagine a tattoo lasting years, but I could never quite grasp it lasting decades. It's also difficult to deal with the fact that any person's life course might end tomorrow. Life can be experienced as permanent and temporary all at once.

An approach to the human body that foregrounds its temporary, even pliable, qualities echoes Susan Bordo's postmodern philosophy about the dematerialization of the body.[6] But tattooing helps people render the body into a physical object of inevitable decay. What more is my "junk leg" than a leg, after all? In the world of tattooing, the body's material, carnal presence is brought front and center.

I was like most of the tattooers I met, though, in that I was often freaked out by the permanence of what I did. This was true even if I had a hard time accessing the real duration of the marks I made. When it came to the tattoo, I approached its longevity as involving two parts: (1) the time I spent doing the piece and (2) the time it would likely remain on the body. While the first seems fleeting and the second more enduring, both involve long-term effects.

A client of mine walked into the shop one day, and I pointed out an excellent tattoo on her arm. She was like many of my clients in that she had some really cool tattoos. She appreciated the comment and paused before describing how she got it some years ago while traveling. She agreed with me that it was "amazing" while quickly adding that she used to hate it. She said, "The guy was a dick. It took me a while to like it."

She always knew the tattoo itself was a good one, but she had to learn to like it over time. That the guy was a dick had staying power. The memory of the interaction with him lived on in that tattoo. She experienced that memory while looking at her arm after the fact—and repeatedly.

I was talking with a tattooer one day in San Francisco about all of this, relaying the story of my client and mulling over the details through conversation. They described what I had come to know well, that the "*process* of the tattoo is crucial." They challenged me to consider, "If some jerk gave you a beautiful tattoo and if a friend gave you a bad one, which would you like better?" While the logic definitely had its limit, the answer was obvious: I'd take the bad one.

My clients were much the same. Some had truly world-class tattoos, but most of them had pieces from people they liked. That work from people they liked wasn't always technically great, but it didn't matter so much. Their being technically great wasn't the point. The point was that the people loved the tattoos and especially the process of getting them. Some clients would direct my attention to squiggled lines and patchy sections in a tattoo from a friend while smiling, recalling just how awesome the person was who put it there.

This insight was incredibly useful. For one, it helped motivate us at the shop to create a positive scene. We worked to give our clients a welcoming, comfortable, and fun experience. It helped me understand that every "good" tattoo I ever did would have its flaws and that I might be able to make up for the flaws by ensuring the client had a good time.

Many tattooers I met shared this understanding. One said, "I just try and give them a great experience because that's super important, maybe sometimes even more important than some aspects of the piece itself." This lesson about tattoos meant that giving someone an awesome experience might save your ass if you mess up the piece. Of course, the near-opposite stands: giving someone a negative experience might wreck the best tattoo you ever did, at least for the person who has to see the thing every day.

So, we labored at the level of client experience. We conjured a scene of confident optimism with the hope that our backstage fears and concerns would go unnoticed and that people would recall a good time while looking at their tattoo, even years after it was put there. This was a central demand of

our paid work—of our effort to navigate the intersection of people, bodies, and money—both as a team and as individuals.

Tattooing, after all, involves much more than design work. It demands people learn to manage others, and it forced me to manage myself. That self-management began with an awareness of my body in time and space. It required me and the tattooers I met to do a great deal of emotional labor, but it also required I learn new things about my arms, hands, and even feet. Mostly, it demanded I learn how to move them and how to keep them very still at the same time. Noticing new ways to be in a body after more than thirty years of practice was strange. I fumbled around. It was crushing to get it all wrong and empowering to get at least some of it right.

Noticing Bodies

Like many white guys, I'm often unaware of my body. It's rarely an object of inquiry, and it's almost never an article of public interest or scrutiny. But I was very aware of my body during my first days at Premium. For starters, I didn't know what to do with it—where to sit, stand, or walk. I also didn't know how much to talk or what to say. I stood around awkwardly that first day, sitting only after Matt spoke with a tangible degree of irritation: "Are you going to sit down or what?"

I gained comfort in the space by directing my body toward productive work. Mainly, this involved cleaning. It was a rewarding practice because it helped me establish a meaningful relationship with the shop's contents, textures, and edges. There was a daily sweeping, mopping, dusting, and arranging. I also jumped on any opportunity to run an errand. This was before I got to do any tattoos.

There was no trouble in finding direction for my body once I began tattooing. This was because I had found comfort in the space by then and because tattooing requires a person to draw designs, handle equipment, and manage clients. Occasionally, and especially during the early days, Matt stood over my shoulder as I tried to steady my hands enough to tattoo with confidence.

Matt would coach me to "ground" myself in the chair, suggesting I place my feet flat on the floor. And because I tend to keep my shoulders near my ears, he would tell me to roll them back and breathe. He would suggest I ease the grip on my machine, and he would have me "reset," or stand and then sit down again, if he sensed I was too pent-up. He once said, "I could feel you crushing a walnut with your ass from across the room. *Relax* your body, my dude."

Tattooers I spoke with relayed similar stories, even those who hadn't gone through apprenticeships. These people would sit with their bodies all tensed up while trying to do the careful work of tattooing.

After one particularly instructive day at the shop, I took to my fieldnotes and wrote, "It's like a yoga workshop in there. Matt telling me to concentrate on my breath." I added, "I had no idea this was a full-body thing." And it was far more like Yoga or meditation than I would have ever imagined. Matt would tell me to try and balance my weight across points of contact with the Earth, chair, and client. He'd help me become aware of my breath, and I used this awareness to resolve some anxiety on the inside so as to present confidence on the outside.

The fact that tattooing springs from the body of a tattooer meant that Matt would try to communicate a capacity for *bodily awareness*. He had to teach people how to become—and hopefully stay—aware of the bodily demands of their work. I did my best.

I would do anything that seemed to invite ease into the situation with clients. This included work to gain awareness of myself while still maintaining the perception that I was doing everything for them. It could be comforting, walking them through the tattoo process verbally. It was like coaching them while coaching myself at the same time.

I would say something like this to begin: "We'll start by prepping the area to be tattooed by cleaning it. . . ." I'd then squirt alcohol on a paper towel. "I'm going to use some alcohol to clean the surface." I would clean the surface of their skin, shave the hair off, and describe the stencil application process. I would tell them we could erase that stencil and move it as many times as they wanted.

I gained considerable progress doing tattoos over the course of my first year. Matt congratulated me on the wins. Pauly did, too, mostly after tearing my work to shreds with commentary. And while my tattoo designs had gotten better over time, it was clear to me that whatever skill I was gaining had its source in the effort to experience bodies in a new, technical way—both my own and those of my clients. The demands of tattooing inspire those who do it to think of bodies as deserving of practical attention or as things toward which physical labor should be directed.

Matt told me I'd be good at tattooing when I could do it without much thought. "Eventually," he said, "you just *do* it. You won't have to think about every little thing." I knew I would never be free from the fear—that I would never even *want* to be fearless in my tattoo work—but there was a yearning for thoughtlessness nonetheless. I wanted to routinize the process so that it

could spring from a taken-for-granted approach to the world. This would take years of practice.

Matt seemed to have it like that, but he also seemed to experience a kind of tension: he wanted things to be predictable *and* exciting. Sometimes, they could be both. Those were the blood and lightning moments, when the tattooing was done with ease and when it still offered the jolt it gave you before you did it a thousand times. Being so close to the beginning, I watched with envy, often while swimming around in a bucket of self-conscious worry. I would have traded *boring* for what I had, any day.

Muscle Memory

Experienced tattooers seem to work with ease. They look as though they're drawing on people—like the thousand calculations required for tattooing weren't involved. This is partly because the demands of tattooing have been built into their bodies over time. They've learned how to use their bodies in a smooth, commonsense way and respond properly to tattooing's many demands.

I spoke about this with a tattooer of nearly twenty years. The conversation took place over the phone from my car, at the height of the COVID-19 pandemic and during a bad spate of wildfire smoke in the Bay Area. I was in my car because construction was being done inside the small apartment above my own, smaller one.

This tattooer was in good spirits, though, and we talked about our work. She told me tattooing "becomes ingrained in the body over time." She added that tattooers "absorb it, their muscle memory, their body just aligns to it." She said she forgets about all the little things she used to do intentionally. "It's like driving," she added, "but, you know, much harder."

This tattooer also said her chiropractor had learned "all the little nuances" of her working life. Her body revealed how her "entire, physical frame has come into alignment" with what she did all day. We laughed it off, but I knew it might've been a rather serious issue for this person.

I worried about my body, hunched over as it was for hours each day tattooing. How could people hack it for decades? I was concerned for Karime, setting out as they were for a lifetime of tattooing. How would they handle its bodily effects over time? The prospect of them not having health insur-

ance and not having a solid plan B inspired a form of paternal concern in me. I told them about this concern one day, and I got back a youthful shrug of the shoulders.

Regardless of all this worry about an injured body, it was easy to want what good tattooers seemed to have: an immediate link between their bodies and the demands of the job—the kind of finesse a skilled carpenter has with their tools, or that seemingly effortless way a great speaker can draw an audience into a story. I wanted to become *tuned* or somehow *molded* to fit into tattooing such that my presence within it would appear obvious and natural. Like other wannabe tattooers, I had a strong desire to close the distance between thinking about and doing tattoos—between becoming and being a tattooer.

This desire is not specific to tattooing, of course. It only signals a familiar attempt to cultivate a specified constitution, or "habitus."[1] The word *habitus* refers to a person's dispositional and embodied approach to life. You can use it to explain why some people seem to naturally relate to the demands of their situation. It's also helpful when describing what happens when someone undergoes an intense, often embodied transformation—when they begin to fold the foundational conditions of a new role or situation into their everyday thoughts, feelings, and movements.[2]

Matt's tattoo habitus was full-blown. He could engender quick trust with strangers, work intuitively with their bodies, and manage the money elements of the job without seeming to step beyond his everyday routines. Sure, he could be a bit short with clients sometimes, but he approached his work as though it was a natural extension of his being. There was nothing so natural about it, though, as he'd learned how to do it across thirty years of practice. It was the outcome of work carried out over the course of decades.

At some unspecified point in time, Matt enfolded a new capacity into his life—an ability to transform what he did with his body into money and even social status. All tattooers cultivate this capacity, this "bodily capital."[3] It's a type of exchangeable value rooted in the body and, in this case, made transferable (rendered liquid?) through the implementation of body labor.

I and other wannabes tried to develop a tattoo habitus, one that would allow us to interact with every corner of tattooing as though it was the most familiar corner of our lives. That I, in my prereflexive thought, feeling, and movement, could eventually thrive in tattooing offered substantial comfort.

It did so for Pauly, Karime, and Matt, too. Matt assured me that getting there was the hard part.

This process of "getting there" involved a combination of practice and feedback. The practice part is rather obvious. Tattooers have to do tattoos to learn how to do them well. They can practice all they want on grapefruit or fake skin, but these items don't talk, squirm around, or feel pain, and, of course, they're disposable. A person might learn what it feels like to hold and move a tattoo machine by putting it up against a grapefruit and wiggling it around, but people learn the most important things about tattooing from within the heat of the action. To recall that *streams* metaphor—you have to navigate the waters to understand what they might demand of you in a variety of conditions.

If they're in an apprenticeship, wannabe tattooers may be lucky enough to receive feedback before, during, and after they try to do a tattoo. Feedback before the piece can be a huge help, because new tattooers often make designs that won't work so well as tattoos. It is easy enough to assume that you might try to tattoo whatever you've been drawing. But a good drawing and a good tattoo design can be two radically different things.

Matt saved me countless times by explaining how to transform my drawings into tattoo designs. He implored me to simplify everything and to shoot for symmetry, making sure to properly "weight" the design by ensuring its top/bottom/right/left contained a similar degree of detail and value. He had me cut down on the number of complicated angles, circles, or parallel lines. He also encouraged me to make designs that people would actually want to get as tattoos. As absurdly obvious as that last point might seem, it helped a great deal.

Feedback during the tattoo process was crucial, as well, even if it was only possible while tattooing friends or people otherwise allowed to experience a break between our front and backstage. Feedback in the form of post-tattoo critique was often the most difficult, if ultimately instructive. It was then, on the back patio, when Matt and Pauly would zoom in on a photo and show me all the mistakes I had just made. I dreaded Pauly's attempts to tear my work apart, but he did help me develop a way of seeing that later became intuitive and important.

The fact that I would *get it* someday sent me into rather vast daydreams. I'd imagine myself a witty, effortless tattooer with an immense following. I

would conjure the image of running my own shop, traveling the world, and working when I pleased.

But, of course, I was an amateur. My lack of maturity in the face of tattooing was obvious every time I tried it. This was partly because dealing with the client, as a person, could distract me from dealing with their *body*—my fundamental site of work. Among many things, it made me want to avoid the stories that often came with tattoos.

Your Story Is Part of the Work

Some clients, especially those with few or no tattoos, would describe why they wanted the piece. They'd tell me it reminded them of something important, for instance, or that it was meant to guide their future decision-making. Or, perhaps, they would spend some good time convincing me they always loved snakes. While I would get involved with the stories, usually the *why* behind their tattoo, I often found myself distracted and even uninterested. The demands of the practical task in front of me were all too consuming.

Sure, it was cool that a client loved snakes. I dealt with a great ball of snakes myself and often, although I wouldn't tell them as much. But I would sit there with the client, thinking: Does a snake's head have a flat spot on it? How quickly does it taper off at the end? Does the snake I drew look too much like a worm?

I would ask my clients for things I needed to know. "Do you want the piece in color? Where would you like it to go? What is your budget?" There was a lot to learn, including how big I would get to do the tattoo. Large tattoos are easier than small ones. People concerned about money would often ask for smaller tattoos, and once I figured this out, I would offer to do the piece slightly larger at the same price. Bigger was easier—less demanding of my stress, attention, and even time. For one, they allowed me to make thicker lines (use larger needle groups).

The clarity I needed involved elements of design and placement. These elements demanded things from me, and they required I operate from a place of technical necessity. I had a job to do, and I wanted to do it the best I could.

There is the potential for a problem here, though, and one that's rooted in the tattooer's position within that people-bodies-money intersection. Sticking to the technical details can cause you to risk losing sight of the broader

intersection, and mainly the *people* segment. Tattooers can never just attend to one thing if they want to pull off a good overall tattoo experience.

I began to notice my lack of interest in the meaning of tattoos while preparing to do a piece for a dear friend of mine. Even though I had done a dozen or so tattoos by then, I was still quite nervous. My friend had recently moved to New York City, and I wanted to know all about his new life. But just as he began describing what his chosen design—a goat—signified for his Jewish heritage, I slipped into a form of technical planning:

> *Okay, the line value is going to be rather thick, that's great.*
> *I'll use the seven-liner and then the three-liner for those contours.*
> *Going to have to go real light near that wrist.*
> *Is that a scar up toward the elbow?*

I'm thinking all this while he's going on about what the goat means to him. His voice took on the wah-wah sound of adults in Peanuts cartoons. I wasn't listening. In fact, I was trying to escape the reach of his soft, deep voice.

He slowed his speech and became quiet. This change suggested the onset of disappointment, so I summoned an expression of interest and worked to save the moment, for him and really for both of us. I looked up into his eyes and began to listen.

I explained this scene to a tattooer a couple of weeks later. She laughed with recognition, one-upping me by describing how she would even wear headphones while tattooing people who had a lot to say. She told me, "I know I probably shouldn't, but I need that concentration." She added, "Like sometimes I just can't hear the stories. Like, maybe this is bad, but I'm just not into the big stories about the tattoos. I need to work, you know?" She didn't even play music into the headphones.

Tattooers fret over the client experience partly because they know their clients may be having a very special day. The day of a new piece can be a big one, especially for people with few or no tattoos. But for those who do ten or more tattoos a week, it's just another day at work. The day is full of practical problems, some of which have very little to do with the act of tattooing. And the tattooing itself is much more of a technical gig than many clients may realize. As I've tried to explain, clients are often *kept from* this realization on purpose.

Among other technical concerns, tattooers must respond to the many unique features of the individual body. They plan out their marks by guessing how thick the skin will be over bodily features (think bone, muscle, tendon). They pay a lot of attention to the thickness of the lines they are going to make, and they attend to the spaces between lines and shapes. Because tattoo marks tend to spread in the skin over time, tattooers often avoid putting lines closely together. They know those separate lines may blend into one larger line eventually.

Tattooers also consider the relationship between shapes and how those shapes will look when tattooed on the body. There is no place on the body that is flat, which means lines and shapes always look different on the body than on a piece of paper. Tattooers, for instance, sometimes have to warp a circle to make it appear circular on the body itself. Same goes for squares. I messed this up a couple of times, tattooing a decent enough circle or square on someone only to stand back and see that the shape looked off once it was applied on top of muscle and bone.

When doing a piece, tattooers have to angle their machine just right and move it at the appropriate speed—keeping a consistent speed for lines and alternating from very slow to very fast for shading (while lifting up smoothly, too). They determine when to switch needle configurations and move from one technique to the next, paying attention to their machine to ensure it's running properly. They also attend to the arrangement of bodies and furniture, wondering if they could better access that small spot near the armpit if they had the client lie down, sit up, or maybe turn around.

If they're working in color, they have to ensure the colors make sense design-wise, and they usually tattoo the darker tones before the lighter ones. They have to rinse the hell out of their needles when switching between colors so as to not contaminate, say, a light Robin's Egg Blue with a striking Lipstick Red.

They do all of this, and so much more, while perhaps greeting someone who's just walked-in, chatting with fellow tattooers, and talking to their client about some ex-lover or their dead dog. In the case of my good friend from New York, I was *trying* to talk with someone about their religious history and its related political implications.

For my client, the symbolism of that goat design was at the center of what we did that day. For me, its presence in our moment required some extra

work. I did that work, but I didn't want to. I approached the scene fearful that too much attention toward him would require an irresponsible decrease in my attention toward "the work" as I understood it then. The problem was, I could've messed up the *experience* of the tattoo by not giving him and our more interactional process the attention it deserved. I had to alter my understanding of "the work."

While many tattooers I met would avoid becoming involved in the meaning of tattoos, some of them routinely dove deep with clients. They would explore the significance of tattoo designs and approach their role as demanding such exploration. I met and spoke with two of these people. One said they "really dislike tattooing just random stuff without meaning." They preferred work that connected their clients with indigenous roots. Another described their tattooing as a form of "processing" or "therapy." They said they loved getting into the specifics of each piece.

I did my best to dive in with people, even if I didn't always want to, because the "task at hand" involved much more than putting tattoo marks on skin. It involved the entire process, which brought me into an intimate, carnal experience with other people. So this isn't to say I was unconcerned about what I did to the bodies of other people.

There were plenty of requests that made me pause and a few that made me stop. It's just to say that I usually found such engagement over the tattoo's meaning to interfere with the other tasks at hand and that I didn't need people to convince me the tattoo I'd be giving them was especially meaningful. As long as it wasn't over the top—being placed on the face or symbolizing hatred—I would do the piece happily.

Many clients seemed to appreciate my asking about the meaning of their tattoo, so long as the tattoo wasn't just a "fun" or otherwise meaningless piece. If it didn't have a ton of meaning, a question about its meaning could come across as critique. What I needed to know was pretty simple: where they wanted the tattoo to go, how big they wanted it to be, and whether or not they wanted color.

Knowing the desired location of the piece helped my planning immensely. This is because some areas on the body are much harder to tattoo than other areas. The range of difficulty is determined by a number of factors, including ease of access to that area of the body, the degree of the skin's elasticity, and how much pain it will cause.

That pain bit is a big deal. It is easier to tattoo someone who's in less pain that it is to tattoo someone lurching from it. The person in considerable pain can squirm a lot; twitching, sweating, and hoping to (their) God that you finish quickly. But it's also the case that putting someone through a great deal of pain can be hard on *you*; at least it was for me. Their pain could seep into my own experience and distract me from all the things I had to be doing.

Hurting People for a Living

As unbelievably naive as it might sound, I was surprised by the fact that I—as a tattooer—would have to hurt people. Of course, I knew that tattoos can hurt a lot. As much as some people like to claim tattoos don't hurt, they do. I just hadn't put it together, the fact that I would be the one causing the pain. And there was a lack of understanding involved, as I did not realize that a person in pain can be a hard person to tattoo.

I actually apologized to my first clients. I would move through the piece and become impacted by their wincing faces. Their bodies would tense up; their breath would grow quick; they would turn red, begin to sweat, swear, or otherwise have an obviously hard time. I'd sit there trying to tattoo them while their bodies twitched and jumped in response to my movements. In response, that is, to me. I felt bad about it, and I would say so, coaching them through the pain with what I'm now sure was an overbaked voice of comfort.

"Stop apologizing," Matt told me. "They came here to get a tattoo. Give them one." He would tell me to just get the damn thing done. And Matt wasn't only motivated by the desire for efficiency. The deeper thing here involved the fact that I, at the core of this intersection of people, bodies, and money, needed to constantly ensure my clients that I knew what the hell I was doing. They needed to know they were taking part in a predictable process, that their bodies were being taken care of, and that I would simply do my job. My apologies could undermine this assurance because they exposed some of the intentionally obscured elements of tattooing—bringing those elements front stage and potentially disrupting the glamour of our work.

To my relief, though, Matt wasn't shocked. He knew it could be hard to hurt people for money, and he knew that wannabe tattooers like me were often struck by the pain they caused. "I really used to trip on that," a tat-

tooer told me during a casual conversation, "Like, I hated causing the pain." Another who felt similar said, "You've got to get to a place where you don't think about the pain . . . because the thing is, they came here for that [the tattoo] and there's no way around it."

I would try to remember all this while jamming that machine across the belly of some twitching person. I'd remind myself: "They're paying me to do this." The payment helped considerably because the money they offered in exchange for the work signaled acknowledgment of the skill and time involved. The standard payment, and especially the tip that often came with it, communicated the fact that it was my *job* to put these people through pain. They came into the shop wanting it, usually after having found and interacted with me over Instagram. The pain was a baseline element of what we did together.

I would still try to avoid seeing the pain made visible in their eyes. This was often hard to do because people often stare at you while you're tattooing them. It was odd and occasionally creepy.

Back when I sat doing my first tattoo on Matt's white upper thigh, he said, "You think what we do is *nice*?" He'd later ask me to tattoo myself and go over the lines multiple times. "It'll teach you what you are doing to other people," he said. "Get those lines right the first time." This directive was a response to the fact that I would go too light with the machine. This light touch would make it so that I would have to go over the lines more than once to get them in properly—that is, cause more pain by trying to avoid it.

Matt and Pauly disparaged my hesitancy, sharing their anger and disappointment after the clients left. Matt would say, "You're hurting people because you don't want to hurt them, you see that?" He told me, "Run over them a few times on your leg to see how it feels for other people when you don't get it right the first time." I did just that and saw, or rather *felt*, my mistakes. I had wanted to become a tattooer with a "light hand," as some tattooers are known to have a "heavy hand," but I didn't know the nuances of pressure, angle, and speed at that point.

Matt tattooed his mom a few years before I joined the shop. He told the story for its educational potential. "She was crying, man, and she told me, 'You hurt people for a living' and I was like, 'Sit still, Mom.'" He said, "My own mom, dude, I had to make her cry to get the piece done." This story ran through my head while I gave *my* mom her first tattoo, joking with her while

doing the small piece, "I've put you through pain before." She said with a grin, "I gave birth to you and your twin brother," adding, "This is nothing. Just don't mess up."

I mostly got over it, which means I grew into a more complete understanding of my role in the production of tattoos over time. Like other new tattooers, I developed a tattoo habitus as I went along. Eventually, my arm applied the correct pressure with the machine more intuitively. My ears better detected the slight changes in the machine's sound, indicating whether it was in the right or wrong spot. My hand felt for and noticed the appropriate vibration. I could put people through pain without feeling the need to apologize.

I occasionally found myself enjoying it—putting people through pain. I seldomly opened myself to this feeling. When I did, though, I found it waiting. It was nearly inviting.

It first happened while tattooing a black rose on a guy's upper thigh. He and his partner had both come to the shop wanting tattoos from me. His partner went first, having me put a quick design above her knee. It was a baby chick resting on a cloud. She sat composed, talking through the piece as though nothing was happening. Her partner was quick with jokes. We all sat closely as I started and finished that first tattoo.

I took pictures of the piece before wrapping it up and cleaning the booth. I prepared to tattoo the black rose on her partner's thigh, and everyone was in a great mood. He amplified a kind of humorous, self-deprecating mode of storytelling as we grew closer to doing the piece. This was fun, and it also told me he was nervous. Working to keep the positive energy alive, I matched his almost-silly demeanor with an animated excitement for our upcoming project.

I asked him to take his pants off, as the tattoo was going up near his crotch. He nearly jumped at the chance to remove them. It seemed he was waiting for the moment, and I found out why pretty quick. With his pants on the ground, he stood in front of me wearing bright red bikini style briefs. His dark hair jutted out from the seams. He laughed and then made sure the whole shop noticed by prancing around. Everyone chimed in with a few bits, and it was a good time.

I shaved the area and prepared it for the tattoo, placing the stencil on his skin and asking him and his partner to review the placement in a mirror.

We got it right the first time. I then had him sit upright on the table facing me. He was talking and joking all the while, which made it hard to have him follow my direction. Eventually, his legs dangled over the edge of that table, and we were ready to go.

With one of his legs in between my own, I dipped the needles into a cap of black ink, hit the foot petal to engage the machine, and steadied my hands against his pale thigh. I then pulled the first, thick line.

He reeled in pain, exaggerating it to amuse his partner and those of us in the room. It was clear he was having a tough go of it, though, and the jokes stopped after a few more lines went in. He began to sweat profusely and grew white as a sheet. I noticed all of this because I had learned to watch out for signs of a person in distress. I could tell when my clients were in substantial pain and when they might, as in this case, be on the verge of puking or passing out.

I dropped the tattoo machine on its tray, took off my gloves, and made a dash for a bucket kept near our handwashing sink. It's likely I reminded myself to sanitize that bucket later. Matt stopped tattooing and offered to help. We both knew this guy might lose it.

With the client holding that bucket near his body, I pressed a dampened bunch of paper towels to the back of his neck. Seeing that I had the situation under control, Matt leaned over with a smile, "Don't let that dude puke on you!" We had discussed the possibility before, with Matt telling me, "That shit *will* happen." He'd been puked on for sure, at work and by an adult stranger.

The color came back to my client's face quickly. I asked him, "How we doing, dude?" He began to make fun of himself, which told me he was starting to feel better. I let him relax there for a while and then sat near his knees once again, mere inches from his bright red briefs. "We have all the time we need," I told him. He said he was ready and asked me to tattoo as fast as possible.

I moved slowly, though, to ensure he wouldn't grow pale, and only began cruising once he seemed up for it. He wailed in his humorous way, and I picked up the speed.

"I just dug in there and blasted through the piece," I wrote in fieldnotes that night, "with him all squirming and reeling. It was actually super fun." Maybe it was his dramatized approach to the scene. Maybe it was the bright

red briefs, I don't know. I *do* know that putting this guy through pain was an enjoyable experience. I liked the fact that I was hurting him. I even told him, "You fucking asked for this, dude; you're paying me for it and, well, here it is!" The piece was done (see fig. 5), and we hugged while he was still in his briefs.

The experience inspired confidence. I actually felt powerful. This feeling made me approach the power I had as a tattooer with new clarity and caution. It also gave me insight into what tattooing might offer someone who yearned for power on a regular basis. I told Matt about this later, and he smiled: "If you didn't have that in you, you would've never ended up here in the first place." The whole experience made tattooing *feel* like it probably looks to some people from the outside: tough and cool, rock and roll, fun and free.

This experience was rare for me. Ultimately, I approached the pain as an element of my job, not as a thing to fear, celebrate, or enjoy. Tattooers put people through pain for money. It is simply part of the gig. Wannabe tattooers have to find a space for themselves in that fact.

Much like Karime, Pauly, and Matt, I learned how to tattoo people by first learning about myself. It required me to gain insight into my relationship with, among other things, interpersonal power. My strengths and weaknesses were laid bare, at least to those invited into the backstage of our scene. The fact that I would be putting people through pain congealed into a larger set of taken-for-granted postures within myself and my body. It was an element of that tattoo habitus people need to acquire so as to pursue their work from a place of intuitive ease.

This is to say that, in the attempt to develop skill at the intersection of people, bodies, and money, tattooers must form a new relationship with their own bodies along the way. They have to reckon with the body's position in time and space, gaining a new capacity for carnal attention. They have to notice their breath, hands, elbows, and feet. It's all necessary in the effort to find success in the messy, intimate work. But there's something more specific and fundamental to how tattooers relate to bodies. They have to *touch* them.

Matt, Pauly, Karime, and every tattooer you'll ever meet has to initiate and hold sustained, pointed contact with strangers. They must reach out to others and encounter their bodies, often for hours at a time. Tattooers touch

FIGURE 5. *Finding a rare sense of delight with pain. A rose designed by Matt and tattooed by me.*

people's butts, feet, bellies, breasts, legs, and ears. They move the skin and flesh around—stretching, prodding, and poking their way through the task.

The fact that tattooers are made and not born can be seen in the area of touch. This is because people must *learn how* to touch if they want to make it as a tattooer. And as simple as it might appear, touching strangers for money all day is a challenging and occasionally odd thing to do.

Touching Bodies

I tattooed some baby cherubs with machine guns across a guy's torso one afternoon. I designed the piece with reference to medieval etchings, and gave it a "Charlie's Angels vibe," on his request. He had me center it across his lower chest area. The baby angles and their death machines would be in permanent display for anyone happening upon his shirtless, pale body.

He was skinny, so skinny that I might have seen his heart beating in his chest. His ribs protruded a little, sending the stretchy skin into recurrent modes of slack and tension.

The variations in the condition of his body and skin made it so that I, while tattooing, navigated a complex terrain. I had to move through soft alcoves between each rib before advancing up and over raised, crest-like outcroppings of bone. I then had to spend time working amid his soft upper belly, feeling squishy organs beneath my hands down there. There was a caution to the movement, one characterized by a fear that enough pressure might send my hand into direct contact with the table he was lying on.

It was like any tattoo in that it demanded the skin be stretched so as to get the needles in there. I typically spread the skin between the finger and thumb of my left hand, the one not holding the machine. In cases like this, though, I used my entire hands and arms for the job. The skin needed further manipulation, as the distance between each touch point surpassed what was possible between finger and thumb.

I anchored the outer edge of my left hand above the area I would actively tattoo, applying pressure to that edge while pulling the skin upward. I also grounded the edge of my right hand just below the tattoo area and pulled this skin downward. But the stretch was only one part of it.

There was the demand to constantly adjust the pressure, angle, and speed of the arm moving the machine. I worked to match the changing conditions of his skin, bones, and organs by softening the touch and quickening the

pace while tattooing over the ribs. I hardened my touch and slowed down the movement while working the soft in-betweens.

This would have been hard even if the client wasn't moving. He had to breathe, after all, and of course there was the pain. His breath came in starts and stops, such that my work surface jerked upward and downward. Pauly once described this experience as "riding a pony." He would also say "yeehaw cowboy" when watching me go through it. He seemed to find some joy in watching me struggle.

My client and I got into a rhythm by synching our movements, with me pulling the lines during his outward breath. I wiped his tattooed skin with a damp paper towel and dipped the needles into black ink on my setup. He took this moment to breathe in before more lines were pulled. We proceeded together like this. The rhythm saved the day, as it steadied the surface enough for my marks to land with some success (see fig. 6).

Having my client hold his breath also stopped him from telling me about his fascinating life. It was a riveting story, as much as it was distracting. He lived on the edge of things, it seemed, balancing hardship with hope for better times. His tattoo was all about that hope. Specifically, it was a visual representation of his enemies being killed. He told me he swore there were angels out there murdering the people who wanted him dead. He sat up once the piece was finished and looked into a mirror before shedding a few tears. It was a meaningful tattoo, and it was important to me. It was the largest I had done by that point.

Running a tattoo machine across any person's body brings the tattooer into contact with mysterious elements of bodily content. It became clear, at least to me, that the skin is an elastic, porous layer tasked with the job of containment. There's a world of fat, muscle, tendons, organs, and bones down below. And while this inner stuff dwells in the depths in some areas, it's all right up near the surface in others.

Tattooers deal with the body's physical depth and surface on a daily basis. They must learn to read and negotiate the qualities of this terrain to succeed at what they do for money. And even as there are patterns, no two bodies are the same.

As soon as you know how deep to pull lines over one fatty thigh, the next fatty thigh seems totally different. Then there's the hairline-thin layer of skin that tracts over the shinbone. Getting it right in all tattooing is a matter

FIGURE 6. *Tattooing demands bodily knowledge, something gained over time and through experience.*

of millimeters—going neither too deep nor too shallow—but hovering just above the shinbone has an uneasy, shallow quality to it. It's amazing that anyone could tattoo *just* the skin. There's also the knobby knuckles, elbows, wrists, and ankles, where it's hard to tell what's going on at all. Then there's the butt.

I once tattooed "baby boy" on someone's butt. This was before I tattooed a cloud on the butt of someone else, the very next day. One of them farted while I worked, and we both pretended it didn't happen. The strangest thing was that tattooing one butt felt radically different from tattooing the other, even as the two butts looked similar. It turns out no two butts are the same.

Each new client—with their unique body—poses a new set of challenges. Different bodies require different things, as do the *people* who have those bodies. But all tattoo projects require *touch*.

The touch is, or at least should be, a one-way deal. Tattooers touch clients. It's different for others who work on bodies, like sex workers, where the touch might pass between client and worker as a two-way experience.[1] But no matter the direction of touch, tattooers and sex workers alike learn to manage the bodies of their clients, transforming *these* bodies in *these* workplace settings into sites of practical, even technical, labor.

Touching Right

How do you learn to approach the body as a *thing*? Tattooers, or at least the ones I met, try to isolate the physical body from its cultural meaning—carving out near impossible space between the thing itself, the body, and its social significance. Surgeons do this, too, pursuing a kind of "affective neutrality" while working over (and inside of) the bare bodies of their patients.[2] It's neutral in the sense that surgeons, and in my case tattooers, aren't supposed to have emotional responses to the bodies they're touching. Most important, they should avoid becoming aroused.

This comparison between tattooers and surgeons might seem like a bit much, but tattooers I met used it. One explained that we (tattooers) were "like surgeons," not because we saved lives but because we handled and changed bodies for a living. They added that tattooers also interact with the more "sexualized zones" of the body and that we had to do so "without getting turned on." Another described that they approached the bodies of their clients "like, you know, a doctor or something," before telling me, "We've always got to be professional."

A major distinction between surgeons and tattooers, beyond the obvious difference of their work and its stakes, is found in their training. I never met a tattooer who'd gone through medical school, although I met one who was a nurse. Medical school would help, though, if only because it encourages people to encounter bodies through the objective lens of biological science. Surgeons and other medical practitioners can use this lens while incorporating strategies to desexualize their carnal encounters.[3] They're trained to

place distance between the physical and cultural body, even if some men are utter failures when it comes to this crucial dimension of their work.

Unless they seek it out on their own, tattooers don't experience the *scientific socialization* encountered by medical students. Many tattooers don't have a lot of experience with the positivist logic of formal scientific inquiry and, as such, can't rely on it while working with bodies.

Moreover, tattooers work without explicit rules of bodily conduct, and they encounter bodies within emotionally charged environments. The surgeon's task of assuming affective neutrality is accomplished in the cold steel of an operating room, while the tattooer's similar demand is levied in an environment of affective *centrality*—it's drenched with emotion.

Tattooing is, as Matt explained, an inherently passionate practice. Most tattooers work in shops jam-packed with sentimentality. To those who appreciated it, the Black Sabbath, Grace Jones, and Iron Maiden played at Premium could conjure feelings of love and heartbreak. A rose, skull, or dagger in the tattoo design could provoke sentiment, as could the memorial pet-portraits and the names of lovers. So, how did we, and how do most tattooers everywhere, isolate the body from its powerful meaning?

We followed rules. Specifically, we followed what sociologist Kristen Barber calls "touching rules," or social norms that work by "enabling and constraining who can touch whom, how, and under what conditions."[4] Touching rules are much like the "feeling rules" I described earlier. They are a component of site-specific expectations of the scene, part of the *definition of the situation* à la Erving Goffman. In tattooing, the touching rules are unwritten, sometimes talked about, but nevertheless present and powerful.

In general, touching rules dictate what kind of touch is appropriate for the environment in which the touching takes place. They also help shape how people should feel about the touch they're giving or receiving. The presence of rules implies a more-correct and less-correct mode of feeling, thinking, and acting in the area of physical interaction.

People can *touch right* when they follow the rules. In tattooing, touching right is another aspect of the work that spans across and throughout the intersection of people, bodies, and money. It's yet another quality of the job that extends beyond the design work—another reason why someone who is really good at drawing might fail miserably at tattooing.

Most tattooers know they should check in with the client before touching sexualized areas of the body. They know they should only touch the area where the tattoo is being done. They also know they should approach the body with a calm, confident hand. And as touching rules include modes of *feeling about* touch, tattooers know they shouldn't get turned on.

Tattooers, like physicians, incorporate strategies to help them *touch right*. Some use humor, like Pauly, and others follow scripts, like I did. We both spoke with a sense of confident detachment when it came to butts, crotches, and breasts. We approached these and all areas of the body as physical aspects of the person we worked with. They were technical features of the job we were there to do.

I encountered touching rules in casual conversation among tattooers, but I also found them in publications, like a book from New York tattooer Tamara Santibañez titled *Could This Be Magic? Tattooing as Liberation Work*. While it doesn't use the phrase directly, the publication includes information and workbook sections to help tattooers *touch right*. I also learned about these rules while talking among tattooers in a weekly conversation on racism in 2020, as well as across social media posts by influential tattooers like Santibañez.

But such things are rarely discussed in an active, intentional way. Tattooers don't have codified standards, and they vary in their strategies of client-interaction. They can proceed with clients in a wide variety of ways while still not violating touching rules. I asked my clients for consent to touch their bodies, for instance, while Matt did not. Neither did Pauly or Karime, but that didn't mean they were doing something understood to be wrong.

I once encountered pushback while suggesting that everyone at the shop should ask clients for consent. Matt told me, and in effect the group, "I know why you do that, and I totally support it, but our clients know what they're getting themselves into—that we're going to touch them."

He suggested my request for consent might serve *me* more than my clients. He argued that it helped put me at ease. He was partly right there, as the request for consent helped calm me down in the face of an upcoming project. It slowed the process a bit and made me feel more confident that my clients would speak up if they needed something. This confidence did, after all, help me do the tattoos.

Matt wasn't violating a rule of touch by refraining from a quick request for consent. As his client for six years and as someone who later watched him do many hundreds, if not thousands, of tattoos, I knew he worked to ensure his clients received a straightforward experience. He could be quick and even cold, but this seemed to engender the trust required for the intimate interaction. He came across as a straightforward pro. He drew the line where most tattooers drew it, at the point of sexualization.

"You absolutely can't fucking creep on your clients," a tattooer told me one afternoon. He and I were sitting across a small table behind a tattoo shop. He described a tattooer who took pictures of a woman's ass while she lay on the table. "I heard he sent her dick-pics," he said, before adding, "Anyone needs to be careful about this shit but especially men. It's the fucking men who do this kind of shit right?" Yes, some men in tattooing—just as in medicine and nearly every other type of work—have failed in this basic requirement repeatedly.

Touching Wrong

Many of my clients identified as women, queer, trans, or gender nonconforming. They offered me praise through statements that don't exactly seem praiseworthy. "You're the only dude I'd get a tattoo from," one of them said. Another told me, "I wouldn't let a different cis-dude tattoo me." More than a few expressed something similar—that I was somehow exceptional when it came to the numerous white, cisgender, straight dudes who did tattoos. It was a huge compliment, at least it felt that way for me, but the background of the compliment was troubling.

I spoke about all of this with a woman who had been tattooing for more than thirty years. She said that some men who tattoo have sexualized their female-bodied clients for decades. She described the scene "back in the day" when the men she worked alongside would flirt with clients who were women. They'd ask them on dates and occasionally request they remove bits of clothing unnecessarily. "It was a different time," this tattooer assured me, one wherein some women who were clients exchanged blowjobs for tattoos. The sexualization of women seemed to be just another aspect of the scene. She stressed, though, "There's a real power thing tattooers have and they shouldn't be asking their clients out or trying to sleep with them."

This "power thing tattooers have" involves an unequal level of control between tattooers and their clients. Not only do tattooers sit with buzzing machines inches from their client's body; they operate in spaces over which they have near-total control.

We at Premium were like most tattooers in that we led clients through the entire experience, often telling them where to stand, when to turn, and how high their pant leg should be raised. Tattooers determine the price, the amount of time it will take, and often whether there will be breaks during the tattoo process. Clients often don't know much about the situation and are inclined to go with the flow, following direction with the hope everything will go smoothly.

It was shocking to watch clients grow so deferential in the tattoo process. They often asked me to just tell them what to do. They would stand awkwardly awaiting my instruction, and I—in the beginning—would become awkward in response. I didn't want to tell them what to do. They, however, needed this from me. They needed me to take charge, at least to some extent. Karime, in contrast, was rather good at telling clients what to do. This was an important skill to have, and it probably helped them make up for their otherwise strained approach with new clients.

Telling people what to do with their bodies all day wasn't so easy. Sure, my clients might have been nervous, but of course I was also nervous, especially at the beginning. It was yet another thing I'd have to learn how to do, manage my clients while managing myself both physically and emotionally.

I brought this up with Matt, and he confirmed that people have asked him for direct instruction for decades. "They have no idea," he told me; "you have to tell them what to do." He said tattooers get on a "power trip" because they tell people what to do all day, and those people mostly listen. I was pretty sure Matt agreed it wasn't something we *got* to do but rather something we *had* to do. We had to set the terms, direct the action, and ensure it all went to plan—navigate the raft down what could become difficult waters a few times a day.

These conditions of situational power offer tattooers a set of responsibilities that can go unmet. This is because people, mostly men, use power to perpetuate violence against other people.

I met several tattooers, clients, and observers who were fed up with tattooers who took advantage of the power they gained during the tattoo

process. The organizing work of these people motivated what some called a "#MeToo moment" in tattooing—a considerable wave of activism among tattooers and their clients to align tattooing with broader, historical calls to hold men accountable for sexual violence.[5]

Several women, for instance, brought charges against a tattooer named Alexander Boyko in 2018. Boyko had sexually assaulted them either during the tattoo process or afterward. He was accused of such violence by many women, three of whom brought formal charges. Ultimately, Boyko was found guilty of three counts of fourth-degree criminal sexual assault.

Two years later, in 2020, thousands of tattooers rallied in support of women who accused a prominent tattooer of sexual aggression and assault. He was from Tucson, Arizona. He was known to be a generally violent person. People said he creeped on his clients. He had the words "I WANT TO KILL YOU" tattooed across his forehead. I nearly got a tattoo from him.

His design work was inspiring, and I often shared his Instagram posts with folks at Premium, wondering aloud how I might tune my work to a similar wavelength. Admittedly, I was a bit drawn-in by his tough-guy social media presence. As embarrassing as it is to share, I thought he was cool.

For me, not getting the piece was simply a matter of money. He demanded $800 for a small-to-medium-sized tattoo and told me I had to pay it all upfront (including a tip) before meeting him in person. I wasn't about to do that. I had a guy do something great in the same spot for $250 a few months later in Paris, a kind and incredibly talented tattooer I'd followed on Instagram for years.

In the larger scheme of things, this guy from Tucson wasn't a good tattooer. That's not because his tattoos were bad (I thought they were very good) but because he failed repeatedly at the people part. In addition to the more typical forms of violence, he was said to improvise on bodies—on people—such that they got different tattoos than the ones they had asked for. He was known to dig into them, too, causing more pain than necessary.

Those who rallied in support of the women impacted by this guy's predatory behavior created an Instagram account to collect and share stories of harm. The account exploded in popularity, pushing what was a rather internal conversation out and beyond tattooing. Comment sections spilled over with debate. Tough-guy-bro-tattooers tried to frame it all as a "cancel culture" minute—dismissing the harm and instead wrapping the whole thing

up into a broader set of complaints against a world that increasingly decentered them, their point of view, and their power.

The mobilization and subsequent court case against this guy attracted the attention of prominent journalists, bringing the often-obscured tattoo world into public view. One of these journalists published a piece in the *New York Times* on May 4, 2022.[6] It foregrounds the story of women who were harmed. It also works to explain how the history of this tattooer amounts to "an unsettling story of power, predation, and the surprisingly blurry line between artistry and abuse."

That "blurry line" between artistry and abuse can be thought to separate a person's creative vision and their more ethical commitment to the client. This guy crossed that line; at least he was criticized for doing so, by changing designs on people without telling them, on the fly, like some sort of creative genius working over a canvas.

His tattoos might have been technically clean, bold, and otherwise impressive, but that was nearly beside the point. It doesn't matter how good the tattoo is, if the person who wears it forever never wanted it to be there.

For the record, the article about this guy features an interview with me. I describe him as being "part of the new cult of celebrity." This is because he, like reality TV stars and social media influencers, gained a central position in the wider tattoo world by creating and perpetuating an image, or even *brand*, out of himself and a seemingly unique lifestyle.

That position is like several things in tattooing—built on reputation. As noted of Boyko, "The tattoo world, both locally and nationally, functions like a very small town, and word tends to travel quickly."[7] Boyko was kicked out of this town before he landed in the courtroom, and this guy from Tucson was essentially barred from tattooing in 2020.

To be barred from tattooing was, in this case, to be denied opportunities to work. People denied having him tattoo out of their shops, and tattooing's precarity became plain: you can't work unless you're working with clients. Tattooers across the country also followed his movements and, as no prominent shop would host him, tried to shut down his more DIY attempts to establish pop-up tattoo events. He once tried to tattoo out of a warehouse, for instance, and people reported him to health authorities. It was easy to see what he was doing because he posted his activity on Instagram to reach clients.

The Tucson guy wasn't charged in court, to the great disappointment of many. The *New York Times* article captures this element of the saga in its title, "'A Monster in Our Midst': How a Tattoo Industry #MeToo Case Collapsed." The thing fell apart on the desk of Kent Volkmer, a prosecutor who dropped the case in Arizona. His team said they wouldn't win. As the article notes, jurors often don't convict men who sexually assault women; they don't believe women, especially those associated with cultural underground activity.

Every tattooer I met expressed outrage at the mention of men who assaulted their clients or even approached the bodies of their clients sexually. They seemed to be growing more suspicious of tattooers trying to make a name for themselves by cultivating a tough-guy public image, generally. It was an instance of thought, feeling, and action that helped reveal the connection between what happened inside and outside tattoo worlds. The boundaries are porous, just like the skin on which tattooers produce and experience their best work.

I, too, was outraged and also surprised but not because there were predatory jerks in tattooing; there are predatory jerks everywhere. The surprise was inspired by the fact that I had encountered the incredible challenge of tattooing. It almost always demanded my whole attention. Who had room for this shit?

Working right underneath a person's breast, across their midsection, or right on their butt was always, to me, a physical task that consumed my near-entire being. Even Matt, who embodied the demands of tattooing far more than I ever would, seemed too enveloped in the requirements and responsibility involved—that is, the technical difficulties of the tattoo itself and the obligation toward the person being tattooed. He wondered aloud how someone could ever get turned on while working.

Touching right demands an absence of feeling—sexual arousal being the one most likely discussed among tattooers I met and worked alongside. Touching right also demanded the presence of other feelings, self-confidence for instance. The confident touch is a necessity, especially as it instills the kind of certainty you needed to produce good-enough work.

And while touch is a physical act, it's characterized by a great deal of *meaning*. Forms of touch have the ability to communicate. Consider this, a slight amount of pressure, the quickness with which that pressure is re-

leased, and any degree of hard or soft touching will *say* something to those who understand the local meanings of touch. You can tell what's on the mind of the person who's touching you by attending to the nature of their touch. The meaning of touch in tattooing is rooted in a way of thinking about people, bodies, and the act of doing tattoos. For many of the people I met and worked with, it's a masculine touch. There's no pampering involved.

A Nonpampering Touch

A tattooer told me one evening that they, and "probably most tattooers," don't really "pamper their clients." This seemed true enough, even as we admitted we didn't fully understand what it would mean to pamper them in the first place. We agreed it would involve offering some comfort or soothing, and in that sense, we were mostly right.

It turns out that the word *pamper* stems from the Middle English/Dutch term *pamperen*, which meant *to cram or to stuff with food*. The indulgent, bodily character of the term remains active, even if we don't use it to indicate food cramming. People are pampered when they're treated well, but there's more to it. Sociologist Jo Little explains that pampering involves "a range of practices," namely those through which a person receives some type of bodily indulgence.[8]

People, mostly women, are pampered in places like spas. Their bodies are, as Little explains, "'treated' using a variety of (often small scale) luxuries."[9] The pampered body receives treatment, and that treatment aims to induce some degree of relaxation in the person.

Like tattooers, those who *do* pampering labor try to conceal the difficulties they face on the job. They develop skill in the area of emotional labor, and, like tattooers, they strategically employ environmental and architectural features. People are frequently pampered in situations where they and their bodies seem enveloped in an atmosphere of solace.

The scene might be characterized by a "sense of the exotic,"[10] and you can picture it: white people in California encircled by Himalayan salt lamps and Buddhist statuary. The Tibetan Singing Bowls are in full chorus, the saunas and steam rooms are spritzed with eucalyptus oil, and the turmeric lattes are on their way. Deep breathing is had by all, and, to be fair, I love this kind of shit.

Unlike in tattooing, though, there's a larger rift between pamper-givers and pamper-takers. The rift tracks hierarchies of race, gender, class, and immigration status, with wealthier and whiter patrons soaking up the work of their less-white, less-wealthy, and less-documented counterparts.

While upper-middle class men are paying to be pampered at historic rates, pampering's intimate, emotional, and caregiving quality affords feminine significance to its related people, practices, and products.[11] There's also a racial component to all of this. Sociologist Miliann Kang makes the connection—explaining why, for instance, customers of Korean nail salons might (wrongly) conclude that the women doing their nails are "naturally" suited for the job.[12] Manicurists aren't born, Kang argues; they're made.

Tattooers I met didn't pamper their clients, but they *did* work to ensure the client felt comfortable. They also knew the tattoo process could offer a spa-like experience for some people.[13] Tattooing can offer someone a time out, give them a sense of respite. And aren't those flash-covered walls, along with the loud music, somewhat exotic? What about the smells and the banter? Don't forget, too, that you'll leave that place high as a kite.

In an interview for the podcast *Books Closed*, prominent tattooers Austin Maples and Paul Dobleman describe being surprised when a ton of people sought tattoos after shops had been closed during the COVID-19 pandemic. Podcast host Andrew Stortz, who tattooed in Portsmouth, New Hampshire, stressed that he had never been so busy. He agreed with Maples and Dobleman that people get tattoos as a form of therapy, suggesting they seek out the *process* as much as its product.[14]

We were also very busy at Premium. It seemed true that my clients were hungry for a break from their daily lives. I picked up on this and moved to use it in my tattoo practice, laying it on a little thick by telling them their only job was to sit still. I would say something like, "You have an awesome opportunity to do nothing right now." I'd then cause these people considerable pain, moving through the tattoo while they winced and twitched.

Some clients said they enjoyed the pain, actually. It was part of why they were there. I never enjoyed it when clients liked the pain. Maybe it was an issue of consent. It was clear to me that I never signed up to satisfy their fetish, but there I was doing just that. Both Pauly and Karime had couples come in who tried to make out while one of them got a tattoo. It gave us all a bad taste, in part because it wasn't our role. We didn't occupy *that* spot

of the intersection of people, bodies, and money. Or maybe it was that our intersection—our Venn diagram, coalescing streams, or ball of snakes—was altogether different.

Of course, people experience pain at the day spa. Waxing hurts like hell, and maybe some clients like that. But the point here is that tattooers don't expressly pamper their clients. The lack of pampering contributes to the masculine meaning of tattoos, tattooers, and the broader environs of tattoo production.

The confident touch plays its part in all of this. It helps tattooers distinguish themselves from other, more feminized, forms of body labor.[15] This is because soft touch is, like the soft apprenticeship, not the hallmark of a craftsman. But whether you seek to be a tough-guy tattooer or not, you still have to learn to touch with confidence.

Matt repeated the need for a confident touch and especially after watching me work with some clients early on. I would nervously interact with their body, touching them too lightly. I'd hesitate and be all awkward with them.

Matt said one afternoon, "You've got to really touch people, man, hold their bodies." We were on the patio, that backstage area of reflection, preparation, and even relaxation. He touched my arm, using his hand to move it slightly up and down before giving it a minor rotation. He didn't squeeze my arm but rather maintained a sure and stable grip. The movements were smooth, not jerky, and they complimented the way my arm would move if I were to control it on my own. His grip communicated something about him and his relationship to my body. It said he knew what he was doing

He touched and moved my arm before saying, "Now do that to me." I took his arm in my hand with a light touch. I overcompensated with a squeeze, leaving pale marks in his pinkish skin, before approximating the grip he gave me. It was a difficult thing to do and proved especially hard to reproduce with strangers. Months of tattooing would pass before I could *touch right* in this regard without thinking about it all that much.

I wrote pages about touch in my fieldnotes. It's a useful thing to consider. One of the fascinating things about touch, in tattooing and elsewhere, is that it can offer a window through which we can understand bigger things about the social world. It helps us notice, for instance, how gender is produced through moments of social interaction. It helps reveal gender to be a result—an outcome—of people doing things together. Exploring the gendered

character of touch can highlight the broader, relational accomplishment of masculinity in tattooing.

But tattooers also deal with bodies without touching them. They *see* bodies, and they work in shops where bodies are displayed. I tattooed that guy who sat in bright red bikini briefs, and I saw many bellies, backs, breasts, and thighs. It was standard, everyday stuff that would otherwise be strange or even illegal beyond the tattoo booth and out on the street.

Pulling Your Pants Down

People in tattoo shops can, like people on the beach, show a great deal of their bodies without disrupting the scene. A scholar of the beach, Obrador-Pons, describes a scene that could very well be the tattoo booth. It's at the beach (and in the booth) that "the exposure of the flesh is a fundamental component of the experience."[16] Sitting in the sand on a sunny day in California, wearing a pair of tight jeans with shoes and socks on, no less, could make the point on its own. Even wearing shorts on some European beaches can make you feel that you didn't get the memo. A similar thing might happen in a tattoo shop.

If there are *feeling* rules and *touching* rules in tattooing, I'll add that there are also *exhibition* rules. There are norms of appropriate bodily display.

People routinely lift up their shirts and take off their pants while getting tattoos. They pull up sleeves and pantlegs, and they often remove their shoes. They might slip one arm out of a tank top or strip down to their underwear.

We at Premium would offer bibs or stickers to people with breasts if they wanted to cover their nipples. We did so to put them at ease. It wasn't for me, at least, because bodies lost their sexual meaning within the shop, especially within the region of the booth. This was a feature of the scene, part of what Goffman would describe as our "situation."

But clients, especially those unfamiliar with tattooing, are unlikely to intuit the norms of the situation. They might suppose they're in space that's like any other retail environment—one where you can't just take your shirt off and have it be cool. Folks who are new to tattooing didn't really know what to do in the space, and while their lack of knowledge demanded work on our part, a kind of situational education, it also produced some interesting moments.

Clients routinely showed up in the wrong clothes. They chuckled with embarrassment on finding that, indeed, they had to offer access to their knee in order for me to tattoo it. Their tight jeans stood out as a mistake, as would their long sleeve shirts, wrist watches, and even the way they styled their hair. I believe I gave a few clients a rubber band so that we could keep their long hair up and out of the way.

Some clients were uncomfortable with exposure in a more general sense. A tattooer and I spoke about this one morning over coffee. She said she often worked with Muslim women, a clientele gained through word of mouth and to her surprise. These women would request a situation that would prevent men from seeing their skin or hair during the tattoo process. The tattooer honored this request by placing screens around the client. She said it was crucial but added, "At the end of the day you know, we're in a tattoo shop and really it's the case that nobody cares, you know?"

She knew, however, that her clients cared. She responded accordingly, because tattooers do more than just put tattoos on bodies. They deal with people and the immensely social aspects of their bodily experience. The better ones work to meet people where they are, assessing their needs, and offering reasonable accommodation. They see it as part of their job.

But to suggest that tattooers work with bodies and with people is to remain a bit vague. Of course, they work for money, but there's also that bit about bodies being two things: bodies are always sites of physical *and* cultural experience. They are physical objects that can be made sexy through the application of sexual meaning to various features and movements. They can also be made racial by applying racial significance to their physicality. You could apply this insight to any category of difference, be it ability/disability or even social class. Bodies are multiple, and those who labor on them daily wrestle with this fact while attempting to find success at work.

As much as tattooers touch and manipulate bodies, they work most directly with *skin*. "Skin is the medium," a tattooer once told me. We'd been talking about the difference between tattooing and painting or drawing. Quite unlike canvas or paper, skin is alive. We agreed that it seems to move on its own sometimes. I swear I caught it breathing once. It's also porous: skin leaks.

There are many qualities of skin that a tattooer must consider while digging into a project. There are stretchy bits, thick patches, stiff sections, and

it's all different on different bodies. Tattooing the banged-up knuckle of a mechanic presents a challenge, one that's different from the sundried forearm of a roofer. Skin's thickness matters—try tattooing the paper-thin stuff across the top of an older person's hand.

The condition most discussed, debated, and ardently considered in my little corner of tattooing was skin tone. Matt would say, "The tone of a person's skin matters," and, "You've got to learn how to deal with skin tone." This was an issue of physical necessity, as tone-related qualities of skin demand a measured response from the tattooer. But the focus on skin tone was about much more than that. This is because skin tone is, at least in the US, almost inseparable from its more social realization—race.

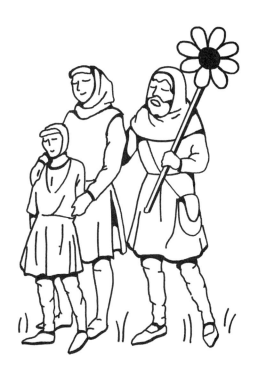

The Physical and Cultural Life of Skin

The average human is wrapped in about twenty square feet of skin. It weighs roughly nine pounds, making for a well sized and weighted bowling ball if it were rolled up.[1] Skin is on your face. It's also on your hands, feet, neck, and ears. It covers your body, the whole thing. It's the largest organ, and it serves as the final, porous barrier between a person and their world. Tattooing can bring the physical and cultural elements of skin to the surface, forcing everyone involved to notice, talk, and work with it directly.

A young woman walked into Premium around noon one day looking to have some scars "covered up." I use quotes here because many cover-up tattoos don't exactly "cover." They rather distract the human eye. Good ones are good illusions, and in this case the good cover-up would obscure some thin, keloidal scars that sat in neat rows across her inner forearm. They were all lined up there, just above a bundle of noticeable veins.

I had tattooed over the self-harm scars of a dozen people by this time. I stood in front of her discussing the tattoo, and, as we focused on the scarred area, it's safe to say we were discussing her body, and even her life, as much as we were talking about a tattoo. I'd grown to appreciate my role in the lives of others, helping some of them move on from a time when self-harm seemed to make good sense. It was great to assist their effort to ensure an updated match between their outer and inner lives. I was happy to work with this client, and I was energized by a busy day at the shop.

It was a special day, Friday the 13th, which is a holiday of sorts in tattoo-ing. We offered simple flash designs at forty dollars each, and our goal was to do as many as we could. These were indeed cheap tattoos, reduced from their usual $150–$200 cost. While we made some money on those days, it wasn't really about the immediate cash. We wanted to attract new clients, ones that would come back for more extensive pieces later on. We also loved drawing a crowd, and we dug on the rapid pace of things. It was exhausting

and exhilarating—tattooing for ten hours or more with the music blasting.

Those days were full of fun tattoos. Clients would get swept up in the scene, as the glamour would be in full effect. We would all get high on that sweet effervescence, and because the tattoos were so cheap, we could jam through them without fussing so much on the details.

The designs were generally made with speed in mind, as we had to do them quickly. They would be simple from the tattooer's point of view—designs made up of decently thick lines, minimal shading, and no color beyond the standard black. Some shops would constrain offerings on the level of placement, doing only arms and legs so as to avoid the more diffi-cult and time-consuming work of tattooing ribs, necks, and bellies. You just weren't paid enough to do more than that, and, importantly, you wanted to tattoo as many people as possible. Like a tattoo from an apprentice, the dis-counted work that's done during a tattoo event isn't likely to induce a ton of scrutiny from the client or tattooer.

This is because the price, and namely its reduction, organizes how people think, feel, and act toward the work. That "money" feature of the intersec-tion plays its role, organizing how everyone involved handles the process of tattooing. It shaped our assessment of the tattoos and of the interactions through which they were produced all day.

We had about twenty folks crammed into the shop's waiting area when I called my client's name from a growing list. She jumped up from one of our loveseats. She'd been planted there alongside a few friends for what might have been an hour. She approached the counter and, before talking about the cover-up, asked me straightaway: "Can you tattoo my dark skin?"

I wasn't surprised by the question. People of color had asked, as one put it, if I could "work with darker tones" before. These folks knew that some white tattooers in the US either can't or don't want to work on skin that's toned darker than "white." These clients approached tattoo shops as they likely approached hair salons, hoping the practitioners inside were able and willing to work with the features of their nonwhite bodies.[2]

"I can definitely do the piece," I told her. I said that our most immediate challenge involved the fact that she didn't know which design she wanted. This also wasn't too surprising. While the less-tattooed person might wonder aloud how someone could just point to a design and have it put on their body forever, those who do tattoos and people who get a lot of them are pretty

familiar with this kind of activity. It often led to the best tattooing and, as such, the best tattoos.

We both stood near the front counter while she scanned the flash. She paused on a rose design and told me she wanted to get it. I allowed her some time with the decision, only about a minute, in case she changed her mind. I was trying to withhold my own excitement during that minute, working to produce a neutral face so as not to encourage her immediately.

The design was perfect: it would do a good job obscuring the scars and, importantly, I could knock it out. It would stand boldly on the skin, and its demands matched my skill set, as it was made with thicker lines and rudimentary shading. I eventually said the design fit her rock-and-roll aesthetic and that it would complement the tattoos she already had, one of which had been done by Matt. She decided to go for it, and her choice relieved me from a tinge of anxiety.

I was confident in my tattoos by this point, but that tinge of anxiety came from the fact that there was a design I didn't want to do sitting right next to that rose. Karime had drawn it up and—it seemed to me—*snuck* in a bunch of fine linework that would be a pain to tattoo. I could do the piece, but I was less competent in the fine-line technique. It would make me sweat a little, and I wasn't there to sweat the linework, not on that day at least.

I scaled up the rose design to better fit across the field of scars, which was something we typically didn't do on those Friday-the-13th days. I did it anyway before guiding the client through the process, inviting her to move through the saloon-style doors and back toward the booth.

It was fun to watch people move into the tattoo experience after waiting for so long. It was like they had won something, and you got to give them the prize. It was unclear whether that prize was the tattoo itself or the painful practice through which it would be put on their body. At the very least, it was their chance to change something about themselves and to get a quick high along the way.

I led my client toward the booth and asked her to stand in front of me. She unhinged her right arm, displaying its long-healed marks so that I could lean in and get a good look. It seemed like she'd learned how to keep those marks out of view, and I felt grateful to be invited in, to be allowed to look closely. She was, after all, offering me entrance to her very own backstage.

I looked over the area and asked for consent before wiping the skin and

scars with an alcohol-soaked paper towel. I used my gloved hands to lather green soap on the area before shaving some hair away, being careful around the scarred tissue. I transferred the stencil and asked her to look it over in the mirror. She said it was in the right spot. So, that was that; we were ready to do the thing.

I asked her to sit in a chair facing me and to lay her arm across a red, plastic-wrapped armrest with the palm turned toward the ceiling. I tattooed quickly. Her arm was between my knees and we talked the whole time. She also watched my every move.

While I was growing used to the experience of having someone watch me do a very difficult thing, it could still be unnerving. I generally didn't like it when my clients sat watching closely. It made me cherish the privacy of painting, drawing, and writing. It reminded me that tattooing was an inevitably *social* experience—an act done between at least two people in real time. While we were always in our booths and behind the saloon-style doors, we did public-facing work.

She and I got into a rhythm with ease. We shared stories, spoke casually, and dug on the jams. I enjoyed it, and I also had that waitlist in mind. The shop worked through the waiting clients *as a shop* on such days. We did one tattoo after the other until the waiting area held only remnants of the people once crammed within its borders: a stray water bottle or a hoodie left behind. We kept a tally, actually, tracking the number of tattoos each of us did. Matt, a guy who could do a simple tattoo in ten minutes, always did the most. We also tracked the designs chosen and rooted for our own. While I was pretty slow, my designs always did well.

My client seemed to be having fun in the bustling shop. I pulled the lines quickly and switched my *liner* needle to a *magnum* for the shading. The magnum, or *mag*, has a different arrangement of needle points than the liner. The points in a *liner* meet to form a circular tip while the points in a mag meet to form a fan-like shape. I shaded the rose petals by pulling that fan-shaped mag quickly across the skin, starting from a petal's edge and moving toward its center while lifting the needles up and away from the surface. You can create a pleasing effect by slowing the needles down (decreasing the machine's voltage) and whipping the hand fast: each puncture appears spaced out, almost like you'd put each dot there on its own. Some tattooers call this technique "whip shading."

I finished the piece and was a bit disappointed by the shading. I tried to avoid worrying about it as she hopped out of the chair. She either didn't notice or didn't care. In fact, she held her arm toward a mirror while smiling. I wondered what it must have felt like to look at that spot in a new way, to see what she'd been seeing for so long through a new lens. She thanked me repeatedly, as the piece came out fine enough (see fig, 7). At the end of the day, the rose was well worth the forty bucks. She was exuberant, and we hugged before a quick goodbye. She showed the work to a few people on the way out.

While there was power in that tattoo on the basis of what it could do for the client, the power of price in shaping our lives surfaced once again. I

FIGURE 7. *Quick rose covering scars during a busy Friday-the-13th tattoo event. Tattooers adjust their technique in response to their client's skin tone, in this case reducing the machine's speed and moving the hand quicker to avoid causing keloid scars.*

would've been *wrecked* by the poor shading if my client had expected to pay $200 for the piece. She might not have left so pleased, either. Our expectations of the tattoo and of the whole process were conditioned by the money involved. Almost by chance, I was actually able to touch up the piece two years later. She walked in on a whim, and there I was, happy to fix it up for free.

What's more is that she got to walk in and work with someone who didn't seem phased by her skin tone. As evidenced by her first question to me, she had been sitting in our waiting area wondering if we would turn her away. Now, she had been tattooed at our shop before. Perhaps she came back because she knew that we, or at least Matt, could give her a solid tattoo. But the question was there. It was a question that I, as a white dude, never had to ask myself or anyone else.

Some tattooers shy away from working on highly melanated skin. They might not know how to do it well. They may try, only to find that they're causing keloid scarring, in part because they may overwork the area, wondering why the marks aren't as immediately visible as those put into lighter-toned skin. It's also the case that highly melanated skin is generally more prone to developing keloid scars. In addition to a lack of knowledge around how to appropriately use color (as discussed later), some tattooers are afraid of inflicting the scars.

I knew I could do the simple rose tattoo because I'd been trained to prevent keloid scars while working in highly melanated skin. The thin scars already in the area didn't give me much pause. Matt taught me to reduce the machine's voltage and to move a bit quicker. "If it doesn't seem *in there*," he would say one evening, "don't go over it a second time." He coached me to hold back, be patient, and trust my first marks. "You can always hit it again later on," he would say, reminding me to tell clients to schedule a touch-up if they suspect it might improve the tattoo.

Some white tattooers don't get this kind of education and experience. They might've taught themselves how to tattoo at home, unaware of the fact that skin tone and scarring have much to do with one another. They might've done the majority of their tattoos on white friends, because new tattooers in the US are like everyone else—brought up in a nation characterized by racial segregation.[3] But whether they live in a white neighborhood or not, tattooers in the US grow up in a society where, by the facts of history, the *meaning* of skin tone matters.

The Cultural Life of Skin

There's skin, and then there's the ideas we attach to it. Skin is hardly ever just a thing or human organ. It's like bodies generally—loaded with meaning. Tattooing can bring all of this front and center, revealing skin to have a cultural life.

Skin's creases may signal to those obsessed with youth that the person with wrinkled skin is nearing obsolescence. Its blemishes may tell those who attach skin clarity to hygiene that the person with pimples is irresponsibly unclean. I would occasionally talk with clients about their pimples because you don't want to tattoo over a pimple. We'd even adjust the tattoo placement so as to avoid a blemish, making a more permanent decision based on something so temporary.

Beyond the blemishes, though, the most ardent source of skin's cultural life is routed in its tone. Skin's meaning is, above all else, established and contested within the realm of *race*.

We at Premium knew that the tone of a person's skin in the US, a society organized on the basis of light-skin ascendancy, influences every aspect of their lived experience. It associates them with varying degrees of attractiveness, as people have conflated lighter skin with mainstream standards of beauty,[4] but it can also determine their life or death.

And because I taught college courses on race relations, I was especially aware of the fact that this situation is an outcome of work—of effort wielded by people dedicated to molding social affairs into a shape that echoes powerful, historical, systems of human classification. Those with the power to rank and classify humans have, after all, arranged people into hierarchies that take skin tone into consideration. In doing so, they've privileged their own, lighter-toned skin over the darker tones that remain visible across the world's numerical majority. Lighter skin is privileged across racial categories (racism) and within each category (colorism),[5] and this approach to skin influences what we see on the news, what we encounter in the mirror, and what tattooers deal with at the intersection of people, bodies, and money.

Pauly and I talked a lot about racism. I tried to avoid playing sociology teacher. One day on Premium's back patio, however, I explained that racial hierarchies are a partial effect of work done by seventeenth- and eighteenth-century European intellectuals. I told him they harnessed the discourse of

science in an effort to establish hierarchies of racial classification and used biology, at least as it was practiced then, to explain the incredible diversity of Earthbound flora and fauna.

Imagine the scene: colonial efforts were in full swing, and voyagers were returning to "Europe"—then still a rather new idea—on creaky wooden ships filled with plants and people from other places. These places would later be called Africa, India, and South America. European intellectuals seized an opportunity to gain wealth, status, and power by trying to explain what this stuff was, who these people were, and why it was all so different from what they encountered at home.

They promoted some theories, "scientific polygenism" being one of them. When it came to people, the idea was that different-looking humans from around the world were representatives of distinct human-like animals.[6] The approach is reflected in the work of classifiers like Carolus "Carl" Linnaeus, the "Father of Taxonomy," whose 1758 *Systema Naturae* categorized humans into distinct groups: (1) Homo Europaeus, (2) Homo Americanus, (3) Homo Asiaticus and (4) Homo Africanus.[7]

Whether he intended these categories to be stable is debated, but as the science journalist Angela Saini notes, he and other racial scientists classified people into "hierarchies based on the politics of the time."[8] Those politics, perhaps much like the politics critiqued and otherwise discussed among us on Premium's back patio, involved a view of the world that suggests the appearance of a person or group could tell you something essential about who they were, what they cared about, and why it was that they either had wealth or didn't.

These hierarchies associated lighter-toned skin with human traits widely celebrated among European elites. Linnaeus, for instance, argued that Homo Europaeus was, in contrast with other groups, driven by *reason*. Tattooing was in the mix here.

Cesare Lombroso, the founder of criminology, later argued (in 1876) that committing a crime, living in poverty, or getting a tattoo was the result of a person's biological history. Tattooing for Lombroso was "one of the most singular characteristics of primitive men and those who still live in a state of nature."[9] It was one among many traits of people who might break the law on a regular basis, as their bodies were closer to a "state of nature" and, as such, less rational, less governable, and variously more prone to follow

carnal (read *animal*) urges. Lawbreaking was in their bones, he told the world; it was in their brains.

While it didn't always seem obvious in the tattoo shop, the legacy of scientific racism continues to bring negative judgment on people with darker-toned skin.[10] The history of human classification informed how I, my clients, and the tattooers I met experienced skin's cultural life. It's a history that continues to trouble the moments between people, one that seems hidden yet so out in front at the same time, silently shaping so much about people's lives and yet remaining just beyond the frame of public conversation about race and skin tone in the US.

And while these early classifiers were steeped in a dedication to white European dominance, absolutely reeking with culture and drenched in the desire for power, the broader project of human classification can be understood as a venture to comprehend humans from a *technical* perspective.

The tattooers I met weren't trying to create global hierarchies to justify racial violence, but they *were* trying to approach the bodies of their clients from a technical point of view. They, like all body laborers, had to objectify the body to some degree—wedge themselves between the physical and cultural life of bodies and skin. They had to account for the body as a thing in front of them, while keeping track of the fact that the thing belonged to—indeed, *housed*—a person.

Turning skin into an object of tattoo labor requires attention to its tone in a procedural, practical sense. It remains unclear whether contemporary tattooers, or anyone in the US, can deal with the color of skin without also dealing with its racial significance. I will argue it's impossible and at times, unnerving. Many tattooers I met knew this to be true, or were at least dedicated to learning about it, and they tried to teach others.

There were many educational resources available on the subject of skin and race while I was a tattooer. Many were aimed at disrupting a white-centricity of mainstream US tattooing. There were enough just on Instagram to teach any new tattooer the basics of tattooing a variety of skin tones. Indeed, whole accounts were built and maintained for the purpose, such as *Ink the Diaspora*, *Shades Tattoo Initiative*, *Tattoos on Dark Skin Tones*, and *Melanin with Ink*. Prominent tattooers—including Maiya Bailey, Jacci Gresham, Tamara Santibañez, and Oba Jackson—also worked to distribute information on the matter. YouTube was foaming with videos, and the

subject landed within digital imprints of *Cosmopolitan, Men's Health,* and *Medical News Daily.*

The fact that people organized to distribute such resources, ones often bursting with antiracist sentiment, helped reveal a growing awareness of the desire for tattooers to address the deep-seated role of whiteness in tattooing.

Karime, Matt, Pauly, and I occasionally shared the resources. We also knew that tattooing was, after all, *developed* by people with dark skin thousands of years ago. It's simply not the case that tattoos don't work on dark skin, but whiteness and light-skin preference were built into the technology, training, and aesthetics of tattooing over time by white people. We approached all of this as a problem, as did most of the tattooers I met.

Those who mostly work with white clients can develop practices most suited for light-toned skin and in this way rely on a specific condition of their client's body to realize success in their work. They're kind of like developers of facial recognition technologies who build products most amenable to white faces.[11] These engineers and tattooers default to whiteness and approach darker-toned skin as in need of accommodation. Many tattoo clients know this about tattooing, no doubt because of the proliferation of its related discourse across social media. Hence the question on that Friday the 13th: "Can you tattoo my dark skin?"

I'd occasionally try to imagine an alternate world in which contemporary US tattooers had to adapt their baseline practices to find success working with *lighter* skin. Tattooers developed their skill, after all, with darker-toned skin in mind. Their clients with lighter skin might face pushback from tattooers because their skin proves "problematic." It's more prone to revealing error, after all, and it fails to produce the keloidal marks that—in this counterfactual—made for *good* tattoos.

This, admittedly, is hard to hang on to, partly because there are enough white people doing and getting tattoos in the US to warrant its impossibility. It's also true that some tattooers mostly tattoo people of color. They work in racial enclaves.[12] It's also hard to imagine because, sociologically speaking, the assumption of whiteness in tattooing is an "institution." It's built into the common sense of people who share a situation—in this case, tattoo production.[13]

Tattooers discussed the issue, tried to work it into forms of training, and shared its related resources online. But the actual work of it all was accom-

plished through daily activity, most of which could be rather straightforward. You had the person in front of you, standing there *in* and *of* their body, asking you to do something to them in exchange for money.

Tattooing involves numerous steps of interpersonal negotiation, some of which revolve around the client's skin tone. When all is well, those steps are hardly noticed. It often looks and feels like everyday stuff, so obvious in fact that it might not seem worth mentioning. Tattooers navigate each step of the tattoo process by employing what they have learned over time. This includes relevant skill in bodily awareness, interpersonal communication, forms of touch, and matters related to the design. When it comes to skin, they work to notice and consider texture and tone. They can become, among other things, tone-conscious.

Tone Consciousness

A man walked in to Premium one afternoon and placed his hand on the counter. He asked with a smile, "You think, with my dark skin, we could put a name on and still see it?" He *did* have dark skin. I began chatting with him, saying something about the necessity of contrast. This involved telling him our eyes rely on distinction in tone and texture, that the color of ink would need to be different from the color of skin to be seen well by us humans. I also said I would love to work with him.

He nodded his head while I spoke, and we both chuckled a bit. It seemed we were aware of—and finding some enjoyment in—the uniqueness of our conversation. White and Black people who don't know one another aren't likely to talk about skin tone so directly. I, at least, hardly went there with people outside the classroom setting, where teaching race relations was my job. This man and I stood together at Premium while I removed a black marker from its package. I told him we could write on his skin to see if we could see.

I took his large, rough hand in mine before writing the name on his outer wrist—a name I failed to record in my notes. I recall it being of his spouse or daughter, a name I wrote in a clear, simple font. He held the hand up when the name was done, catching the text in afternoon light. He angled his wrist and showed it to me with a smile. A shimmer off the quickly drying ink was the only thing to be seen there, and I hadn't really expected more. The text

was hard to read while drawing it on in the first place. He seemed to conclude we wouldn't, after all, be doing the tattoo.

We both nodded and I told him, "I could surely give you a tattoo, but you may not be able to see it so good right there." I began describing areas on his body that might work better—ones that got less sun, like the upper shoulder, inner bicep, or thigh.

I made this suggestion because I'd become familiar with patterns of tone variation on bodies while tattooing people. Being a white dude only occasionally familiar with the naked bodies of Black people, I would find surprise at just how light the skin would appear on the upper thigh of someone I had initially thought of as having darker skin. I wanted to give this man a tattoo and was confident we could put it somewhere more visible. He had come in with the direct question of visibility, and I was working to get him what he asked for.

He patted my back, though, and thanked me before leaving. Standing there, I wondered whether he left on account of my being white and if he would've worked longer with Karime, a person of color. It could have been me, or something about me, that botched the process. Of course, he might have left because he fulfilled a suspicion that he wouldn't be getting that tattoo anyhow.

I knew, however, that we'd experienced a unique kind of interaction, a conversation about skin tone among strangers the likes of which I had rarely encountered. Tattooers have to learn how to have these kinds of conversations if they hope to find long-term success in their work. Here again lies a demand of tattooing that has little to do with design skill. It's yet another thing that can go right or wrong—a feature of intersecting people, bodies, and money faced by tattooers at work.

The fact that tattooers actively consider and talk about skin tone means they have a hard time assuming the stance of racial "color blindness." They can't do like others who try to avoid responsibility for racism by claiming they don't "see" the color of a person's skin.[14] Tattooers must, in the words of Kimberly Jade Norwood, "Do something we say we do not like to do: Notice color."[15] They can't just *notice* color, though. They have to become *tone-conscious*,[16] hyperaware of skin coloration.

Tattooers who are more sensitive (read *skilled*) when it comes to tone approach skin as a series of semitranslucent layers. They know that tattoo ink

goes past the epidermis, where the melanin is, and sits down in the dermis. They know the human eye will encounter the ink through that dermis layer—that anyone looking at a tattoo sees it through a melanin filter. While it's a bit complicated, the more melanin there is, the stronger that filter will be.

Most tattooers know that using black ink and bold design work—employing thick lines, high contrast, and simple composition—will produce the most visible tattoos and ones that will stay that way for a long time. They apply this knowledge to all tattoos, especially those done in darker skin tones. If you have darker-toned skin, your standard street-shop tattooer will probably try to simplify a design and avoid using much color while working with you and your body.

But some tattooers, the best of them, develop techniques that allow for vibrant color and nuanced design with darker-toned skin. They find success with a variety of skin tones, and the darker tones in particular, by employing color palates that account for the melanin filter. They can quickly identify the base tone of someone's skin and use color theory to select pigments that will work best. They might, for instance, avoid using yellow in a tattoo done on skin with substantial yellow coloration. They know the yellow won't be so visible through a more yellow-tinted filter.

These tattooers have learned that, generally speaking, darker and warmer tones work well within darker-toned skin. They use bolder reds, darker greens, and richer blues or purples. They make sure the colors *work* in the design, too, offering the balance and consistency that makes good tattoos look good for the long haul. I met some tattooers who did *color tests*—tattooing small dashes in different colors so that they and their clients could see which ones worked best. The seasoned tattooers, though, didn't need to do this because they could simply look and tell.

While this ability is important for all tattooers, it's especially crucial for the person who's going to tattoo the bodies of people with a variety of skin tones.

Premium attracted a rather diverse flow of walk-in traffic, which meant tattooers working out of the shop had an opportunity to encounter people wrapped in variously toned skin. This also meant that finding success with walk-ins demanded you gain skill tattooing people of color. You surely couldn't refuse certain walk-ins because you couldn't tattoo darker toned skin. This would be unacceptable to Matt and everyone else, both on the

basis of our shared desire to grant anyone a good experience and on the plain necessity to make money.

When it came to scheduled appointments, Pauly attracted people of color because he grew up in Oakland. He had spent decades developing a social network within environments where people of color were overrepresented. Karime, likewise, brought in many people of color. Karime, a Latinx person, had a friendship circle of Latinx folks, as well as a Chicano-inspired tattoo style. Matt and I seemed to draw a mostly white crowd, although Matt often tattooed people with darker-toned skin.

I had the whitest clients. This surprised me, and I got defensive about it. I mean, wasn't I participating in discussions about racism in tattooing? Wasn't I teaching college classes on race relations between appointments? But there I was, tattooing white people and almost exclusively.

After some reflection, I asked a few tattooers why this might be. They quickly identified the overwhelmingly white representation of bodies across my Instagram portfolio. If you were to scroll through the pictures real fast, you might see a blur of pale white skin marked by some lines. It was easy to understand how my Instagram portfolio could impact my clients, and it felt like a conundrum: the more I posted photos of my work, which was often done on white people, the more I might exclude people of color from my practice. There was something about me, my work, and my public presence that attracted white people to my tattooing.

While I didn't reach out to tattooers of color and request they educate me—solve my problems—I brought it up with someone who almost exclusively tattooed people of color. They jumped in straightaway, excited to talk with me about the issue. I was excited, too, partly because the tattooer offered a prominent voice against racism in tattooing on social media. They were deep in the conversation, an all-out reliable source. We built quick trust in one another and dove in.

Among the many ideas we explored, I suggested I could reduce the price of tattoos for people of color. This, I thought, might increase access to the work. The tattooer explained this idea was "a tough one." We were both quite sure it was offensive and therefore not the right step. We ran through many scenarios without much success. The problem was easy to identify but difficult to resolve. I'd like to report otherwise, but it continued, and it was something I worried about.

Outside of the shop, conversations about skin tone and tattooing almost always involved direct concern over racism and racial justice. What was striking about such conversations *in* the shop was that people could talk about skin tone and get *very close* to doing so without talking about race at all. This was an achievement. Matt, Pauly, Karime, and I could edge toward a very unique experience—an event where skin tone became a *technical* matter. We could almost address skin's physical life on its own terms.

There was a daily flow to this kind of work with clients, one that seemed rather matter-of-fact and not especially political. It didn't require academic language or an intellectual understanding of history but rather an attentive approach to interpersonal experience. The relationship between skin tone and tattooing became *very* political in the spring and summer of 2020, though, again mostly through conversations online.

The Long, Hot Summer of 2020

It had been eight years since the vigilante killing of Trayvon Martin in Florida, six years since the cops killed Michael Brown, Eric Garner, and Tamir Rice. It had been five years since the police murder of Sandra Bland, four since that of Philando Castile, and two since that of Stephon Clark. There were other Black and Brown people killed by cops and vigilantes during this time, as there have been for hundreds of years in the US, but these cases made prime time.

Their names were in the streets and on the minds of people who usually didn't organize against racial violence. Nonprofit and corporate organizations distributed "statements" to emphasize their alignment with historic efforts toward equality and justice. "Diversity, Equity, and Inclusion" departments were formed and debates erupted—inspiring some degree of change or at least exposure of embedded, often unspoken, practices contributing to racial discrimination.

It was a strange time, and not just because Black people so visibly faced the brunt of police violence but because there was also a new virus ripping its way across the globe. Breonna Taylor was killed by plain-clothes cops who had forced entry into her Louisville home on March 13, 2020, the same day that we at Premium held our last, pre-COVID, Friday-the-13th event.

Largescale shelter-in-place orders came down from California state offi-

cials three days later. Most people I knew, including tattooers, had been sheltering in place for ten weeks when Minneapolis cops killed George Floyd, on May 25, 2020.

All of this (and more) fed the flames of a social movement that worked its way through tattoo worlds in the spring and summer of 2020. *Ink the Diaspora*, "a platform of visibility for dark skin folks who struggle to find representation for tattoos," remained a visible element of this response.[17] Like many other tattooers, I watched what this group did closely. I also joined a weekly *Racial Justice in Tattooing* discussion group when I wasn't doing other things, like attending protests and phone-banking to try and get then-President Donald Trump out of office.

Dialogue on racism among tattooers was mostly accomplished on Instagram, and it focused on skin-tone discrimination. Participants in this dialogue distributed information on skin tone and tattooing while critiquing those who claimed to find special difficulty working with darker-toned skin.

Journalists had taken notice of the issue before that summer of 2020, but their articles seemed to gather new attention. Two examples are found in Isha Aran's 2015 "Why Do Some Tattoo Artists Balk at Dark Skin" and Rachel Charlene Lewis's 2019 "You Can't Be an Ink Master If You Only Tattoo White Skin." The latter responds to tattooing's most visible manifestation, TV shows. It offers a brief look into the racial dimensions of tattooing and how pop-culture representations of the practice might contribute to broader currents of racial ideology.

Now, every tattooer I met hated tattoo TV shows, partly because people on the shows, on *Ink Master* at least, used the word *canvas* to describe clients. They occasionally voiced preference for light-toned "canvas," too. One contestant on *Ink Master* explained, "My ideal canvas would be, like, paper-white skin." Another said, "I don't want the dark canvases," while adding, "They take away half your skill set. My stuff is dark and creepy, and I don't want to go that dark on dark skin." This second tattooer concluded, "This is not the canvas for me."[18]

Such statements wouldn't feel racist if they were made by a painter, for instance, who declared preference for one type of canvas over another. Skin is, technically speaking, a different material than canvas, but it's also different on the cultural front. Human skin has been granted significant meaning.

Any TV show about skin might have the power to shape that meaning, so people are concerned about the representation of skin and bodies on tattoo-related TV shows. Critics don't want the shows to perpetuate a preference for lighter-toned skin.

The crux of the matter is simple: people aren't canvases. Describing them as such employs a metaphor that might encourage the potential for racial discrimination. It also flattens the great complexity of tattoo labor. A tattooer told me, "You know, those shows describe people as 'canvases.' Thing is, the people you tattoo are *people*, you don't get to work with *canvas*. I hate that 'human canvas' shit!"

Referring to a client as a canvas ignores one of the crucial ways that people and bodies intersect in the world of tattooing—an intersection that can get muddied up when agents of popular media refer to someone's skin as a type of canvas. It's as if someone is there trying to redraw your Venn diagram, reroute your streams, or add a new batch of snakes to your growing snake-ball.

Some tattooers are more skilled than others when it comes to working with and talking about skin tone. Matt and more seasoned tattooers I met seemed rather at ease with the task. Those who failed at it the most—succumbing to the tension between skin's physical and cultural life in a public way—were the tattooers who actively preferred lighter-toned skin. They might've tried to frame this preference in technical terms, as we see in the conversation about "canvases" on TV, but they didn't always try. Even when they did try, though, they often didn't do it very well.

Skin Like Fine Vellum Paper

"Clear, white, unwrinkled, and unblemished skin is the best." That's what a tattooer told sociologist Clinton Sanders in the 1980s. Sanders, whose ethnography among tattooers topped the list of academic books on the subject for decades, explains that the tattooers he spoke with understood a "good" client to possess, among other features, "finely textured, clear, light skin." People told him that "dark and coarse skin" offers a set of "artistic and technical problems" not present when working with skin "like fine vellum paper."[19]

Skin tone is, of course, a technical matter for tattooers. They work on and manipulate skin for a living. Different conditions of skin call for different techniques, and not all tattooers will thrive in a variety of techniques. But while they seem to approach skin tone without animating direct conversation about race, at least as presented in Sanders's book, the conversation inevitably has racial implications, particularly in the context of the social movement activity of 2020.

There were, however, public incidents of racism among tattooers that were easy to classify as racist during my time. One involved a guy named Oliver Peck, a tattooer and TV personality most known for his role as host of the show *Ink Master*. In January of 2020, photos surfaced of him in blackface. One of those images showed him in full blackface, wearing a superhero-style costume. The costume was in the liking of a Superman bodysuit; it's just that the big *S* framed in a diamond shape that's usually on the front of Superman's torso was replaced by a big *N*. It reads: Super N*****. He lost his TV job.[20]

I spoke with a tattooer who had worked with Peck and others from his social scene. We sat over expensive pastries in San Francisco while they told me, "It was everyday shit to find pickaninny dolls and even some swastikas in shops like his." They continued. "It's really no secret, at least in that scene. I mean these dudes are straight up racists, in that old-school sense." That "old-school sense" involved the promotion of explicitly racist tropes, language, and imagery. This was less about "unblemished skin" and more about deep-seated and hypervisible bigotry.

But there were incidents in tattooing, like everywhere, that proved a bit more difficult to classify *as racist*, even if they likely motivated systematic patterns of racial discrimination in areas of practice and representation. They helped me understand the body's physical and cultural life—the intricate webs of meaning and practice that encircled my life as a tattooer. Some of them echoed what Sanders found in the 1980s.

For example, I had a tattooer tell me, "I hate to say it, because it sounds racist, but I like tattooing lighter skin." They added, "It's just that my style and color palette work better on light skin." Their speech was full of qualifiers. It seemed clear they knew they were in choppy waters, navigating the potential for racial discrimination and doing so with a person they'd just met. Another tattooer was a bit bolder. He said his tattoos "just work better"

on lighter skin and that "it's a fact. We're dealing with contrast here." He told me, "You have to be able to see it." He seemed to be defending himself against a critic in his own head.

Often without formal education on the subject of race, one that might impart productive language to explore its social history, these tattooers were learning how to think about and act toward skin tone in real time. One of them, a person of color, described feeling "something like a traitor." They said this was because they began "thinking like a racist or something" when developing a preference for tattooing lighter skin. They and others I spoke with seemed dedicated to learning techniques that would allow them to find success with a variety of skin tones, but they had a preference, one they didn't seem to like.

I met some tattooers who jumped to express how much they, as one said, "love tattooing with all that melanin." This white tattooer seemed motivated by an all-too-familiar desire: to have others know they weren't racist. Another said that they loved tattooing darker toned skin because "the tiny mistakes can't really be seen, so in a way it's actually much easier." Matt, Pauly, Karime, and I shared a similar appreciation. Highly melanated skin could be so amenable to the tattoo process. Matt would say, "And no shit, tattooing was *invented* in dark skin."

Most tattooers I spoke with knew they were getting into a potentially difficult conversation when we talked about the technical features of skin tone. They took a deep breath and settled in for what could be a challenging moment because it's hard, if not impossible, to talk technically about skin without talking about it culturally.

Matt always told me to avoid developing a preference for any skin tone in tattooing. He called such things "fucking racist bullshit." He would rail against "racist fucking white-dude bro-club ass-hole tattooers" about every three weeks, assuming a mockingly deep voice and puffing up his chest. "I'm a fucking pirate racist jerk-off, but it doesn't matter 'cause I *tattoo*." He would return from the bar loaded and ready to take on the bros, if only in animated critique with me on that back patio.

But in more instructive moments, he would avoid the continuum of "light" and "dark" skin and speak of "richness." He'd say something like, "Now if your client has super rich skin, check in with them to see if they develop keloid scaring." Or he'd use the language of light and dark with

caveats: "If your client's got darker skin you adjust your colors. It's not that it's somehow *worse*; it's just you've gotta know how to do this." He said it was something I had to learn, and as hands-off as he could be, he seemed to know it was on him to ensure I learned it.

I was like other white tattooers who had come into a political aware-ness of racism through leftist street activism: fearful I'd be yet another white person who perpetuated racism through my thoughts and actions. But I also, simply and selfishly, really wanted to be good at tattooing. "It's a basic requirement," a tattooer told me. "Any tattooer who's good at what they do can tattoo any skin tone." A good tattooer knows how to use their tools with versatility—how to dance, not struggle, through the intersection of people, bodies, and money.

Learning how to promote yourself was a key step in that dance. Promo-tion could be tricky, too, because of the inability to separate the tattoos you did from the bodies you did them on and the people you did them with. The tattoo was a visible product, and selling yourself required you to represent that product to others, a task achieved on Instagram while I was a tattooer. But every post you made to showcase the work also showcased a body, or at least that arm, leg, torso, or otherwise small patch of skin in which the tattoo was embedded.

The politics of bodily representation—the organization of power when it comes to how bodies are displayed, projected, or exhibited in public—became fundamental in conversations about tattooing and race in 2020. And because we were simultaneously consumers and producers of "social" media, we were all wrapped up in the mix.

Are We Tattooing Corpses Here?

A young tattooer told me that Instagram was "really everything right now." They didn't have to mention it because I was spending hours a day on the platform. Beyond the TV shows, it was the most prevalent source of tattoo-ing's representation—broadcasting a largely sanitized and cool, fun, cute, or *hard* version of tattoos, tattooers, and a broader thing you may call "the tattoo lifestyle." A few hours on Instagram could teach you a lot about tattoo worlds, including the localized pockets of style, imagery, and technique.

And whether you were there to focus on it or not, you would learn quite a bit about skin, too. Because where there's a tattoo, there's skin.

Tattooers were like other users of Instagram in that they enjoyed, or at least *used*, the app's photo editing tools. This means they altered their photos, adjusting everything in the frame if even slightly, including the skin tone of their clients.

Tattooers could reduce the saturation of the image and increase conditions of contrast to make their tattoos appear more vibrant on the screen. It was almost too easy to make your work "pop" on the small square of an Instagram feed, and it was good to have an image pop because it helped you get clients—get money. The editing practices, though, could also make the skin on which the tattoo was done appear lighter than it might be in real life.

As benign as it might seem, these widely used editing practices, and namely the reduction of saturation, had their cumulative effect. A prospective client could engage the endless scroll of tattoos and find miles of work done on very light-looking skin. The person could settle on the idea that white people, and especially pale white people, are the only ones who get tattoos. They may also conclude that pale white people are the only ones who *can* get tattoos.

It was just another channel through which my privilege as a white tattoo client was realized. I could scroll through any tattooer's portfolio assured my skin's tone would be heavily, if not overly, represented. This amounted to a problem that should be solved; at least, it was that way for me, those around me, and observant outsiders.

Ink the Diaspora was among many forces organizing against the prolific use of these editing techniques—of such a wide-ranging production of pale-skin representation. They launched a campaign against the photo-editing work of an elite New York shop called "Bang Bang."

The shop had posted a highly desaturated photo of a tattoo on its Instagram page. The post contained a few images, the first was desaturated, and the second wasn't. The second revealed the tattoo client's skin to be a richly dark tone. It was a bit surprising, given the first image, which made it seem like the tattoo was done on a white person.

Ink the Diaspora reposted the image and wrote: "When your shop culture is based on colorism and white supremacy @bangbangnyc." Bang Bang

responded with a description of the desaturation technique: "On lighter skin it reduces the visual redness and irritation. On darker skin it serves the same purpose as well as adding contrast to show the skill of the work." They added, "Dark skin is hard to photograph and even harder when there's blood and ink on a fresh tattoo. This makes glare a near impossible obstacle. We use special polarized lenses that filter this light and help add to the presentation of our work :)."

Their response troubled those who were organizing against colorism in tattooing. This was because, in part, colorism and race remained outside of the discussion. Addressing skin tone without acknowledging the fact that such an address involves race seemed like a cop-out.

I followed this campaign while experiencing a tinge of regret, as I'd heavily edited images while in charge of Premium's Instagram account during my first months in the shop. Matt reproached me for doing this, and I stopped. "Don't do that," he said. "You can't desaturate them that hard." He told me, "Look at that skin! Are we tattooing *corpses* here?" Matt, a hard-headed man when it came to technology, and one who often resisted overt attention to marketing, was rather up to speed here. He told me, "It looks like all we do is tattoo white people in here."

Tattooers I met wrestled with the fact that skin is a physical *and* cultural thing. We tried to deal with it and its tone from a place of technical curiosity, while not overlooking its profound social significance. We had to notice it, talk about it, and eventually approach it from a place of mastery. Doing all of this could animate the interpersonal exchange with clients. It helped produce the intimacy and trust of good tattooing. It also helped organize the risks and rewards of our work, connecting our lives to the lives of others while establishing our role in the intersection of people, bodies, and money.

The fact that tattooers work intimately with skin makes them likely to engage with, or at least talk about, race as it relates to their work. And while some tattooers might be flat-out racists, I came to believe that the missteps many of them made while discussing race had their source in a failure to properly navigate the tension between skin's physical and cultural life—that intractable tether connecting the *thing* that is skin to its profound social history.

Now, while the complexity of skin could reveal some of the risks and rewards of tattooing, nothing could show you what was on the line better than

the horrifying tremors that came from making a mistake, from messing up someone's tattoo. Blowing it, and permanently, on the body of another person could fill you with dread. And it was *way* too easy to do. In fact, far easier than getting it right.

Tattooers keep up the glamour in the shop and work to ensure a sense of ease among their clients for many reasons. They do this to produce good experiences and to make sure they do good tattoos. But like everything else they do, tattooers try to fulfill the emotional, carnal, and skin-related demands of their work because they know—they fear—the whole thing might collapse at any moment.

All it took was a slip of an elbow, a quick spasm of the wrist, or a small failure of equipment—the anticipation of it crumbling, of what it could do to your client and what it could do to you. Working with the knowledge that it could all go wrong was like knowing your thatched raft could tip and send you and your client scrambling within the frigid waters of an unknown river. It kept me up at night. When it finally happened, when everything actually fell apart, it took my breath away.

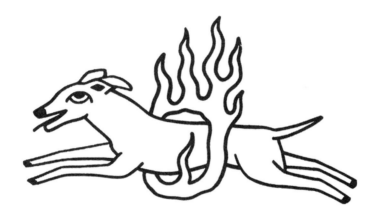

Mispld and Other Mistakes

You can't throw your bad tattoos away. This fact was always there, but the act of tattooing could bring it to the surface, as could the terrible experience of making mistakes. It could also rear its head in conversation.

One such conversation involved Matt, me, and a guy who had become a friend of the shop. The guy had done some work-trade with Matt, crafting some black aprons from leather and canvas in exchange for a tattoo. The aprons were rather masculine pieces. They were made by a rather masculine dude. He wasn't quite a baseball fan, but he was close.

He would stop by, for instance, when he didn't have an appointment. I got the sense that he dug on the scene, but he was also building a business aimed at selling handcrafted goods to tattooers, bartenders, barbers, and whoever else may want to buy his stuff. We all sat talking one afternoon while Matt tattooed an eagle across the guy's outer left forearm:

"You know," the guy said, "sometimes I work really hard on a wallet or apron only to toss it into the scrap pile . . ."

Matt responded, "Yeah, I get that for sure."

"Working with my hands," the guy continued, "it's like what you guys do . . ."

Matt shot me a quick smile, "Yeah, but the thing is, man, we don't get a scrap pile."

I smiled back at Matt, appreciating what his look meant. There was a canyon separating the experience of making aprons and doing tattoos—between doing work that *gets* a scrap pile and that which doesn't.

Putting a tattoo on someone, changing their body immediately and permanently with every mark of your hand, just isn't like making other things. That person might be sweating and breathing on you, squirming around while you wipe blood from their skin and while you work to calm their nerves through conversation.

Of course, there's a little snobbery in this. It's a bit rude to charge out at someone and tell them they don't face the fire as hard as you do. It's also a bit romantic. Tattooing doesn't always feel so immediately profound. But there's some insight here that's worth exploring—a bit of information that helps explain what the people who navigate people, bodies, and money often feel, think, and do.

There is no scrap pile, and as much as *you should be scared* because tattoos are permanent, you should really be scared because you can fuck up. You work within the gnawing potential of blowing it every time you do it.

This possibility, dear reader, is the ultimate organizer of tattoo labor. Tattooers do everything they do and experience everything they experience under the unnerving shadow of this dreadful fact. It conditioned everything I loved and hated about the whole thing.

The fact that you could make a mistake was all too easy to worry about. I fretted over it while doing tattoos and while doing just about anything else. There I'd be at a birthday party, let's say, sitting at some table while living deep in my own mind. It was too easy to imagine my hand slipping across a person's shoulder with the machine blasting a line down the arm where none was planned.

A person could simply bump into your elbow while you worked, perhaps someone scooting by your booth in the small shop. Or you could just slip because, after all, there was almost always a slick layer of some fluid between your gloved hand and the person's body. I met someone who did just that— slipped and ran a line across someone's forearm.

It was also easy to imagine touching surfaces in the wrong order while giving someone a tattoo and thus exposing them to serious infection. While this never happened to me, I pictured the client showing up with a swollen arm asking for help. Another serious mistake, although not resulting in an infection, could be that you dip the tattoo machine into the wrong ink-cap, filling a spot that should have been yellow, blue, or red with a deep and permanent black. I actually did that a few times but was able to conceal it.

I also thought about how it would feel to give someone a terrible experience by losing sight of my own patience, exposing the glamour to be what I often feared it might have been all along: a sham. At this point of my vision, the whole intersection of people, bodies, and money would come falling down and right on my head. The river would be wild with rapids and under-

currents. Or maybe it wouldn't flow at all. That great ball of snakes would appear, demanding I try my best to keep them from multiplying, spilling over, and flooding the whole shop.

My worries were occasionally all-too-close to my actual, lived experience. These moments were as awful as they were instructive because, more than anything else, messing up could reveal what might be gained or lost— what was actually on the line and what was ultimately demanded by the work of tattooing.

Blowing It by Blowing Lines

A young woman arrived at Premium one sunny day around noon. She had an appointment with me, something we set up over Instagram a few weeks before. She'd asked me to tattoo a weeping willow on her body. I had designed the piece some months earlier, and it caught her eye.

She learned about my work while chancing on a flyer I had put on a public light post near a café in the neighborhood of West Oakland. The idea of putting flyers around town came to me while I was sitting at Premium one day without much to do. It wasn't an altogether fresh idea, as I and so many others had done such a thing before while promoting uninspiring punk rock bands—mine in Bakersfield as a high school student. The flyers actually brought me a few clients.

The design was composed of simple lines in a folk-art style. Although I always intended to tattoo it in black, my client requested it be done in a dark green. She asked me to place it where the arm and torso meet, facing forward on the body. You could say we put it over her anterior deltoid. She was very thin. The thin layers of skin stretched across tendon and bone.

I had never worked on that area of the body, and I'd never done a tattoo in that color. I also hadn't spent much time with the smaller needle group used for the job—a cluster of three points rather than the seven, nine, and fourteen I had grown more accustomed to. Matt would've told me to be careful about that area of the body and to be especially watchful over the depth and speed of my machine, given the smaller needle group.

I moved into the project without telling Matt anything about it, mainly because I had tattooed dozens of people by this point. In fact, I approached this piece with an embarrassingly high degree of confidence. It was more

than a year before I gained the skill needed to do the bumblebee on a uni-
cycle, described earlier, but I nevertheless approached this weeping willow
as a quick job.

By this time, I had learned how to touch with confidence and other-
wise do the whole work of tattooing with enough success—at least, that is,
a dozen times—to convince myself that I had it about knocked. My self-
aggrandizing was hard at work here, offering me enough self-assurance to
obscure just how freaked out I usually became in the face of tattooing.

This bout of naive confidence was bolstered by a quick affinity gained
with the client. She was a punk rocker who had just bought an old SWAT van
with the intention of turning it into her home. We hit it off, talking about
politics, music, and the homemade tattoos across her arms and hands. We
built the quick trust that's so key to good tattooing. I didn't fret so much
about the piece, given my less-than-humble assessment of personal skill
and given her wide collection of dodgy tattoos. It was clear we'd work well
together.

And then it happened. I went through half of the design without wiping
away the excess ink, blood, and plasma that always collects on the surface of
skin while you tattoo it. There I was cruising, not especially worried and, as
such, not checking in on each mark as it was made. You might guess what
was actually going down here: I wiped away that ink, blood, and plasma to
see I had been fucking up the whole time.

In this case, I had "blown" almost every single line (see fig. 8). You *blow
a line* when you go too deep with the tattoo machine. You are pumping ink
down into the subcutaneous fat of the hypodermis instead of keeping it
contained in the layer just above, the dermis. This means the ink spreads
through the fat underneath the layer you want to be hitting—that upper
stratum wherein those beautiful, "crispy," and "clean" tattoo marks can be
held. The ink "blows out" down below, spreading beyond what should be
the outer edge of the tattoo. A blown-out tattoo has a fuzzy shadow, or halo,
around it. It's never a good look.

The "tattoo blow-out," explains Dr. Nicolas Kluger in his 2014 article for
the *International Journal of Dermatology*, is "likely an underestimated acute
complication of tattooing."[1] It's an amateur mistake, one that remains easier
to make in areas of the body where the layers of skin are closer together—
often places where veins and bones seem easier to see or touch.

FIGURE 8. *The "blow-out" is among numerous potential errors in tattooing. The presence of a fuzzy, cloud-like effect occurs when the tattooer goes too deep. You can see this error in the fuzzy shadow that appears on the left half of this tattoo.*

I went along jamming that thin needle in there without truly noticing my error because I didn't pause to wipe the surface and check. My own sense of false confidence was distracting. I allowed myself to go on autopilot way too early in my time doing tattoos.

Once I *did* wipe the area, I sat there looking at the mess I'd made. It quickly occurred to me that I had been the cause of a permanent, visible mistake on this person's body. I began to feel anxious and awful. I hated

tattooing. It was so damn hard and forever. It was dreadful, as well, to know that Matt would have to be consulted. The music in the shop that had been enjoyable became a nuisance. I wanted to stand up, remove my apron, and leave forever.

I kept my shit together, though. I took a deep breath and made sure I put on a display of confidence so as not to worry the client. I remembered the lessons I got from Matt and the overall scene: stay cool, ground yourself in the body, and make sure the client is having a good time. I made careful marks with the tattoo machine and tried to make jokes to ease what I feared was likely an obvious shift in the mood. I finished the piece and experienced a great sense of disappointment, both in the work and in myself.

My client stood up from the chair and asked if she could use the bathroom. She glanced into a mirror as she walked away from the booth. Now, there was a little relief there. Her quick movement offered a brief delay to the inevitable realization and its associated conversation. I stood, feeling like an anxious bag of garbage and removed my gloves. I took the apron off, washed my hands, and detailed the situation to Matt.

We were still near the tattoo booth, but with the client in the bathroom we were effectively backstage. We devised a quick plan. I stood there feeling like an unfortunate character in the movie that was my strange life, watching the seconds tick by. I held a brick in my stomach waiting to put our plan into action, feeling grateful for Matt and our productive teamwork.

My client left the bathroom and walked toward the booth. Matt and I watched her look at the tattoo in a mirror. Once she arrived, Matt chimed in with a calm, self-assured expression and tone. He said, "There are some lines in here that we call 'blown.' They're a little shadowy over there do you see?" He pointed with his finger toward the blown lines, sure to not touch the new tattoo. She nodded in recognition, and to my surprise, she didn't seem at all discouraged. He said, "If that gets worse, or even if it stays the same, just come on back. I can fix this for free, okay?"

With a quick nod and smile, she said, "No worries!" She didn't seem bothered by the gravity of what had just gone down—the fact that I'd made a serious mistake. Or maybe she just didn't care.

She also didn't seem to notice that a hairline crack had formed on the surface of our glamour effect. Matt's stepping-in revealed that he was the

one who *really* knew what he was doing. Out of necessity, we had exposed the distinction between our front and backstage lives. We owed her that much, and, of course, I felt I owed her more.

I wondered if her nonchalant response was an effect of her having been hit with endorphins during the tattoo process. She actually seemed excited about the piece, and I thought something might be off. Now, she *did* have a bunch of poorly done tattoos. She had given some of these to herself. Those pieces were also blown out, and some of them worse than this new one. She may have approached her body as readied for tattoos—and ones that weren't so good.

I was sure her response would have been different, and perhaps more difficult for everyone, had this willow been her first piece. As another tattooer said one afternoon, "Those first pieces, especially if they're like front and center and super important to the person, you really can't fuck those up." They added, "I mean, you can't fuck up anything, really (laughter), but a mistake in those new and nervous clients is the worst."

My seasoned client left with a smile and a hug. She paid for the piece, too, while leaving a tip. I tried to give the money back, on account of feeling like I didn't deserve it, but she refused. I repeated something like, "Stay in touch, let me know how this heals" and "Stay in touch okay?" She walked out into the day, and I stood there knowing that something important had just happened.

I went to our back patio and sat on a near-broken little stepladder in the sun. Clear from any expectation of performance, I buried my head in my hands and made guttural noises. Some terrible sounds returned to me as echoes from a retaining wall, apparently the ones I was making. I felt awful, and it wouldn't be the last time tattooing made me feel that way. In fact, there was a similar mistake months later after I tattooed more than a hundred people without a hitch.

Matt slipped past the aluminum screen door. Hard on himself, he told me, "I should've been right there my dude. I was busy, and you didn't ask anything. I thought you had it handled." He invited me to join him down at the bar, and I accepted. We knew the experience deserved some good attention. It was the first time I had disturbed the flow of things enough to rupture the shop's momentum. While we didn't speak in these terms—they

weren't at all on my mind at this point—Matt knew I'd been overpowered by the complexity of the intersection we tried to manage as tattooers.

He told me I was generally "doing pretty damn good." He drank down some vodka with soda, and I mostly stared straight ahead, nursing soda and bitters and wishing I was somewhere else. He said his first tattoos were "horrible," in part because he went "far beyond his scope," transcending the boundaries of his tattoo skill as they were arranged at the time.

Matt found his scope by fumbling through early mistakes back in the 1990s. "I took on *huge* pieces, man, like full arms," he said. This was before his apprenticeship and before he really knew how to use the coil tattoo machine. A few tattooers relayed similar stories, with one shaking his head while describing the huge projects he attempted back when he "had no fucking clue" what he was doing. I was lucky to have mostly avoided this kind of thing.

But I was in that bar wishing I had never picked up a tattoo machine in the first place. It wasn't until later that Matt brought some heat. He lectured me in harsh tones for about an hour, "Don't you *ever* do something new without consulting me," and "Do we need to have you step back a little?" He had his fill about halfway through the lecture and only seemed to carry on for the sake of momentum. Matt loved the pace of energetic language, especially as powered by booze. He finished with kind words, though, as he always did: "I'm sorry bud, it happens" and "Let's get you back on that horse, man; you can absolutely do this."

I reached out to this weeping willow client every couple of weeks, having had devised a plan with Matt to improve the piece. Of course, I wanted to fix it. I sent her messages describing that myself or Matt would do it for free and any time. She wrote back, "That's so nice," and, "Totally! I'll get back to you for sure. Thanks!" She didn't follow through. I never got to fix it and would grumble about this to Matt. "Sometimes," he told me, "you just don't get that redemption." He added with a sign, "Gotta move on, my dude; learn from the mistakes and just let it go. It's a risk we deal with."

The language of "redemption" fit the scene, especially as tattooers often spoke in terms of *tattoo gods*. The tattoo gods are a stand-in for a karma-like system. They conjure a metaphysical force of luck, fortune, or some version of fate. You can be struck down by the tattoo gods, for instance, if you were like me and blew it on a piece you thought you'd nail.

The willow tattoo continues to haunt me. There's this additional sense that is difficult to shake—the fear that I employed some kind of deception. This only means I feel what nearly *every* tattooer I've met has felt at some point: that I presented myself as more skilled than I was and got caught.

A guy who had been tattooing for thirteen years told me, "All tattoos have mistakes." He added, "It's about learning to make sure those mistakes can't be seen." And concealing mistakes is indeed a skill, something seasoned tattooers can do on the fly and without skipping a beat. If you have a tattoo that you've always thought was perfect, it's likely that a veteran tattooer could look at it and notice where the person who put it on you corrected for some misstep.

Most mistakes in tattooing are so trivial that they go unnoticed by clients. This is in part because many clients don't approach their tattoos with the discernment required to notice small errors and their corrections. Matt trained me to fix and otherwise obscure mistakes. He also tried to convince me that I'd never, ever do a perfect tattoo. He would look at me with a sense of sarcasm while I beat myself up over a minor misstep and say, "Oh, you're human after all?"

But sometimes mistakes are big enough to escape disguise. Tattooers go too deep and cause blow-outs like I did. They also make errors in design, tattooing tales on animals that aren't supposed to have tails, for instance. I met a guy who did just that—tattoo an accidental tail—and he said he was able to convince the client that the piece was cooler with the tail. "I got *super* lucky on that one," he said while laughing.

But when it comes to the technical side of tattooing, there's one mistake that tops them all. I got to watch Pauly make it.

This particular miscalculation sends enough tattooers down a path of such disappointment and ill-feeling that you wonder how anyone is tattooing at all. How, given the fact of this possibility, are there so many tattoo shops in your town? The fact that this most dreaded mistake was available to me caused an actual case of lasting nausea. I was sure I'd never crawl out of the pit that would swallow me whole if I did the worst, most awfully embarrassing and absolutely regretful thing you could to as a tattooer: misspell a word.

Mispld

It happened at night. I picked up the shop's ringing phone to hear laughter and the sound of a young woman's voice over loud music in a moving car. She asked for a tattoo and acknowledged we were speaking just minutes before closing time. She wanted to have the word "Pendeja" tattooed inside her bottom lip to commemorate her grandma, who had used the word as an affectionate nickname. It means "asshole" in Spanish.

I'd never done a tattoo inside the lip, and I didn't want to try that night. Matt expressed disdain at the opportunity, as he hated doing tattoos within the inner lip. "Their drool and spit can get all over the place; it's a fucking mess." He shivered and told us, "I've been tattooing too damn long to keep doing those, especially at the end of a long day and in *my* shop loaded with tattooers."

Matt nominated Pauly, who took on the project with enthusiasm. Pauly was stoked for a fun piece and a little cash. He also liked to jump into things that could please Matt.

Pauly had either never done an inner-lip tattoo or had remained quite unfamiliar with its requirements. Matt walked him through the motions, demonstrating what to do with the lip and client.

He told Pauly to avoid using a stencil when tattooing inside someone's mouth. It would quickly disappear if you got it on there at all. He explained, "You've got to dry it out so that the marker you'll use to write the word stays visible on that wet and slippery surface." He added, "We're talking the inside of a mouth, man." Matt told him to make each mark deep into the lip to ensure the tattoo wouldn't peek out on the lip's surface when the mouth was closed.

The client and her friend crashed into the shop with positive spirit. We were swept into their enthusiasm. What had been a scene of deliberative planning became a near-party atmosphere. The glamour was in full swing, although it spoke the language of *party* more than anything else. We turned up the music as the client sat in the chair. Her friend was filming and chatting us up. Pauly was into it, trying to balance his excitement for social engagement with a necessity for quiet planning. We loved creating scenes like these for our clients, but we always had to concentrate on our work, too.

Now, Pauly is a native Spanish speaker. So, it's not as though he didn't understand the word or didn't know how to spell it. Nevertheless, he wrote it on a piece of paper so that we could check its spelling. Matt taught us to do this with any word we'd ever tattoo. We showed it to the client, too. Some shops make clients sign off on the spelling of a word during the waiver process. We were more casual. We joked and passed around the paper on which *Pendeja* was spelled correctly. With the word checked-out, Pauly set into the piece.

He drew on her lip with care. It was clear to me, though, that he was swept up in the moment. Like a bartender who switches sides and begins partying instead of working, Pauly slipped beyond the level of intentional control and over to the more enthusiastic scene. He became a subject, or even audience member, of our glamour effect.

He took her bottom lip into his hand by sliding the left pointer finger along her chin, running it parallel to the bottom lip. He used the tip of his left thumb to wrap her lip over that pointer finger. He anchored his right elbow against his torso, as he was standing, and he took a deep breath before diving in. He tattooed fast. We stood around having a good time. The client was wincing and had tears welling up. Pauly was done in a few minutes.

The client stood and looked into the mirror before giving Pauly a high five. She, her friend, and Pauly were stoked. Matt, however, shot me a wide-eyed glance as his face went pale. He slipped out the front door and toward the bar in what seemed to be a fight-or-flight moment. Maybe he knew his ongoing presence would wreck the scene.

I took pictures of the tattoo and the clients. They posed together and with Pauly while making funny faces. I'm pretty sure they all said "Pendeja!" like you might say "Cheese!" in a group photo, but I don't have that detail in my notes. We all stood around saying goodbye and thank you as the clients walked out of the shop and into the night.

Then we looked at the pictures. I pulled them up on my phone before passing it around. Although filled with loud music, the room grew silent. It was easy to recall Matt's face turning pale. I rewatched his escape in my mind, remembering his decision to remove himself and his unmanageable face from the scene.

Pauly, it turns out, did the very worst thing. He spelled it wrong.

There are many ways to misspell anything. In this case, Pauly forgot to put the *e* between the *d* and the *j*. This means he tattooed the nonword *Pendja* on the inside of his client's lip rather than *Pendeja*. Someone said it out loud: *pen-jah*. The realization came to us in waves. It hit Pauly in a way that proved hard to witness.

He began by laughing. Then he paced about with a huge smile on his face and looked around with wide eyes. He took off his hat and began running fingers through his thick, dark hair. I watched as his smile turned into a discernible expression of tension and near-terror. He stopped pacing and stood, looking down in silence. Someone turned the music down. I heard Pauly whisper—and then nearly shout—in a form of rapid repeat: "Holy SHIIIIT."

I looked at my phone if only to avert my gaze, noticing a series of text messages from Matt, who was, by this time, sitting down at the bar. I opened the series to read, "Did he misspell it!" "Please fucking tell me he didn't misspell it!" "My dude, you there?" I looked up to see Pauly swinging the front door wide open on his way to the bar—on his way to Matt and their fountain of vodka and soda. Pauly was in for it, both from Matt and from himself.

Then the shop's phone rang. I recognized the client's number on the caller ID. After a brief pause, I picked it up and encountered a familiar scene: Laughter and talking over music in a moving car.

"So . . . I was *just* in there getting a tattoo . . ." I searched for any indication of her state, attending to the tone of voice, the speed of the language, and whether or not it sounded like she was smiling. She laughed. ". . . I think we misspelled it." The "we" part was good news, as was the music and laughter. She'd sent photos of the piece to a few friends and a family member, one of whom promptly told her what she hadn't noticed, that it was misspelled.

"I guess that's what a *pendeja* deserves," she said while laughing. It was as though the misspelling was a cosmic "fuck you" from her feisty grandma. I told her to come back to the shop, and I nearly ran to the bar after hanging up.

I found Pauly and Matt drawing on a crumpled scrap of paper with a dull pencil. They sat pouring over a plan to "fix" it, hoisting their effort toward an attempt to force an *e* between the *d* and the *j*. It wasn't looking good. It looked rather desperate, actually.

Matt hardly roused on hearing my description of the phone call. I had done so with enthusiasm, amazed the client wasn't furious. Matt looked

older than his years, shaking his head in that tired bar. He coached Pauly before telling me, "I fucking knew he misspelled it man, fucking awful." Matt was dealt a blow because it went down in his shop and because he had been Pauly's mentor. "He should fucking know better, man." The injury was double, and the stakes of *his* life in tattooing—those of the shop owner and mentor—stood bare.

I left Matt and walked back to the shop. The client and her friend came in smiling. She joked with Pauly, and I watched as he apologized profusely. He showed no sign of the great amount of booze I was sure he'd just had during the twenty minutes since he realized his mistake. He worked up a presentation of composure and dignity. She expressed appreciation for the fun experience and left with a hug, promising to return so they could try and fix the piece after it healed. She told Pauly, "Mistakes happen."

The fact that this client had a great time during the tattoo process *mattered*. If people experience their tattoos partly on the basis of their memories getting them—as they say they do—then we might assume the positive experience through which Pauly's client got that bad tattoo helped her secure some appreciation for it.

The glamour of our shop did its job, and it was clear that Pauly (and all of us) had succeeded in the *people* side of things that night. The intersection of people, bodies, and money hadn't collapsed entirely—turned into a reeling and uncontrollable ball of snakes. Pauly might have misjudged his place in the management of that intersection, but it wasn't a full-on disaster.

To be sure, though, Pauly was wrecked. Maybe he had been caught up in the atmosphere, or maybe he was distracted by the bodily requirements of the job—the drool involved. Either way, it seemed a sign that he was, maybe and after all, not cut out for the job. It dug at his self-worth. He went on a bender.

He actually had Matt tattoo *mispld* within his lower lip. This act, he told me, was done "to appease the tattoo gods and to learn (his) fucking lesson." I have photos and videos of the mispld tattoo. They invoke a similar degree of ritual significance as those of my first tattoo, the wobbly triangle on Matt's thigh. Both were granted a sacred quality, even if Matt wasn't so hot on the *mispld* idea. He knew it was important to Pauly though, so he did it.

Pauly didn't quit tattooing. He regained confidence after doing a few solid pieces. I even offered my body to this process, asking him to tattoo me

the next day. He didn't take it, though, and instead reemerged through work with paying clients, from within the real stakes of the game. His tattoos were better than ever.

Pauly was actually able to fix *pendja*, as the inner lip has a tendency to kick out tattoo ink. He grew close with the client along the way. They eventually posed together for a photo of their lips out: Pauly's *mispld* next to her *pendeja*. I took that picture. They couldn't smile, but you could see some joy in their eyes. They had traveled together from front- to backstage and back again. I'm sure that if they ran into each other in public, they would hug.

Pauly became our inner-lip guy. We would look to him when a client came through the door requesting the job. He'd do it, no questions asked. That was great, because I didn't want to do those tattoos, but the fact that I could and would make such a mistake made me want to bail. It also made me want to shout a message of caution to wannabe tattooers: Yes, it's fun but tread carefully. Actually, run away and just do something else.

You Might Be a Piece of Shit, After All

Blowing lines on that weeping willow made me question my ability and integrity. Specifically, it dealt a blow to what we may call my *conscience*. It encouraged self-doubt, enough to make me work toward regaining a positive vision of myself as a tattooer.

While the conscience is usually relegated to a person's inner experience, those who have studied such things have long illustrated a profound connection between our inner and outer lives. Here are a few examples.

Philosopher William James suggests there to be several "constituents of the self," among them a "social self" through which people come to understand their experiences in light of their social lives. Sociologist W. E. B. Du Bois argues that people view themselves through the eyes of others, and George Herbert Mead explains people gauge their self-understanding by consulting a "generalized other," or the "social attitudes of the given social group or community."[2]

If we have a conscience, it arises out of a process of social consultation. We evaluate who we are by drawing on the presumptions we acquire from the people around us. That our conscience arises from social interaction illustrates, among other things, why botching a tattoo *feels* terrible. Making

such a profound mistake can add fuel to the self-conscious suspicion that you might be a piece of shit, after all.

The tattooers I met argued that making a mistake *should* make you examine yourself. The person who remains unfazed by mistakes has, in the eyes of other tattooers, an objectionable relationship with their clients, with tattooing, and perhaps with themselves.

I interviewed a guy over the phone who told me about an old-school tattooer in his shop who never seemed bothered by the mistakes he too-often made. The guy did tattoos with enormous errors and didn't seem to care. The tattooer I had on the phone told me this old-school guy should quit "if he no longer cares about fucking people up."

Just like *being scared*, the social display of a harmed conscience does something important. An outward expression of shame, regret, or anger toward oneself at having made a mistake offers a kind of public affirmation. It signals an appreciation for the conditions of tattoo production—its intimate nature and its bodily permanence. It tells people that you understand the stakes.

I sat on that near-broken little stepladder behind Premium after blowing those lines because I knew I'd fucked up. It seemed that Matt found some comfort in my reaction. It offered evidence that I understood the gravity of our position. Tattooers have it as their job to manage and otherwise keep everything afloat. They fail when they let something slip.

People who do tattoos try to make sure that a substantial mistake in one area of the people-bodies-money intersection doesn't bring the whole thing down. The ability to make a mistake in one area and save the rest will depend on the client, of course, and on the overall scene. Tattooers get help from the work of people around them and from their environments. But there's always a chance that the backup won't arrive in time and that even if it does, it won't be enough.

Matt and other seasoned tattooers could quickly recall projects that went bad. The botched jobs stuck with them for decades. We can take this and learn something from it: for one thing, it suggests these tattooers care about what they do. Sure, they want to avoid mistakes because they want to save themselves, but they also seek to do good things for people. They are motivated to be a positive force in the lives of their clients.

But as much as they or any tattooer may want to do good for people, there

is always an opportunity, and sometimes a necessity, to do tattoos you don't want to do. You want to avoid them, not because you feel lazy or hungover but because you don't believe in the work. It's the case that people come to you with all sorts of bad ideas. Maybe it's the design, the size, the color palate, the placement, or something else that can be radically improved, and the client just isn't hearing it.

You often do the work anyway. It's your job, after all, your source of income. But I and the tattooers I met occasionally refused to do some tattoos, taking an ethical stand in our work with people and their bodies.

We can start wrapping this thing up, the story, by looking to one of the features that keeps the intersection held together, because as rock-and-roll as tattooing can seem, and as commercial as it always will be, tattooing is chock-full of moral concerns. I mean, would you tattoo a pile of dogshit on someone's face?

How Much for a Face Tattoo?

"How much for a face tattoo?" I looked up from my drawing to see someone smiling. He seemed to recognize that the request would conjure curiosity, if not skepticism. He was young; I guessed he was under eighteen. The request added character to an otherwise uneventful spring afternoon at the shop.

"Wait," I said smiling. "Did you just walk in here asking for a face tattoo?" We laughed and hit it off.

"I want 'Heartbreak' here," he said while pointing above his left eyebrow. I quipped, "So who's the heartbreaker? Also, how old are you anyway?"

"I'm eighteen," he said. "I'm an adult."

We went on like this for a while before I told him, "No way dude. I'll do it somewhere else but not on your face." I didn't do the piece. Granted, it was a word and not a pile of dogshit, but still.

His asking for the face tattoo added some energy to the day. It also helped me understand the power of *placement*. A tattoo of the word *Heartbreak* wouldn't cause a stir if it had gone on the arm or leg. I would've tattooed it without hesitation, partly because it would be less likely to change his life all that much. But on the *face*?

The most benign tattoo, content-wise, could amount to an explosive gesture if put on the face. It could also make you, the tattooer, wonder about your role in the lives of other people. It could make you feel you weren't doing right by them—that you were out there ruining lives. While there are risks and rewards of tattooing generally, each project involves its own stakes.

Those of a face tattoo are high for a few reasons. For one, the piece is incredibly visible. Almost anyone that encounters the person will interact with that tattoo. It can also change a person, as those who deal with facial transplant surgeries make clear, because a person's face offers a steady source of identity construction.[1] Changing the face can change more than just the

face; it can animate a substantial break between someone's past and their future. You, the tattooer, would be aiding and abetting that break—though less abetting and more aiding, given you probably didn't incite the idea.

But what about the money? Tattooers often avoid doing face tattoos, and this decision highlights the fact that they occasionally act against their own financial interests. The commercial character of tattoo labor, that money part of the intersection, doesn't always call the shots. It's balanced out by the other features, ones I suggest as involving people and bodies.

Because it involves people, and especially because the act results in a permanent change to their body, tattooing is full of ethics. Making this point requires a bit of corrective effort. I have explained all sorts of things that tattooers must do if they are to find success in their work. So far, I've left this explanation lying around as a one-dimensional character in the story.

To be sure, there's a "business case" involved with everything tattooers do. They need to establish an inviting scene and otherwise attend to the interpersonal quality of client interaction. They need to remain steady when clients nitpick their designs, express a distracting level of nervousness, or simply become annoying during the tattoo exchange. Tattooers need to touch right, and they need to figure out how to notice and respond to skin tone. They need to do all of this and more to build clientele, maintain a solid reputation, and ultimately earn a living. It's demanding work and almost exclusively done for pay.

But to assume that tattooers think, feel, and act in a way that always maximizes profit is to ignore the role of culture in their work. The assumption applies a reductionist explanation of human behavior generally, condensing the complex quality of people into automaton-like extensions of an overbearing, mechanical type of social structure. It's offensive, sure, because it assumes people are like robots, but it's also just not true.

The idea that people are economic maximizers doesn't survive scrutiny when it comes to tattooing, and its death wouldn't surprise a student of economic sociology. As Viviana Zelizer reminds us, money doesn't rid social relations of their more intimate, personal qualities. It organizes our interpersonal lives and even strengthens their seemingly less-economic features.[2]

Indeed, the theory of a truly economic human doesn't hold up even when it's levied against the most money-seeking professionals you can think of. Research among investment bankers, traders on the stock exchange floor,

and people who deal in life insurance supports this fact: culture shapes what people do for money and in every outpost of occupational life.[3]

If it exists at all, the ideal economic actor is *very* hard to find. Like Bigfoot, it probably lurks in the minds of wishful people more so than it ever winds its way toward financial advisers, personal finance applications, and home-grown spreadsheets. It's even got a kind of cult-name, *homo economicus,* and its potential attendance among everyday *homo sapiens* has inspired more than a century of debate among people we now call economists, sociologists, and political scientists.

All this to say, while tattooers can do right by their wallets when maximizing profit, the ones I met tried to earn a living while also doing right by *people.* They set out to foster a sense of respect and care with their clients. While it's hard work, the ability to make money *and* care for people usually lines up in tattooing, with one stream simply flowing into the other and at a similar rate. That steady flow allows for smooth navigation of the tattoo experience, one that is simultaneously intimate and profitable. Money, that is, doesn't wedge its way between the people involved—it brings them together.

The price of the work and its payment, for instance, help the people immersed in this exchange acknowledge the fact that there was time and skill involved. A client's payment tells the tattooer that their ability is worth something. It's so damn good, in fact, that it can be exchanged for a place to live, a series of hot meals, and if they're so inclined, a lot of beer. Rather than threaten the more personal aspects of the exchange, the client's payment strengthens the intimacy, as does the tip.

The flow of respect and care travels from the client to the tattooer but also from the tattooer to the client. Tattooers can offer respect and care when they give someone a tattoo, attending to the process and the piece itself appropriately, but they can also offer respect and care by refusing to fulfill the more ill-conceived requests.

After all, who wants to wake up one morning to find they had gotten a face tattoo while on a bender—to discover that some tattooer agreed to fulfill their clearly intoxicated and quite-obviously bad idea? The tattooers I met didn't want to wake up wondering if their clients were having these kinds of experiences.

These tattooers sometimes called hand, finger, neck, and face tattoos *job stoppers,* even as this phase and its related significance seemed a bit out of

touch among younger tattooers.[4] Rather than make it so that someone has extra trouble finding a job, the tattooers I met said they loved to help people. They knew tattooing could be important work. It could, as one tattooer put it to me, "help people become who they want to be."

Luckily, there are plenty of opportunities to help people in the role of tattooer—guiding them through a hard time, helping them find love for their bodies, or simply offering them a fun afternoon. There's also a chance to help people "cover up" tattoos they already have. We all did cover-ups for clients who needed to have some tattoo changed, although Matt was most skilled in this difficult work.

Matt, for instance, helped a guy who walked into the shop one day with a rather new tattoo. It was a dagger done in black with gray shading, and it was placed on his inner left forearm. The tattoo was put there the night before by the guy's friend, someone making their bones from a kitchen table, doing the prerequisite bad tattoos. Maybe they'd eventually do better ones and even join a shop. Maybe not, though, and of course that might be better in the long run. There are many things a person can do for money that are more predictable and altogether easier than tattooing.

Technique-wise, the tattoo actually wasn't so bad. The lines mostly stayed their course, wobbling here and there as one may expect from a new tattooer, while the shading offered a somewhat-convincing sense of depth and texture. The biggest problem was in the design. The blade itself was in pretty good shape and it looked aright where the dagger's handle met the blade. It was the handle and its phallic endpoint that contained the issue: It *really* looked like a penis.

I was standing with Matt near the shop's waiting area when the guy detailed the situation. Matt and I both knew what he wanted before he asked because we had seen the thing on his arm. We saw the problem (the penis) immediately because the design bore a rather stark resemblance to the penis shape. We also noticed it quickly because we faced the same challenge many times. You might be surprised by how easy it is to make a dagger's handle look like a penis, and it's not often that a person asking for a dagger wants something that looks like a penis tattooed on their body.

While I'm not sure about Matt, I definitely sympathized with the person who put it there. They and all tattooers have to learn how to look out for a penis in their designs. The same is true for other unwanted shapes that can

occasionally sneak their way into a tattoo by accident. Anything that bore even the smallest resemblance to a swastika, for instance, no matter how buried in the design and no matter how accidental its cause, had to go. Same thing with a penis.

The guy talked in a small voice, but we worked to set him at ease. There was no shame to be had here. There was simply a penis where there shouldn't have been one. It was like going to the hospital with an "embarrassing" condition only to find that the nurses don't seem to care at all. They want to know how they can fix you up, when they can do it, and whether or not you have insurance.

Given that we were in a tattoo shop, though, we laughed a bit. There was even a little pride, or something like respect, in the air. Matt and I liked this guy for having gotten the piece while sitting at some kitchen table. I also appreciated the fact that he had the good sense to seek an expert to try and fix the thing. We told him as much.

Matt set up an appointment for a few weeks later only because he wanted the tattoo to heal-up before touching it over. Another tattooer might not have taken this precaution, instead jumping in right away to fix up the piece, but it was a smart move to wait. Who knew if that kitchen-table-tattoo would become infected in a couple of days? Who could trust it would heal well, knowing it was done by such an amateur? I got the sense Matt didn't want to have his handiwork swimming around in whatever had gone down the night before.

This also meant, of course, that the guy went about his daily life for weeks with a rather prominent penis tattoo on his arm. While I don't have it in my notes, I'm pretty sure Matt quipped that he could wear long-sleeves. He probably had a little smile on his face while he said it.

While the accidental-penis tattoo involved a lighthearted exchange, there were plenty of heavier moments through which we could help people as tattooers.

Matt often did memorial portraits for people seeking closure. He did a piece for a woman who had lost her adolescent kid to some disease. Matt cried on the back patio after finishing the job, hurting on account of being a dad and knowing something of the pain this client might have been in. He was also proud to have been a part of this person's healing process.

I once tattooed a trans person who said the piece helped them take

ownership over their body. They'd wanted to die, and for a long time, on account of feeling trapped inside of something that didn't feel right. It wasn't an easy experience, but it was a good one. Pauly did work like that described above, helping queer folks express their identities and ushering people through hard times. Regardless of the tattoo, he'd go out of his way to make people laugh. He thrived when they were having fun on account of his work.

We usually did good work, and we tried to avoid doing bad work, but wanting to avoid bad work didn't stop people from asking us for it. Walk-in clients of a street shop will ask for the most absurd things you can imagine. You, the tattooer, have to debate whether you'll fulfill their request. That is, you have to debate whether earning a buck is worth threatening a positive vision of your role in the lives of other people.

To be sure, some tattooers throw in the towel here. They assume the position of a service monkey who does anything people will pay them to do. I met a couple of tattooers who talked like this; but in its own way, the talk seemed like a tough-guy play. Maybe they actually didn't give a shit. Maybe they tattooed young people's faces all day for the money. I doubted it, though. Either way it was more sad than impressive, more dejected and tired than interesting and tuned-in.

To be sure, the line between good and bad tattooing is often hard to define. It can shift on you daily, responding to your mood and to an array of conditions related to the client, including their level of observable intox- ication and the number of tattoos they already have. And for anyone whose main source of income is tattooing, that line between good and bad work can bend in response to the status of their bank account.

Generally, though, the people I met seemed to know that doing tattoos they didn't believe in wouldn't pay off over time, even if it offered same-day cash. This is because there's an opportunity for tension to arise between the flow of money and the flow of ethical care. The two forces mostly build on one another, with clients paying for stuff that tattooers can rest easy about, but they occasionally clash. People want to avoid the clash, the rapids.

Figuring out how to anticipate, manage, and recover from such a thing is yet another demand of tattoo labor that extends beyond the technical task of tattooing and into the more interpersonal, cultural, and even ethical realm of social relations.

Two women called Premium one morning (at least I presumed they identified as women given the sound of their voices). We weren't open for business yet, but I answered the phone anyway because I had been standing near it when it rang. My general discomfort with downtime led me to hope the call would bring us some work, and I was always happy to jump on the phone anyhow. I smiled there in the shop with the phone to my ear and said what I always said with a near-hokey voice, "Premium Tattoo!"

The music in the background and the presence of at least two people on the other end suggested I was on speaker phone. The women asked me a question, talking all at once and quickly. They wanted to know if anyone at the shop would tattoo their names on their faces.

Names on faces . . . Their names? Whose names? Like, do you want me to tattoo your name on your face? Both of you? I was pacing around the shop. They clarified: not their own names on their own faces, but the names of each other on each other's faces. They wanted it done soon and promised they could come down "with cash."

The whole thing was confusing until it wasn't. The clarity hit me with a bit of force. It made me stand still and double-check. I said, "You're telling me you want us to tattoo the name of your friend on your face . . . and do that for both of you?" Yes, went the response, in all seriousness. It was like they were ordering a pizza.

For fun, I covered the phone with my hand and asked Pauly if he wanted to take these fantastic walk-ins. He didn't jump for the job. Rather than accept more than $300 for what might have been two hours of work, Pauly said without any hesitation, "Tell them to get some fucking sleep." He muttered to himself while I walked away, "Goddamn (laughter), what the fuck?!"

I didn't tell them to "get some fucking sleep" but, instead, said that we wouldn't be doing their tattoos. I wanted the experience to go on a little longer, though, because the whole thing was fascinating. What inspired this idea? Were they besties growing up? Had they saved each other's lives at some point? Or was it that they had just spent a couple of nights in some apartment doing coke together? We will never know because they hung up. Perhaps some tattooer out there does, though. It was easy to imagine these people dialing the next shop by the time I set the phone down.

More than just another strange thing that happened in a tattoo shop, there is something to chew on here. Why didn't Pauly accept the work? It

was a pretty good amount of money, after all, especially if he was doing another couple of tattoos that day. He would've easily had more than $600 by the time he went to the bar. Also, isn't it his job? Isn't he the one who wanted to be the walk-in wizard, fulfilling the requests of people and doing clean tattoos without a fuss?

It was actually simple: he didn't take the job because he didn't want to be the one to have done it—to have caused these two people, and as such *himself*, the degree of dread that would have followed them out of the shop and back into their daily lives. In his case, that dread would have been exchanged for a few hundred dollars. Maybe the math just didn't work out.

I recalled the whole scene one day while sitting with a tattooer discussing similar, bizarre requests that they had encountered over the years. They sighed and told me, "At the end of the day, *I* need to sleep at night. I've gotta know I'm not out fucking up people's lives."

We avoided face tattoos, but then again, there were some exceptions. We knew some people could get a face tattoo without it changing their life so much. I watched two such pieces being done at Premium. They were put on folks who were already heavily tattooed. We knew them well and trusted, for instance, that the choice wasn't an outcome of some coked-up couple of nights spent reminiscing with a dear friend.

One was a fellow tattooer, and the other owned the barbershop across the street. Both were in their late thirties, covered in tattoos, and unlikely to be much interrupted by these new, if profound, pieces. The projects were exciting but somewhat nerve-wracking to watch. You *really* can't botch a face tattoo. But these were rare occasions.

Matt described the practice of refusing some work to me early on. "We don't give face tattoos to young kids," he told me, "or those who aren't already covered with tattoos." He had guidelines around what he, and subsequently we, did to people. I did a few neck pieces, though.

The first one was for an aspiring tattooer. He was originally from Bogota, Colombia. He was traveling around the US getting tattoos. He had discovered my work online, and I was blown away by his choice to get a piece from me because he was collecting work from great tattooers. We hit it off immediately. Thanks to the kindness of my twin brother, I once got to spend a few months traveling around Colombia, so we talked about that. We also spoke extensively about tattoos.

He looked through my flash designs to make a same-day decision. It was exciting and always nice to tattoo my own flash. I loved the designs, and of course I had made them with my strengths in mind. I didn't have to worry that some feature would land beyond my scope. It was comfortable and often a lot of fun.

My client went for a tiger. I had designed it with reference to imagery from twentieth-century matchbooks—a carnival-banner type of folk drawing. He initially asked me to put it on his forearm. Tattooing the forearm was great, as they are generally easy to reach and not so complicated when it came to the conditions of skin and body. It is easier to tattoo someone's forearm than, say, the top of their foot. I thought this tiger would be a quick and predictable experience.

We stood talking while I made a copy of the design and sized it to fit his arm. He was left to sign the waiver while I ran the stencil. I was setting up my equipment in the booth when I noticed him standing in front of a floor-length mirror near the shop's waiting room. He was holding the design up to his neck with a large smile on his face.

My client glanced at himself from a few angles, turning his body and catching the light playfully. My initial confusion at this scene cleared up quickly, and I later wrote in my fieldnotes: "I looked over and thought: No fucking way. Is this dude going to have me tattoo his neck?" He caught me looking and smiled before waving me over:

"I think it looks real fucking cool on the neck," he told me. "Let's go for it there."

". . . and here I thought we'd do a quick arm piece," I smiled. "Look man, I've never done a neck tattoo before. I need you to know that."

I saw Matt peer into the shop from the back patio.

"I really want you to do it, man. How cool would it look right there?"

I suggested Matt do it instead: "My mentor has some time and he'd make that come out perfect dude. I want this to be great for you; let's have him do it."

His excitement seemed to grow in concert with my hesitation. "I want you to do it, man, today! Your first!"

I asked him to think it over. "That neck tattoo will have a huge impact on your life. What if you don't end up being a tattooer?" He smiled while patting me on the shoulder. It was as though him *not* becoming a tattooer was impossible. I felt, among other things, old.

I offered him some time and space to think, although he hadn't asked for it. I walked toward the back of the shop, went through the screen door and stood out on the back patio. It was good to spend some time backstage. Matt was there, and I asked him for advice. "How should I arrange the client's body for a neck tattoo? How could I get the stretch? How easy is it to blow lines there? What about his breathing?" I also told Matt I was a bit freaked out, but he knew that.

Matt could also tell that behind my fear was budding excitement. He let me stand there for a minute or two. I said I was nervous before adding, "But who else is going to let me tattoo their fucking *neck*, man?" Matt allowed himself a slow smile. He seemed to enjoy moments of slight tension in my work, as most of his tattooing had become so routine. He longed for that metallic jolt that always came with working on the edge of your scope, toward and just past the boundary of your experience.

Matt knew I could do the tattoo, and he also knew that he could step in to intervene if necessary. He knew the client was informed and enthusiastically onboard. It was a best-case scenario for my first neck piece.

Matt spoke slowly, "That dude came here for *you*. He's basically begging you to tattoo his neck, and look, he's got tattoos all on his hands already." It mattered that his body was already tattooed and that there was some bad work mixed in with the really good stuff. Matt mirrored my question, "Who is going to let you tattoo their fucking neck, my dude?"

His confidence gave me motivation. It also supplied permission. I agreed to do it, and he lit up with enthusiasm. "From nose to toes, bud." That's what he always told me when I tattooed some place on the body for the first time.

It's embarrassing to admit that I stepped through our little screen door and back into the shop feeling like a warrior. The shop's masculinizing potential was in full effect. It was really just a Wednesday. There I was, only doing what new tattooers do all the time—working at the edge of a skill in order to grow it. I felt like I was facing the fire, though, motivated by the tenor of our scene. The Dungeons & Dragons played at night and the fantastical themes of Led Zeppelin, Iron Maiden, and Black Sabbath were having their way with me. I was scared, and I *should've* been, but I was also thrilled.

My client literally jumped with excitement when I told him I would do it. We got all the prerequisite stuff in order: I shaved his neck, got the stencil on there, and completed my setup. I had him lie across the table on his left side.

He faced me with his neck laid over a plastic-wrapped cushion. He asked me if he could listen to music through headphones, and because the headphones were connected to his device by a cord, we made it so that the cord wouldn't get in the way of my tattooing.

I took a few slow breaths and tapped on the foot pedal. I dipped the machine in black ink and set into the project, stretching the skin and getting the needles in there.

The skin's elasticity amazed me. It moved under my gloved fingers like a thin layer of warm dough might slide across an oiled baking sheet. It seemed able to stretch across and beyond the edge of the table. I had expected stretchy skin, as Matt told me about it and as I guessed a person's neck-skin needs to stretch while the head moves around, but I didn't quite expect it to feel how it felt.

A tattooer I interviewed captured it well. He was having a debate with some client over pricing, which is never a good sign. You generally don't want to tattoo anyone who's going to push back on the price. This is because pricing isn't only about money, as described above. At any rate, this tattooer said, "I told the guy he was going to have to pay me a lot more than that to work with that *chicken skin.*" I thought of this *chicken skin* comment while beginning to tattoo my client. I might've laughed if I hadn't been so damn focused, so profoundly hit by what I was setting out to do.

Much like a tattoo I described earlier, the one with baby angels and machine guns, I had to do some deep stretching here. The proper stretch was usually achieved by spreading the client's skin between the left index finger and thumb. In this case, however, I used my whole hands, pulling skin upward with the outer edge of my left hand while pulling it downward with the outer edge of my right. His blood pulsed against my hands. I had to put a little pressure on, too, and I worried that I might block the blood from moving between his brain and body.

I dove in with the machine and assumed a comfortable cadence as the lines started making their way into the skin. I finished the piece, and he got up from the table. He stretched his neck and walked to the mirror before smiling and laughing. I heard him say, "Fucking awesome, man!" The piece came out all right, intentionally flat and dopey in the design department. I still cringe a bit, though, while viewing the photo because all I see are mistakes (see fig. 9).

FIGURE 9. *A tattoo on the neck, done with a client after negotiating its fit for his lifestyle. Most tattooers proceed into such life-altering projects with caution, approaching their work from an ethical position.*

We lingered a bit after he paid. I cherished the moment and expressed gratitude for his openness in working with me. We had gone through something big, and, indeed, we had gone through it together. While I silently wondered whether I hadn't just ruined this kid's life, I allowed a quiet euphoria to drench my experience. He left, and Matt took a break from his project to commend my stepping-up to the opportunity.

My PhD oral exams took place later that week. I sat at a large conference table in a windowless room, looking into the faces of professors who graciously sought to calm my nerves. I was calm, though. I actually sat there thinking: I tattooed that dude's *neck*. What was this but a conversation? How hard could it possibly be?

This was how I carried my tattoo experiences from the shop out into the world. I changed other people and was myself changed along the way. This also meant it was easy to lug around the fact that I was sometimes troubled

by the work. That trouble followed me to dinner parties, movie theaters, and to bed at night. I would lie awake wondering if I should have refused tattooing that dude's neck or the neck of a queer woman a few weeks later. Sure, they asked for it, and we spent time talking about its potential consequences. But still, I questioned whether they had really considered the gravity of the act. I remain glad to have refused some projects, such as the "Heartbreaker" on that one kid's face, on account of having to live with having done it.

But I don't want to come across as an especially upright moral citizen. I also don't want to suggest that our shop was full of people that are somehow better than those in the shops of your town. It's the case that I and those I worked around were embedded in a tattoo world. We followed conventions of the trade and, in a meaningful way, were responding to what was expected of us. Let's call this convention, the one that had us refusing some projects, an "ethic of refusal."

An Ethic of Refusal

In his ethnography among tattooers of the 1980s, sociologist Clinton Sanders explains that tattooers exist within an "ethical and cultural landscape."[5] He noticed they were enveloped in a set of expectations for appropriate behavior. These expectations included a general refusal to tattoo hands, necks, and faces—the job stoppers.

Although the practice of tattooing visible areas of the body is more common today, in part inspired by a reduction in stigma over the tattooed body, the suggestion that there's an ethical and cultural landscape generally holds. In the more enclave-like tattoo *worlds* of today, I would say there are many such landscapes. They are characterized by what David Lane calls a "code," a set of expectations shared by a group.[6] And while there may be a code, it's not as if it's written down.

Tattooers don't sign a code of conduct or take an oath before they enter the shop. They don't go to meetings or otherwise participate in committees governing the boundaries of appropriate occupational behavior. So, where does such a code come from? How is it communicated, learned, challenged, and changed? Answering those questions would demand another book, one that's different from this book. But rather than pass the buck completely, I'll explain how I grew to think about it.

The fact that many tattooers in the US adhere to shared ethical land-scapes, say in their desire to refuse projects, suggests that they have developed a patterned approach to the problems they solve on a daily basis. Any kind of code may result from this repetitive problem solving, and it's passed along to newcomers through forms of talk and practice. It stems, that is, from having repeated encounters with the people, objects, spaces, and tasks of tattoo labor—from what's demanded of them at the intersection of people, bodies, and money.

To be sure, there isn't *one* code among tattooers, at least not anymore. As stressed earlier, tattooers work in enclaves. They develop local practices and ethics that appropriately respond to local problems. This is an effect of clustering among tattooers, as they gather in shops on the basis of aesthetic style, level of skill, and on their relationship to the ethics of tattoo practice. Tattooers speak of "shop culture." There are *shops* that do face tattoos and *shops* that don't.[7]

People who become tattooers can be socialized into ethical expectations while working in a shop. Some folks argue that apprenticeships are crucial precisely because they might offer structure to the process of ethical socialization.[8] They want new tattooers to have experiences like I had, watching a mentor refuse some projects and describing why.

But the tattooers I met also knew that, while a person may encounter collective knowledge in an apprenticeship, they won't fully appreciate tattooing's more ethical demands until they do tattoos on people repeatedly. That is, tattooers know the ethical textures of their work are experienced and eventually known through an accumulation of direct exposure. Tattooers are shaped by what they do as they do it. They are *made*, not born.

I often found conversations with tattooers riveting, partly because they often said things that could've been taken directly from the academic stuff I was reading at the time. For instance, I met one tattooer who took on apprentices and who spoke as though he'd been reading the dense works of John Dewey, a philosopher of knowledge, art, and education.

Dewey argues that people develop their sense of morality, let's call it their moral compass, while building a broader set of *habits*. Habits, for Dewey, are a person's "acquired predisposition to *ways* or modes of response," meaning, they shape what someone might intuitively feel, think, or do in the face of some situation. For Dewey and other pragmatist philosophers, habits are

shared by people who encounter similar problems. There are "established collective habits"[9] that congeal into what I've been calling conventions.[10]

Matt told me I would come to fully appreciate the ethical quality of tattooing over time. This didn't prevent him from trying to tell me about it, but he would always end with the suggestion that I would ultimately learn on my own while solving problems on the job. He recounted times when he should have refused projects, and he assured me I'd do the same. This meant, among other things, that I would likely crash and burn before figuring it all out.

I interviewed several tattooers who had gone through an apprenticeship and who told me something similar—that as much as they received guidance, it was a rather "sink or swim" scenario. As one described, they had to "face the realities of tattooing, be in it and feel it and learn how intense it was." So, if tattooers refuse to do some projects because they've been socialized into a set of ethical conventions, the conventions themselves are partly maintained through the direct, repeated experiences tattooers have with clients. They're a result, that is, of habit-formation at work. This is to say that ethics among tattooers reflect the situational character of tattoo-related knowledge and experience.

But it's hard to judge whether or not a neck tattoo will ruin someone's life. And, of course, this is questionable activity in the first place: Should you be the judge? Who granted you the power to decide what would and wouldn't be a "good" tattoo for someone? Who was I (or Matt or any tattooer) to guess at a person's future and decide, upon that guess, whether the tattoo would negatively impact their experience?

Whether it's right or wrong, tattooers do this kind of future-guessing all the time. While their work occurs in the moment, a great deal of it will have its effect over time. The fact that tattoos are forever matters, of course, and the fact that they are done on the body matters too. Tattooers use their vision of the future to assess a project in front of them in the present. They also look to the body of their client while trying to figure out where the line between good and bad tattooing might be drawn. Most of the tattooers I met took cues from the bodies they encountered, because bodies convey important information.

The Markable Body

Your local tattooer, and especially if they've been on the job for more than a decade, will treat a person with no tattoos differently from someone with a lot of them. After having worked with newbies and full-on collectors thousands of times, they've likely come across some patterns that map onto a client's degree of experience with both the tattoo process and with having a tattooed body.

None of this should be a surprise. I'm sure body laborers of all sorts experience something similar: the chiropractor walking a newbie through their first loud, unnerving neck-cracking procedure, for instance. As I've suggested before, what's unique about tattooing is that it results in a permanent, visible change to the body. While a chiropractor's work may have its lasting effects, it's simply not the case that a client's first neck-cracking procedure is marred by the question of whether or not they will regret having done it twenty or thirty years later.

I learned quickly that people with no tattoos could bring unique challenges and opportunities to the work. They could be nervous, stammering and unsure about how to interact with me and the shop. Having never had a tattoo machine on their skin, they were understandably curious if not scared about the pain. Clients with no tattoos could also swing the other way, being so overtly confident that I'd wonder if they hadn't just pumped themselves up in the car before walking in.

On the whole, they were in need of more education, hand-holding, and attention. I didn't always mind this; in fact, doing a person's first tattoo was often an enjoyable experience. You got to walk them through the process. It also offered reprieve from some of the heavily tattooed folks who spoke as if they knew everything there was to know about tattooing—presenting a degree of mastery that I, as a tattooed person and as an actual tattooer, knew I'd never have.

The point is that I quickly, and without much thought, would assess how tattooed my clients were before we began any project. This information was useful while working to ensure the clients had a good experience. If someone walked into the shop with tattoos on their arms, for instance, I knew I had to do less educating. I knew there might be less emotional labor involved, too,

as the client wouldn't be so nervous. I also knew my tattoo would join others, which helped me make ethical choices.

I wasn't the only tattooer to consider the client's degree of being-tattooed while making more ethical decisions. Some of the people I met described certain bodies as being more readied for tattoos than others. These tattooers often did their initial work on people with a bunch of amateur pieces.

On telling me about the first tattoos they ever did, for instance, one said their "punk friends already had a ton of shit tattoos, anyway." The presence of "shit tattoos" was important. It made the body ready, at least to some extent, for more shit tattoos.

Consider a scenario: has someone done right by their client by tattooing "I Eat Children" across their forehead? Probably not. But what if the client really wanted it? What if the tattooer really needed the money? The money part *is* important, but the thing that always drew me over the line—brought me toward a place of accepting what I thought would be unacceptable—was something like this: What if the client already had "Fuck You" tattooed prominently across their neck? How about a cartoonish pile of dog shit on their cheek? What if there was even a tiny little fly there, set into motion above the pile by a small number of trailing dots, indicating a flight path?

Doesn't the presence of "Fuck You" change the situation? Surely the dog shit does something, right? Would "I Eat Children" really seem so bad after all?

Notice the only thing going on here is the presence of tattoos, but, of course, those tattoos say something bigger. At the very least, they express to the tattooer that this person's life may not be so negatively changed by the presence of another face tattoo. Someone with a pile of dog shit tattooed on their cheek already knows what it's like to have strangers stare at them while in line for groceries. They probably have an employment situation where they're *never* in the front stage. And given the content of the ones already there, the fact that the request involves a dramatic phrase seems all the less profound. Tattooers I met probably still wouldn't do the piece, but you get the point.

I came up with a concept to help me think about and describe this phenomenon: the body's *markability*. There are several conditions of the body that have a potential to contribute to its markability and that can shape the ethical—always embodied—experience of tattooers. These conditions

always include the degree to which the body is already marked, but it might involve other aspects of the body—its relative alignment with prevailing regimes of beauty, for instance, which remain a highly gendered and racialized set of meanings and practices.

You can look toward history and find that many people did, and perhaps still do, approach the heavily tattooed female body as anathema to white, hegemonic femininity.[11] This was the case back in the 1860s for Lombroso, that early criminologist and human classifier I mentioned earlier, who conflated the tattooed body with the "state of nature."

I had a few tattoo bros describe the experience of encountering heightened stress while tattooing the body of a woman they found beautiful. This was in 2019, and one of these tattooers even said they didn't want to "ruin beautiful women." They found these bodies to be *less markable* than, say, the ugly men they otherwise covered with tattoos. The logic here suggests that some tattooers might consider the male, fat, old, or Black body more markable than one that's female, slender, young, and white.

I didn't hear such talk at Premium, however, or among those with whom I spent most of my time. The people I met would find great offense at the idea of "ruining" a body. They would likely push back against considering bodies in those terms, pointing to a problematic history of conflating purity with the heteronormative white feminine body. This was true even if they thought it better to have put their first "shit tattoos" on bodies with existing "shit tattoos."

I imagine I would've found more talk about the potential to "ruin beautiful women" among the tattoo bros, but I really can't speak to whether it was an everyday thing. I didn't spend enough time among the bros, in scenes where such talk might be more common.

Tattooers I met often spoke seriously, professionally, and in a matter-of-fact way when it came to the bodies of their clients. This way of talking probably reflected a way of thinking, but it's hard to know for sure whether more progressive tattooers didn't also harbor remnants of the fatphobia, racism, classism, and sexism that so deeply underpin the ideals of purity afforded to thin, white, female bodies. One thing is sure, though: there's an *ethical* thing going on here, a line in the sand drawn by people hoping to establish appropriate alignment between their clients, themselves, and ultimately what they do for money.

While tattooers might've evaluated the body's markability by considering the extent to which it was already marked, clients seemed likewise enveloped in this way of thinking. The tattooed folks seemed more up for additional pieces than did people with few, or no tattoos, some of whom stressed over every detail and worked to assure us the piece was especially meaningful.

This doesn't mean a person necessarily becomes less concerned with their tattoos over time. I and many of my clients got their first pieces at home by drunken amateurs. It does mean, however, that many tattooers and clients look to the already-tattooed body as more markable than one with few or no tattoos.

Matt, Pauly, Karime, and I loved helping people through their first pieces, but I, at least, found more enjoyment tattooing folks with lots of tattoos. I could work with more ease, partly because I could assume the client knew what to expect from the process but also because I knew my additional work on that body wouldn't singularly and negatively impact that person's life. It was often on heavily tattooed bodies that I did my very best work. The stakes seemed lower, even if I was placing my tattoo next to one that I deeply admired.

We at the shop, though, had the most markable bodies of all. We put some of our first and worst pieces into our own legs. Matt, Pauly, and Karime allowed me to tattoo their bodies, and while it involved higher stakes than working on my own, it was still a comparatively low-stakes deal. They were extensively tattooed and not bothered by mistakes. We practiced new techniques on each other. It felt and was more like *practice.*

But like all lessons in tattooing, I learned as I went along. I became more aware of the nuanced quality of this "markability" and its related ethical conditions over time. It was yet another surprising aspect of my experience in tattoos. Like every tattooer ever, I made some mistakes along the way.

Growing into an Ethic of Refusal

Some clients wanted things I didn't want to give them. There were some pretty silly ideas—ones I mostly enjoyed, like the bumblebee on a unicycle—but there were situations that strained my chance at sleeping with a clear conscience.

I grew especially wary of clients who didn't seem fully onboard with their choice to get the tattoo. These were often the folks who wanted me to tweak the design over and over, as though a tiny change to the piece would make all the difference and settle their concerns once and for all. I often told them to think about it for a couple of weeks and return, as Matt had instructed me to do.

Matt even chimed in during these moments to say something like, "What's a week when the tattoo is forever?" He wasn't being especially altruistic here. He did this partly because he knew that doing the tattoo for a person in that state could come back to bite you. The person could return a few weeks later, piling their regrets on you and your day. You could also simply regret it yourself.

Most of my clients who seemed unsure about the tattoo didn't take the opportunity for more time and, instead, decided to get the piece. I did the tattoo wondering if I should've pushed the suggestion of a pause with a bit more force.

There were also some clients who asked for a couple of tattoos on the spot and from an impulse of spontaneity. It was generally fun, as I described in the case of doing that kid's neck tattoo, but it occasionally caught me off guard. I grew into a place of caution when it reared its head, hoping I wasn't contributing to someone's regret down the line.

I had a client, for instance, who loved to make quick decisions about tattoos that, in hindsight, I knew I shouldn't have given him. It was on his torso that I did the cherubs with machine guns.

We were tattooing his hands on a rainy day. He was probably telling me all about his life. Everything seemed to be going fine. I didn't have a ton of work, and I was more than happy to be doing the tattoos. We enjoyed spending time together, and he had become a small fixture of our scene.

The problem occurred later on, because he began regretting some of the work we did on the spot. I had given him my phone number at some point, as he had joined our backstage world, and I awoke to a series of late-night text messages. They included images of his recently tattooed hands. He had edited the pictures so that there were bold X's across the tattoos. I felt a tightness in my gut immediately.

"You're going to kill me," he wrote, "and this obvi has nothing to do with you but I'm looking at my hand still and it's just lacking something." He

added, "Are you willing and ready to try your first cover up??" My stomach knotted, and I experienced a profound feeling of regret. I recalled tattooing barbed wire across his hand and thinking that I should've had him wait a day.

He wrote later, "The unfortunate thing is sometimes I think I'll like something and then I don't." He signed off, "But I still love you and you're fuckin awesome." Well, I didn't feel awesome. That's partly because I had drawn the design on his hand directly, using a ballpoint pen instead of doing the more careful work of constructing the piece on paper and transferring it with a stencil. I even knew while drawing it on that I should pause and give this guy a better tattoo, maybe one that wouldn't have been "just lacking something."

His enthusiasm swept me up, though. He was loving the fact that I was drawing it on, and I was too. It was like Pauly, maybe, jumping over the line from our careful backstage work of tattooing and into the more front-stage fun of it all. I later felt that I'd abdicated some level of responsibility.

I wrote in my fieldnotes, "I imagine a bartender stressing that they had poured someone a drink before they got in an accident on the way home." I added, "That person asked for the drink, paid for it, didn't seem drunk and, well, that's my job anyway, right?!" I eventually imposed restrictions on this client's decision-making process, like "No impromptu tattoos." I would have him return a day later or at least have him spend some time looking in the mirror before we began.

I never felt totally off the hook, as much as I tried to remember that he was in charge of his own life. My restrictions on him had much to do with me, because while I cared about him and his future, I also cared about finding a way to sleep at night. Doing better work with him and all my clients amounted to doing better work with myself. The experience of the client had a direct route to the experience of the tattooer.

One day at Premium, a woman walked in and asked Matt to tattoo her boyfriend's name on her neck. She was deaf and they worked it out on paper. I had watched Matt do this type of exchange with several clients. He described in pencil what he often said out loud to those who walked in wanting the name of a lover tattooed on their body, something like, "You know this is a dangerous tattoo to get, right?" and "I've covered as many as I've done!"

He and this client hit it off, though, with her laughing and having a good time. Matt did the tattoo, and I took photos of it when the piece was finished.

Because every tattoo is done on some-body, I took photos of the client, too. She posed with a huge smile, having fun with the process. She paid and walked out of the shop into the sunny day.

She came back three days later and hit her palm against the wooden counter. I was sitting in the shop's waiting area drawing, and as such had a front-row seat. She wanted Matt to cover it up. I sat there thinking, "The whole scene flipped in *three days*?" Matt ran his fingers through his hair and seemed to be settling in for a familiar exchange.

He stood behind that counter with a solid, I-told-you-so vibe. He didn't seem up for the situation, or maybe he was, but not in the best way. He looked ready for an argument, and I judged him for this, wanting him to be more empathetic and calm. I grew to better understand his experience, though, the more I considered it. Anyone who's tattooed out of a street shop for nearly thirty years has likely done such a thing hundreds of times. I really can't imagine how they—how Matt—could put up with it for so long.

Matt and this client passed a sheet of paper back and forth in what began as, and stayed, a rather tense interaction. She stormed out within ten minutes, and Matt raised his voice to me, "Be super fucking careful man." He said, "I hope you paid attention to that whole thing, there's a lesson there." He crumpled the paper and threw it in the shop's blue recycling can while charging toward the back patio.

I jumped up from the loveseat to get a glimpse at that paper. I picked it out of the can and bent over to smooth it across my knee while standing. I then read Matt's handwriting: "That was YOUR DECISION. YOUR DECISION." I heard Matt open the screen door.

I crumbled the paper back up and looked toward him with the hope that he'd regained some composure. He was clearly working to collect himself, probably because he didn't want to bring negative energy into our day. He also had a noontime client walking through the door. That client could've been getting their first tattoo, anxious and hoping to encounter someone who would patiently walk them through the process. I don't have it in my notes, because I myself had a tattoo on my hands, but I'll bet Matt tried his best.

We sometimes fixed work by other tattooers, like changing a dagger's handle so that it no longer looked like a penis. It was work that could communicate the necessity of being careful about the tattoos you tried to put on people.

Pauly once changed the name of a past lover tattooed across a guy's front shoulder. The guy told us he needed the piece changed, and fast, so that his "baby-momma didn't get livid." He said he spent the day calling shops in our area, only to find that nobody was available or willing to try and change the name. Pauly jumped to do it because he didn't have any work that day and because it seemed like a fun project. One of the first things Pauly said was, "That's why you never get the name of a freaking *girlfriend* man!"

And no joke: Pauly was able to change the tattoo so that it resembled the name of the client's kid, the kid he shared with the woman he was so afraid of. The trick worked because the names were similar. The client left, and we all talked about the tattooer who put the lover's name there in the first place. We wondered if they had considered it twice, but we were mostly having a good time with the experience—celebrating the irony of changing the name from one to another. That's real good stuff and not something you get in many workplace environments.

Of course, not all regrettable tattoos are the names of romantic loved ones. We refused giving young folks work on their faces or doing symbols of hate or gang affiliation, although I was never approached to do either. Pauly *did* give someone a gang tattoo while I was at the shop.

The client was covered in tattoos, including a rather visible one that read "Go fuck yourself." He was almost painfully polite and deferential, calling me "boss" and making me wonder how much time he had spent in prison. He and Pauly had a blast, and the client's existing work left me and perhaps Pauly sure the tattoo wouldn't meaningfully change how most people experienced him.

I talked about all of this with a tattooer who had been in the game for decades. They told me it took them "about ten years" to appreciate and articulate the ethic of refusal. They began refusing certain projects after tattooing anything and everything for a decade, having worked under the initial assumption that it wasn't their place to question the desires of other people. "I think of many, like *a lot* of pieces," they told me, "that I probably shouldn't have done."

Another tattooer with less than four years under their belt told me they had "come around to the wisdom" of being careful about tattoos after doing a few they later regretted. They said all of this with a sense of gravity, speaking seriously and making eye contact. It seemed they were trying to teach me something.

To be sure, these tattooers didn't know whether their clients regretted the work. In some sense, it didn't really matter. They still felt on the hook, or at least they expressed having this feeling while talking with me. I was like them in the sense that I mostly learned about the ethical implications surrounding what I did as I did it. There was great help from Matt in this regard, of course, but I also learned through trial and error.

I experienced how heavy it could *feel* to do a tattoo I didn't think was a good idea, like that name of a lover I put on a guy's side . . . right next to the name of his ex. And while I was at the beginning of things, having only tattooed people for a few years, it was easy to anticipate how tattooing would force me to consider the role I played in the lives of others—the spot I occupied in the intersection of people, bodies, and money. It taught me that doing something to someone's body was always doing something to some-*one*, and to myself.

But that money bit is important. The necessity for money can outweigh the desire to avoid ethically questionable activity, in tattooing and in everything else. Tattooers are like all people who hold jobs: they do some work they don't like because they need the money.

Some tattooers spend a considerable amount of time between appointments, growing antsy over their financial situation. Imagine sitting in a shop waiting for a client to walk in. Imagine doing this for hours each week. Once that client *does* walk in, you know you could have a few hundred dollars from the day instead of none. It might not matter so much if that client wants you to give them a tattoo you think is a bad idea.

I spoke with a tattooer who said, for instance, "You know, I might not want to do it, but I've got kids. Also, someone down the street will do it anyway." They echoed something I had heard many times, that people who want bad tattoos will find a way to get them. From this position, the ethical tattooer can at least try to make sure the bad piece will be as good as it can be.

There's ultimately a great privilege involved in avoiding work you don't want to do. It's also the case that refusing a project or trying to change some aspect of it demands a lot of effort—sometimes more work than just doing the thing. Tattooers are more likely to experience moments of tension with clients if they refuse the request or otherwise try to walk the client back from a bad idea.

Disagreements can emerge from the process and be challenging, in part because of the political and historical significance of the body. It's a hard sell—telling someone they can't do something to their own body. It's even hard if what you're *actually* saying is that *you don't have to* do something to their body, just because they ask you to.

Tension in the Refusal

The magazine *Jezebel* published an article in 2015 by Jane Marie titled, "Don't Tell Me I Can't Get a Fucking Neck Tattoo." In it, Marie describes an interaction that helps reveal how tension can arise when a tattooer refuses a project. The refusal can, like so many things, disrupt the encounter by undermining the trust that's so key to its intimate, bodily character.

Marie didn't have many visible tattoos when she walked into the popular "New York Adorned" shop with a friend. She asked to get the name of her kid tattooed on her neck in small cursive text. She writes that the guy working the counter told her, "I'm not sure they'll *let you* get a neck tattoo" (emphasis in original). "Let me!" Marie responds while waiting for Dan Bythewood, her would-be tattooer, in a state of surprise. She assures the reader that she had been denied the same piece at another shop but explains this "was some next level shit."

Bythewood proposed to tuck the name behind Marie's ear. Marie quotes him: "A neck tattoo on someone without a lot of tattoos is like lighting a birthday candle on an unbaked cake." With Bythewood suggesting she was "like an unbaked cake," Marie concluded that he saw her as "a feeble-minded, hysterical girl." She asked him to explain whether he would say the same thing to a man, and he said, "Yes." She left with the statement, "Are you fucking kidding me? I'm not going to give you money . . . let alone have you touch me or put art on my body!"

The *Jezebel* piece gained enough attention to inspire Bythewood and the shop owner, Lori Leven, to respond.[12] Bythewood suggests Marie did a "disservice to true feminism" while explaining that his refusal was sourced not in misogyny but in ethics: "I long ago drew an ethical line in the sand for myself as a professional tattooer to turn down 'job stoppers' on those who are not already committed to living as a heavily tattooed person." Leven, the

shop owner, explains: "Remember! It is a permanent change to your appearance," and tattooers work "as professionals." She suggests their "advice has your best interest at heart."

Back at Premium, Matt and I did something similar with a walk-in client, although we didn't face the fallout of Marie and Bythewood.

It was raining that day, with water pouring down the shop's storefront windows. The client made his way in like a wet, careful mouse. He made sure to wipe his shoes across the entry mat. He was a twentysomething white guy with long brown hair. He peered at us through puffy eyes. He spoke in a near whisper and stood with slouched shoulders. His jacket dripped on the floor, and I'm pretty sure he apologized for it.

He requested we tattoo a dog's name on top of his left hand. He wanted the date of the dog's death there, too. I peeked at the shop's computer and confirmed that yes, it was the same date. Then I noticed his face. His nose, cheek, and mouth had these raised streaks across them. It looked like he was recently bitten, maybe even attacked, by a large dog.

Matt and I agreed, without a word, to try and get this kid to move that tattoo someplace other than the top of his hand. I, at least, figured he was in a state of distress, perhaps one that was inspiring him to make a decision he might grow to at least question a few months, if not decades, down the line. Matt and I drew from a pool of resources built through close, intimate work in our attempt. We'd done it before.

Matt put on an empathetic tone: "I'd love to get you this tattoo, and I'm wondering if there isn't a better placement." I chimed in: "You know, I love the way text looks stacked-up on the inner wrist." Matt asked the client to turn his palm toward the ceiling. He then touched the client's open hand while describing how the more rectangular shape of stacked words fits well in the area, tracing the shape there on his inner wrist.

That was our pitch, an offer to put the tattoo someplace else, although our motive was disguised. We had conjured, as sociologist Erving Goffman may say, a "strategic secret."[13] We didn't come out and tell him our true motivation, and we also didn't tell him he was an unbaked cake.

The client agreed without hesitation, as though the tattoo would be the same for him whether it landed on the top of his hand or on the inside of his wrist. This was a relief. Matt did the piece without a hitch. I am not sure we even talked about it much afterward, maybe a quick comment or two about

how the guy wasn't going to go through the rest of his life with that tattoo on his hand—with having to describe it a thousand times to people who would see it so plainly.

Our situation went smoothly in part because Matt and I had the time to match our client's emotional experience. We were good working as a team, and it probably helped the client to see that I, another tattooer, agreed with Matt.

Importantly, however, we all had some things in common. Not the least of these was our each being understood as straight white men in the world. The effort of Matt and I couldn't quickly be read by our client as just another instance in a series of paternal moments of unsolicited advice forced on people like him. The particular features of our lives made the whole scene a bit easier to handle. The source of our suggestion could more unquestionably stand as grounded within an aesthetic preference, even if the aesthetic preference obscured our more ethical motivation.

Each situation between tattooer and client will be different, but there's something here that exists beyond the interpersonal experience and maps onto a broader phenomenon of freedom, choice, and autonomy. Back at New York Adorned, I wonder, did Bythewood *forbid* Marie from making a choice about her body? Or did Marie try to forbid Bythewood the power to make decisions about his work? From the tattooer's position, there's autonomy in refusal.

Autonomy in the Refusal

Tattooing is a job. It differs from many jobs, though, on the level of self-determination, or autonomy. Tattooers have a lot of it. They largely make their own hours, deciding what they'll do and when they will do it.

Interactions that involve the sort of deliberation I've described offer an opportunity to think about the character of this autonomy, because while tattooers often pick and choose what they do, they ultimately depend on clients. This dependence means they must, to even a large degree, cater to a consuming audience.[14] It means they serve others, and this demand of service in their work motivates them to do things they might otherwise not want to do.

But it's not as if they're beholden to the client. A tattooer told me one evening, "It's not a customer's-always-right situation." They reside in a space

of collaboration with clients. Matt always described tattooing as a "two-player art," underlining the necessity of teamwork between tattooer and client. This teamwork can go smoothly or not. The potential for rough water is always there. Tattooers work to prevent having to encounter such rough patches, and tattooing's at its best when this preventative work isn't all that necessary—when clients and tattooers seem to click, intuitively.

Regardless of the kind of tattooer they aspire to be, some people have far more autonomy than others. Some, that is, are less likely to experience the kind of friction I've described. Those working in upscale shops and private studios face less potential for conflict with clients, and subsequently more autonomy in their work, than do those in the walk-in-heavy street shop. This hierarchy of autonomy should be familiar: consider the difference in the level of self-determination among those in the C-suite and those in middle management, or between the head chef and the line cook. Some people have a better chance at controlling their working lives than do others.

I wondered about all of this when it came to Pauly and his desire to remain a street-shop tattooer. The thing was, Pauly's approach to the relationship between autonomy and service made sense from within his more craft-oriented approach to tattooing. Freedom here was found in a range of ability—of being free to satisfy any request. Restraint, from this position, was found in the specialized, intellectualized artsy stuff. He was largely free from the demand of producing novelty, and he was also building a range of craft skills that would serve him over the long haul. Being good enough at many things was, in so many ways, better than being really good at a few things.

It's also the case that straight white guys who do tattoos will have more autonomy, or at least more of a *sense* of autonomy, than will their nonwhite, gender-nonconforming, nonstraight counterparts, regardless of where they work. These men can be more assured, for instance, that refusing a project might not be read as evidence of a lack of skill or willingness to work. They *get* to be ethical or at least a bit choosey.

I spoke with women who occasionally accepted work they didn't want to do because they wanted to avoid appearing weak, unmotivated, or untalented. Those who had been at it long enough, though, assured me that this type of compromise was less necessary than it used to be, especially in places like the Bay Area.

For one, the women and queer folks I met had a ton of work. Their increased acceptance and visibility gave them more autonomy than they would otherwise have, as did the fact that they could more easily open their own shops and take charge of their booking practices. They could buy equipment online and promote themselves on social media. They were making good money and were more secure in tattooing than many of the tough-looking white dudes around.

The young queer tattooers seemed especially tuned-in to the times. Their design work was highly desired, and their online presence was perfect. They also seemed more ready to tattoo people's hands, necks, and faces than many of the older tattooers I met. This might be a result of their being relatively new to the trade—if it's right that people grow into an ethic of refusal over time. It might also be a result of their dedication to a politics of bodily autonomy.

Just as tattooers are becoming more aware of the politics related to skin tone and colorism, many are also shifting the line of ethical behavior in response to broader acceptance when it comes to the heavily tattooed body. This shift helps reveal the deep connection between what happens inside and outside tattoo worlds.

I could read the results of such a shift across Matt's weary expression when young people walked in asking for tattoos on their hands, necks, and faces. Matt, having begun in tattooing during the 1990s, was surprised by the fact that many people now request and ultimately get highly visible work.

Matt and other veteran tattooers have to alter their understanding of the ethics involved to fit with the times. They need to change so that their stance will properly reflect what it means and what it takes to tattoo. Matt adjusted to some extent by engaging with people asking for tattoos on a daily basis. He had an opportunity to catch up with the youth each time a younger person came to him with the request, which was often.

Matt, in his nighttime mood, would talk as though he gained spirit from young clients. "I stay young because I deal with the youth, deal with their blood, passion, and pain." He went so far as to say, "I'm *vampiric* in that sense, thriving on them." He told me once and through red eyes, "I need them and I need you, my dude. That's what it's all about." Matt said, "People, man, it's about people. This whole thing is about people." He would go on his blood-and-lightning trip, expounding the great potential of what we did together in his small, trusty shop.

He was right about the fact that tattooing wouldn't happen without people. It was the outcome of a profound human intermingling. I came to appreciate the complexity and beauty of it all as time went on, including those aspects of tattooing that reached beyond the actual doing of tattoos for paying clients. Premium was itself a thing to enjoy, critique, and otherwise be a part of. The music, the smell, and the banter culminated into a meaningful anchor for our lives.

The shop might have seemed small from the restaurant across the street, but it was huge to us. Its centrality in our lives, especially Matt's, was made blatantly clear when we closed our doors in response to the 2020 COVID-19 pandemic. The tattooing stopped, as did the music. The shop sat dark and empty, as though it were waiting for the people to come back. Among other things, the pandemic and its related commercial closures told us we weren't in control. We dealt with people and their bodies for money. A disruption to any of these features could shut the entire thing down.

We might have produced the glamour of our scene; we didn't, however, run the whole show. Our work—that labor requiring intimate, bodily exchange—was subject to forces *way* beyond our pay grade. I'm sure many body laborers were hit with this fact while facing down the extent of COVID's impact on the world. While I always knew I'd have to leave tattooing at some point, I had no idea that a global pandemic would encourage, and even force, my exit.

CONCLUSION

The Unleavable Field

Imagine you've spent the last thirty years tattooing people for money. You've hustled for clients, attended to their requests, designed their tattoos, walked them through the process, and done the pieces. You've touched their bodies—shaving the hair off thousands of arms, legs, and chests. You've probably hit a decent speedbump once a week. You've already done your very best and your very worst work. And if you're someone like Matt, you've opened and maintained a small business, built a family, kicked a few habits, and learned a lot along the way.

Now, writers know you should never introduce anything new in a conclusion. It's the landing pad, after all, the place where everything comes together. It's where you're supposed to release the tension you've tried to build. The story is effectively over. But let's go for it.

Matt had a difficult childhood, as well as some tough times during his adolescent years. And while he was prone to frustration, he often seemed grateful for what he had. It seemed true to me that Matt knew he'd been lucky with his shop, crew, skill, and family. He likely knew it could all be lost, even if he probably didn't feel the whole weight of it on a daily basis.

I often wondered how, after all that, he put an extra layer on things by drinking so much, that touch of additional risk. Maybe it helped him. Surely it helped him. But it mostly stressed me out. It's hard watching someone you've grown to love sacrifice some talent and grace for a buzz. I didn't judge him for it, but it did shape how I interacted with him.

I would think about all this and more while watching Matt do tattoos at Premium. I wondered what it felt like for him. He had been at it for so damn long, been through the process thousands and thousands of times. Each was different, of course, but they added up to something larger. I would look and grow curious: would he rather be doing something besides tattooing if given the chance? Would he be painting those castles in Europe?

This is to say, I wondered if tattooing was as good to him as it often was to me, or if it hadn't become a total drag over time. It was hard work, after all, and he had been through a lot.

Matt would wipe the blood, plasma, and ink away from a clean tattoo, though, and his love for the work could be read all over the place. His aching back went unnoticed as he stood with youthful enthusiasm from the stool. He tilted his head this way and that to see the work from different angles. He watched his client stand before the mirror with a sense of anticipation, waiting to see their quick reaction to what he had done to their body. He wanted people to love the work, and, as cheesy as it may sound, he wanted them to love themselves a little more for having gotten it. I know this because he said as much.

Eventually, he accepted payment with a sense of pride. It probably confirmed his suspicion that he knew what he was doing—that he was good at something and that it mattered. He navigated the whole thing with ease, even a kind of straightforward elegance. He could strip what was unnecessary from a complicated process. His designs were clean, as was his practice. It was at the end of those days that he looked into my eyes and said, "Blood and lightning, my dude. Blood and lightning!" These times, the best times, made tattooing seem like the greatest gig there was.

The good times suggested that the messy experience of doing intimate, carnal labor could promote what was right in the world. After all, it brought people together and encouraged them to have an intense and expressly human experience. It made the navigation of people, bodies, and money seem natural, easy, and even fun. It was beautiful, too, because people gave a shit.

Though it was brief, the time I spent tattooing strangers was a privilege. It was also hard. It was something I loved and occasionally hated. But regardless of my attachment, it proved a necessity in the production of this book.

That's because it is *from within* the experience of tattooing that its intentionally hidden demands can be noticed, understood, and at least partially explained. The embodied vantage point can uniquely reveal the complex horizon of work that opens up when someone becomes a tattooer. An analysis of tattoo labor that's rooted in direct experience can help us understand how tattooers think, feel, and act.

While it was hard, if not impossible, to appreciate what happened to Matt across his thirty years of work, I could at least nod my head in authentic agreement with the spirit of epic adventure that animated his blood-and-lightning talk.

Tattooing, after all, heightened my attention toward the strange and sometimes-miraculous intersection of people, bodies, and money. It made me realize that tattooers, and perhaps most body laborers, have to navigate and manage this intersection if they hope to find consistent success in their work. That is, they must prevent it from turning into an unwieldy ball of snakes, with each element squirming around and through the others without sense or purpose. But as you may expect, the capacity to notice this intersection can wane over the course of a tattooer's career.

This is because people who become tattooers increasingly approach their work as a commonsense set of problems to solve. Eventually, the problems themselves begin to appear more like *routines* of everyday life. Like a $30 million view of the ocean, tattooing's assorted demands can become the lolling backdrop to a person's daily experience. I left tattooing for many reasons. One of those reasons was that I started to take it for granted. It was time to write the dissertation and, eventually, the book.

To be sure, I never mastered anything about tattooing. I was only decent at a few techniques, and I had *years* of work ahead of me. I'd spent my first years with Matt inspired and often haunted by the whole enterprise. I'd been his apprentice, and I had been rightly scared while approaching my first pieces. I found wisdom in the terror that came with making real-life mistakes.

But I did grow to more automatically sense and navigate the intimate, bodily encounters I had with clients. I could *touch right* while pulling lines across their skin without thinking about it too much. I could more quickly feel the weight of my torso against the chair and more automatically recognize my emotional state, such that I could mostly project a calm confidence in the face of a daunting task. I was beginning to embody tattooing, to develop the tattoo habitus.

I was inspired by the people I met along the way, cherishing the opportunity to interact with the fifty tattooers who shared their personal lives with me. We spoke at length about the traditional apprenticeship and the centrality of race in otherwise-technical conversations about skin tone. We

questioned whether we should tattoo the hands, necks, and faces of young people. We shared our wins and losses when it came to the body's physical and cultural life.

While I grew to know the tattoo worlds from their backstage, and while I learned some tricks of the trade, tattooing remained magical. The glamour spell was still on me. In fact, I am still amazed by a tattoo done well—by the piece itself and by the ease with which a seasoned tattooer can handle the exchange. Matt carries some responsibility for this enduring sense of wonder. The fact that tattooing was still mysterious and exciting for Matt made it all the more so for me.

But one of the best things about tattooing is also one of its most vulnerable features. It simply can't be done without people sharing intimate, physical space. The tattooer has to touch the client, and, for the most part, the two people must breathe the same air.

This didn't seem like a problem at first; indeed, I cherished the intimate physicality of tattooing when I began doing it. That's unless it involved someone's smelly feet, their drooling mouth, or their bad breath. Okay, maybe I didn't exactly love being so involved with people's bodies. But the deeper problem associated with the necessity of carnal intimacy reared its head with the onset of a global pandemic. You can't tattoo somebody if you can't touch them.

Unmoored: A COVID-19 Story

We stopped tattooing abruptly in March 2020, closing our doors the day after a bustling Friday-the-13th event. I still had work, which also meant I had income. I was a graduate student and a community college teacher, after all, and this meant I had a little money, some decent health care, and a ton of things to keep me busy. I had what Matt would call "another thing." He sometimes described it as a "sure thing," as much as he wanted me to ditch it for tattooing.

I wondered what Matt was going through. He was okay, financially, because he had savings, and he received a stipend from the state, like others forced out of work by pandemic-related closures. I was more curious about his mental and physical state. He'd spent the last twelve years of his life

working out of that small building on Broadway Avenue. He had been tattooing for thirty years, and here he was, staying home.

He was unmoored, trying his best to stay busy in the garden. He also had a new job on his hands, one that didn't pay and was awfully difficult: homeschooling his kids, who could no longer attend their school.

We occasionally met up. Matt and I would stand six feet apart, speaking through homemade masks. His kids would run around and show me their favorite toys. He told me he was doing a fair amount of drinking in the garage while playing Dungeons & Dragons over Zoom in the evenings. It always felt like we had just seen each other the day before. We would rehash old times and try to plan for an unpredictable future.

Matt seemed out of place while standing in his suburban driveway. I thought it was just me, because I always saw him at Premium, but he brought the issue to my direct attention. He explained that he didn't feel like himself outside the shop. The pandemic forced him into a new regime of activity and in this way nudged him away from old routines. He seemed plucked from his own life.

We got back to tattooing when California mandates lifted, but we were now wearing masks and implementing an even more rigorous safety regime. We even tried using these plastic face shields for a while, but the glare obscured your vision, and that would never fly while tattooing. We had air purifiers all over the shop, and we checked people's temperature at the door.

The days of hanging out, doing walk-in projects, and fidgeting through the doldrums of slow time were gone. There was no more standing around watching Pauly try to tattoo *pendeja* on someone's inner lip. There was no more teamwork, either, which made tattooing a bit harder. You couldn't employ the glamour like you used to. The shop was like other public places— transformed into a potential site of exposure. We had a lot of people trying to get tattoos, but doing them just wasn't the same.

There was no more Dungeons & Dragons, no more blood-and-lightning talk, no more conspiring with Karime about how to better handle strangers. I yearned for the old times, especially for moments when Matt walked me through a challenging tattoo or when he helped me rework a design. I missed the time spent passing around photos of our work in the fading sunlight on the shop's back patio. I missed our backstage world.

Matt's enthusiasm for the basics of tattooing—those challenging basics—seeped into my experience and stayed. He made tattooing fun and offered me a sense that I belonged to something important. My loss of the shop inspired within me a feeling of loss in a more general sense. I'd only been at it a short while, yet I felt a tinge of estrangement. I turned toward my academic work but was unsure as to whether I could ever fully leave tattooing. It turns out I couldn't. This isn't because I couldn't stop tattooing people.

My body was the main source of my tattoo experience. And, as I got into tattooing with a research project, it was a focal site of *study*. It was the tool, vehicle, crash pad, and subject. I couldn't leave tattooing behind because I couldn't leave myself behind.

The Body Is the Field

Ethnographers like me often end their stories by describing how they left "the field" or their site of study. They use this description for good story-telling and for a last-minute reminder of their argument. Ashley Mears, an ethnographer who became a fashion model, left the field when she was dismissed from an agency. Her description grants closure and furthers the argument that models are made to feel like the next big opportunity is always just around the corner.[1] But researchers like Mears, and perhaps like me, spend more time describing getting *in* than getting *out*.

This is a remnant of history. Ethnographers have long approached "the field" as a strange (read *foreign*) world.[2] The approach reflects how researchers have thought about and completed their work, as studies have mostly been done by white men traveling to distant lands to describe distant peoples. Getting in among them involved challenges, which prompted researchers to write about the process extensively. Getting out required they jump on a plane and leave.

Many ethnographers now work from home, or at least they study things much closer to home. They have a different relationship with "the field." They *make strange* the people and worlds already associated with their lives to some extent.[3] But even as ethnographers may study closer to home, they still write more about getting in than they do about getting out. This is curious because the process of getting out can involve considerable challenges for the home-based ethnographer.

As I've mentioned, I lived in a *similar enough* world to those at Premium and the Bay Area tattoo scene. I could operate in it without radically changing how I looked, talked, felt, and otherwise cared. My ability to do so was aided by my having grown up as a white, straight, cisgender working-class kid in Bakersfield, California. It's also the case that I got in and got along with Matt because he'd been tattooing me for years before I ever approached him as a researcher. He knew I could be an asset, too, especially in my affable way with strangers.

But the idea of leaving the field—and just what the field was in the first place—remained complicated. For one thing, I was never very far from Premium Tattoo. I could drive there or to Matt's house any day. And it was around the time of this project's initial completion as my PhD dissertation that I became more embedded in tattooing than ever.

Just three days before submitting my second draft, for instance, the owner of a new and already-reputable shop contacted me to see if I might want to "come see the space." I knew this was an invitation to join the shop. I paid a visit and found myself once again imagining my life as a full-blown and long-term tattooer. I was immensely flattered and torn, wondering how I would ever tell Matt.

The shop owner suggested I could do a guest spot or work for a few days to try it out. They were in the same position as Matt, working to develop a solid crew of people who could do good tattoos and give people good experiences. I didn't go for it because Premium had become a home.

But beyond the interpersonal challenges of getting out, of telling Matt goodbye while staying so near, leaving the field in a deeply embodied ethnographic project was hard because the field extended into the realm of *my own body*. My body was the field.

I carry with me a set of bodily practices, forms of attention, awareness, and modes of evaluative judgment specific to tattoo labor. And even if I were to forget all of that, I'll carry "the field" on, or more precisely *in*, my skin. I was tattooed extensively throughout my experience. I did a bunch of those tattoos myself, bad ones that will be there just as long as the good ones.

The fact that I became the field and used my body as a source of direct exposure—as a source of data—was a good and a bad thing. It was both good and bad because the body keeps track.

There are things I would rather have left behind—namely, the nega-

tive impact that even my short time tattooing had on me. The slight tinge I now feel in my neck when I turn quickly to see over my right shoulder, for instance, wasn't there before I began tattooing. I sometimes wonder if anything invisible is going on, too, from exposure to cancer-causing agents within the cleaning products. And while my shoulders began their crunching in graduate school, tattooing did nothing but amplify the matter. Tattooers hunch over working and for hours each day.

There's also that new tendency of my right hand to clinch while I'm asleep, causing me to stretch it repeatedly on waking. Tattooers hold the vibrating machine in one hand while using the other to stretch the skin, a task made especially hard when employing the weighty coil machine. In fact, I didn't use a coil machine because I knew it would rattle my bones all day. Those machines are pretty loud, too, so loud that they cause hearing loss. Picture it: a right-handed tattooer bending their face near the client's body with that machine blasting off near their right ear for hours a day, for years.

I quickly learned, too, that tattooing puts a person at risk of communicable disease. Tattooers expose themselves to the potential of illness in their intimate work with others, a fact that grew more acute during the COVID-19 pandemic. The risk of showing up to work—or anywhere, really—was on the minds of many people in a new way. It made tattooing that much harder, and perhaps more rewarding, because connecting with others in real time became a rarified pleasure for many of us. But I was prone to worry over getting even a slight cold. I scarcely wanted to breathe in that shop while COVID was around.

All this to say, tattooing threatens the longevity of bodies. And the psychical implications of tattooing sediment over time. Matt had what he called a "baseball-sized" knot underneath his right shoulder blade. He would stand up after tattooing for an hour and make circles with that arm a couple of times before pacing on the back patio. His casual walk was stiff.

I once interviewed a guy who spent eight years tattooing out of a very small room. The room was effectively a booth inside a rather esteemed San Francisco shop. It was cramped, though, and he told me he developed a back injury while working in the small space. The injury made it so that he could scarcely tattoo without experiencing a great deal of pain. He was opening up a new, big shop in part because he needed what he called "something to fall

back on." His own tattooing seemed to be slipping away as his body deteriorated. But some people don't even make it eight years.

A woman who'd been tattooing just *one* year told me she struggled with carpal tunnel. She had developed a habit of holding the machine such that the webbed muscle between her thumb and hand "just wasn't functioning anymore." She was really good at tattooing, surprising everyone around her, yet she was consumed by a fear that she wouldn't make it over the long haul. Like many tattooers facing problems with hands and wrists, she switched from the heavier and more vibrating coil machine to one of a lighter rotary style.

While some tattooers I met took preventative measures—exercising, meditating, and otherwise training their bodies to avoid injury—most of them didn't do any of this. Matt and Pauly, for instance, took to booze instead. Many tattooers don't take precautionary measures while working, either. We at Premium contorted our bodies into any position that might allow us to make our best tattoos. We'd mostly work while sitting on a stool, but we would occasionally stand and hunch over if it meant pulling a better line.

There was a popular phrase among tattooers during my time at Premium: "Crooked spines make crispy lines." To be sure, some tattooers I met critiqued the phrase. One called it "ableist" because it was organized by negative sentiment toward people with disabilities. Having taught college students about the social construction of disability, I understood and felt at home in this critique. The phrase lived on nonetheless, of course, and Pauly loved it.

He loved it because he generally enjoyed associating himself with the presumably battered bunch of tattooers who sacrificed their bodies for the great call of tattooing. Of course, he often did things to his body that would damage it over time, anyway.

Whether these things were voluntary was up for debate. I always put his drinking near the voluntary end of things and the manual labor he did outside the shop closer to necessary. He used his body to make money, and he altered his experience of being in that body for what occasionally looked like fun. But he was like any tattooer in that the labor would damage him over time.

Tattooers aren't alone in this fact of bodily harm at work. It only further aligns them with people who do other types of labor, specifically *body labor*. Sociologist Arlie Hochschild's now-classic book about commercial flight attendants explains that they regularly experience hearing loss, dam-

aged ankles, and stress-related illness on account of working in moving airplanes.[4] Manicurists and hairstylists are, of course, exposed to chemicals on top of the demand that they do repetitive movements while hunching or standing all day. Body labor takes its physical toll over time.

A huge problem for many tattooers, especially those who don't own shops, involves the fact that they can only make money by doing tattoos. This leaves a slim margin for error, making it so that a break from tattooing could easily become a break from a decent living.

Most tattooers in the US likely don't have adequate health care. That is, they don't have much protection from the bodily and economic harm caused by repetitive stress injury or acute accident. A few notable tattooers got hurt in motorcycle accidents during my time in tattoos. Others experienced the tragic discovery of cancer. They occasionally organized fundraising campaigns to pay for treatment. I donated a small amount of money to a few of these campaigns. They always had a feel to them—like they were made by people who *really* didn't want to be asking for money on Instagram.

Watching successful tattooers ask strangers for money to cover surgeries made me warry of tattooing, generally. It was all too easy to envision myself lying in a hospital bed trying to type out a funding campaign message after some accident.

This aspect of tattooing, along with the daily uncertainty of work and the many hiccups that could occur with any client, motivated my exit. I also had other ambitions and new responsibilities. I was about to become a dad, for instance.

But if I'm right, that tattooers embody skill as they encounter and solve tattoo-related problems, it might be the case that tattooing is "like riding a bike," as a veteran tattooer said one afternoon. Maybe I could jump on occasionally, although the responsibility of tattooing someone makes me warry of doing it casually.

I like to think that having become a tattooer secures my position in an unleavable field. It's one that I, Matt, Pauly, Karime, and thousands of tattooers have grown to share. We share it because we've all been there, trying to keep our shit together while tattooing the squirming live body of a stranger for money. We might have worked in enclaves, digging on different stuff in different scenes, but there was something broader that held us together.

I *did* leave, though. It was expected that I would break from the shop at some point, but this didn't make it easy. Matt was torn up about it, and he did what he knew best—ripped the Band-Aid off. I wanted to stay on and work occasionally, but he wouldn't have it.

There was a final Saturday. I did five tattoos and had a magnificent time. My clients were great, even if one of them decided to *not* get their tattoo after all. It was best to not do the piece, much better than doing it with even a spark of hesitation. My tattooing was better than ever, as I was moving through each project with ease. I even tattooed Karime as a kind of farewell gesture. We had grown close over the years, and we spoke of the future, especially about their aspirations in tattooing. There were, after all, a great number of shops and heaps of opportunity beyond Premium, that small building on Broadway Avenue near downtown Oakland.

On that last day, I also tattooed someone while they were getting tattooed by our newest apprentice. I had wanted to do this kind of tag-team work from the start. I gave the guy a great deal, moneywise, because I just wanted to do the piece.

This new apprentice was a queer woman of color dedicated to crafting a bold, traditional style. They were great with people and their flash was solid. They joined the shop at the same time as another queer woman, and both of them were thriving. I was sure they would lend a positive spirit to the shop generally. I even gave one of them an old machine of mine, a bright pink rotary. It was clear to me they would be doing good work and making some cash in no time.

Their entry into the shop was a great reminder that, in fact, the world didn't revolve around me. I had been worried about the impact of my leave, but of course Premium would go on. It didn't need me, as much as Matt would occasionally say otherwise and as much as my own ego might've suggested.

I still enjoy the thought of picking up a machine and tattooing people at the shop. I occasionally want to ditch everything and do just that. But, of course, this idea is built on a romanticized vision of the work. It fails to include the great challenges I faced with tattooing, because it's easy to forget just how hard it actually was when I consider it abstractly. The thought is organized by nostalgia, too, because it involves a scene that's stuck in time. Like everything else, Premium changes every day, even if those changes are hard to notice.

But I'll cherish the times: standing on the shop's back patio with Thin Lizzy blasting and with Matt drinking beers and smoking joints could be so good, especially after a long day of work, with Pauly giving me shit. He'd go on in a playful way, one I had come to find endearing. We would share photos of the day's work and pump each other up over the wins. We would also help each other through the losses. Karime would be there, too, standing while digging the scene and chiming in occasionally.

I would miss Matt the most, especially the look on his face when he shifted into his nighttime mood after a day of solid tattooing—when it all came together and flowed without interruption. His eyes would widen, and his voice would deepen. He'd rave about the pains and pleasures of what we did to people and their bodies for money. He would rage about what it all did to us, too. He would get that look on his face, and it wouldn't be long before he'd meet my gaze, clinch his right hand in the air and say, "Blood and lightning, my dude. Blood and fucking lightning."

ACKNOWLEDGMENTS

Like any tattoo, a book is the outcome of people working together. I received a lot of help, and I want to thank everyone who participated in this project, especially the crew at Premium Tattoo, the folks who sat with me for interviews, and the hundreds of people who allowed me to do my best on their bodies—those who will carry with them a series of marks and a batch of memories from a moment we shared.

Matt, Pauly, and Karime are due special mention. This project would've been impossible without their buy-in, help, humor, and eventual friendship. Matt's openness to me and the rambling aim of my curiosity will forever stand as a profound experience in my life. I benefited a great deal from him, his shop, his knowledge, and his everyday work. I would like to also thank his partner, Hillary, for believing in my intentions and, by extension, supporting my dream.

Huge thanks to my editor, Marcela Maxfield, who was able to see a *book* through the mess that was my initial proposal. Marcela's insistence that I remain steadfast in the desire to develop a narrative and embodied ethnography motivated this book's development and eventual completion. There was also Claudia La Rocco, who invited me to research and publish for Open Space. Before Claudia there were Rick and Meg Prelinger, who allowed me to pour through their incredible library chasing a dozen ideas.

I would also like to acknowledge the scholars who brought my ideas to life as a PhD dissertation: Laura Grindstaff, Maxine Craig, and Mary Kosut. They understood this project, and they understood me. Like Marcela, they supported and occasionally protected what I loved most about the work. There were others, too, including Stephanie Mudge, David Kyle, Dave Mc-Court, and Jennifer Lena, who proved essential in my desire to become a person who could think, feel, and act from within a sociological imagina-

tion. David Lane helped me focus that imagination on the world of tattooing, as did tattooer and podcast host Andrew Stortz.

Beyond them, the shop, and everything else stood my partner, Megan Kiskaddon. She was first to notice the potential of this project and, in my return home from the shop after a long day, would encourage me to take notes. She edited the work, listened to me talk about it for years, and supported me immensely. And no acknowledgment could be large enough to capture my appreciation for Arlo, our amazing kid, who will have my heart forever. So, while I dedicate this book to Matt, I remain devoted to many others. Nothing happens on its own. In the case of this book, it happened because of you.

APPENDIX

MORAL CONDITIONS OF ETHNOGRAPHIC WRITING AND RESEARCH

I first set out to study tattooing as a contemporary occupation, peering down at the tattoo world from a position of analytical distance. I was curious about how tattooing seemed to evade the hallmarks of professionalization that have radically altered occupations in the US. Unlike doctors, teachers, and even hairstylists, tattooers don't graduate from certification programs, they don't have professional associations, and they don't maintain any major trade journals.

Questions around the occupational quality of tattooing started to lose their spark once I tried to do my first tattoo. To be sure, I stubbornly held on to the initial questions for a while, forcing myself to ignore fieldnotes that were spilling over with different concerns. I eventually caved, and for good reason, as questions about professionalization didn't really capture what I and other tattooers faced while doing the intimate, carnal work of tattooing.

I turned my attention toward the intersection of people, bodies, and money because it felt necessary. Working to explain how tattooers think, feel, and act within this intersection clarified the core experience of tattoo labor. At least it did for me.

The writing process sharpened this clarity. Most of that writing was garbage, but it was never meant to be good. It was aimed at developing understanding—mainly of what was happening to myself, the people around me, and even the settings in which we lived and worked. The writing process deepened my affinity with Maggie Nelson's claim that writing is more clarifying than it is creative.[1]

The writing was difficult. For one thing, trying to describe how something feels can prompt you to write a lot of words. The majority of those words don't *do* much. Mostly, though, the whole enterprise seemed too internal, personal, and navel-gazey. I wasn't sure it was okay to write that way, and I definitely thought nobody would want to read it. Luckily for me, I'm not the first sociologist to write from within a set of personal, bodily experiences.

Ethnographers have meaningfully paved a path for this book, especially those who became something new in their attempt to better understand the social world. To name just a few: Czerniawski became a plus-size model, Wacquant a boxer, Desmond a wildland firefighter, and Mears an editorial fashion model.[2] These and other scholars have helped develop practices of embodied research that might variously be called feminist ethnography, autoethnography, embodied ethnography, enacted ethnography, and the more hands-on types of participant observation, grounded theory, and participant-action research.

Given that it derives a great deal of value from assuming the standpoint of direct participation, this book joins other ethnographies in offering a brief challenge to the (unfortunate) demarcation separating ethnography from its productive, research-based, and wildly successful counterpart: memoir. My hope is that this and other embodied ethnographies may offer evidence to support this demarcation's eventual erosion.

Among the sociologists, I like to think this book responds to Loïc Wacquant's call for a "sociology of flesh and blood."[3] Wacquant developed this program while training as a boxer in Chicago. His direct participation led him to suggest that researchers could enact, with their bodies, the lives of the those they intend to understand. He promotes an "enacted ethnography."

Wacquant's dedication to enactment stems from an approach to the relationship between people and knowledge, one that suggests people are developed through their involvement with forms of practical social action. He argues researchers would do well by treating the "body, mind, activity, and world" as jointly constituted, and he suggests we work to understand people from within their body-mind-activity-world experiences.

Researchers who do enacted ethnography become *constituted* alongside the people they hope to understand and explain. They develop sets of "embodied practical knowledge" derived from direct, carnal entrenchment in

the "webs of action" that make up the social situation. Researchers can wield this constitution to produce the thick description of good ethnography—the stuff that gives readers access to a new world from within the bodies of those who live in it. As Victoria Pitts-Taylor explains, the insistence of doing research *from* the body has plenty of feminist precursors.[4]

Admittedly, I loved the name, "sociology of flesh and blood." Most directly, though, it offered an approach to carnal experience and knowledge production that helped me understand and explain what I found while becoming a tattooer. That is, the approach was useful.

Of course, not all researchers can or should pursue this program. Enactment produces a type of data that won't answer a variety of research questions. But even if enactment would get at the heart of some curiosity, there are things people shouldn't seek to experience directly for the sake of research. Consider imprisonment, human trafficking, or drug addiction.

It's also the case that some people can more easily do this mode of research because they, like I, have been born into a white, male, cisgender body. I never had a tattooer hit on me, and I never suspected they were talking to me because they wanted to try and have sex with me later on.

There is the issue of skill, too. I had developed skill in drawing and painting long before I ever stepped into a tattoo shop. I would have been hard-pressed to become a tattooer had I not had considerable practice drawing. Alongside this skill is a more fundamental state of ability. The spaces I inhabited were built with a single type of human body in mind, one that reflects the state of ability I occupied. I don't think I could have done what I did from a wheelchair, for instance.

In addition to all this, there is the matter of access to unstructured time. I spent whole days in a tattoo shop and for years, working through evenings and weekends while holding two other jobs. I would have decided against the whole tattoo life if, for instance, I had a newborn at home, like I did while writing this book.

For these and other reasons, it's naive and perhaps wrong to suggest that enactment is the *only* way to understand body laborers, even if you want to explain their embodiment. It was available to me, fortunately, and it proved essential for my work.

But I did more than become a tattooer. The writing and its interrelated task of data analysis involved a huge effort in organization. I had, after all,

written more than five hundred pages of single-spaced fieldnotes, recorded dozens of audio notes, took hundreds of photos, and filled pages with diagrams and bouts of confession. I had compiled books, magazines, podcasts, and news stories. This means that *Blood and Lightning* is only one among many potential stories that still swim around in the data.

I invented a process to help isolate what should be included. I asked myself, "How much does this component rely on my experience becoming a tattooer?" Any detail, occurrence, question, or topic that relied heavily on direct experience with tattooing was a shoe-in. That which seemed answerable from outside the experience of doing tattoos was given pause. The process allowed me to navigate through a large medium of potential.

Of course, there's a lot in this book that doesn't rely on experience tattooing. A person doesn't have to become a tattooer to describe apprenticeships, at least at face value, or the conventions of tattoo practice. They don't have to do tattoos to describe the tools of the trade or how queer folks are creating their own tattoo world. I include these and other components because they help flesh out the setting in which tattooers operate—that intersection of people, bodies, and money—along with its broader historical context. They also grant the story a sense of completeness expected by readers, at least those who offered feedback from drafts and presentations shared before this project ever became a book.

On the writing itself, I tried to communicate the story in the "three languages of the sociologist."[5] These include the language of sociologists, fellow tattooers, and more general readers. My peers in sociology wanted a theoretical contribution, my fellow tattooers wanted an honest yet flattering representation, and I assume more general readers want juicy narrative. I sometimes cater to one audience more than another. The tension between audiences echoes my lived experience—as I spent years balancing the life of a sociologist, tattooer, and writer.

And while I place myself center stage, the book isn't only about me. It's also not just about Matt, Pauly, Karime, and me. The many conversations I had with tattooers and the more formal interviews I conducted with some of them inform the entire work. These and more extended discourses on social theory, methodology, history, and philosophy are often backgrounded.

The fact that this book is about people other than me shapes the more *ethical* aspects of its production. By "ethical" I mean its moral features,

the qualities of good and bad wrapped up in what I did and didn't do. The book likely implicates everyone involved in a degree of risk they otherwise wouldn't have encountered.

I use this appendix to explore the ethical conditions of ethnographic writing and research. I also use it to fulfill the curiosity of some readers who might want to learn more about the details of data collection and analysis.

Ethics of Ethnographic Writing and Action

Melisa Febos reminds us that writers confront an ethical predicament when describing the lives of other people.[6] The predicament stems, in part, from the fact that the product of writing, be it an article, book, or tweet, is a representation of something else. That something else could be a local city council decision, a popular restaurant, or it could be your mom.

The writer shapes this representation through word choice, sentence structure, and matters of punctuation. Everything a reader encounters is the outcome of a choice, and each choice opens one opportunity while closing at least one other.

In my case, I made thousands of choices that culminate into the representation of real people doing real things at work, specifically Matt, Pauly, Karime, and myself at Premium Tattoo. Each choice contributes to their incomplete characterization throughout this book. The choices can render this representation better or worse.

I gave the near final copy to Matt so he could read it over, offer feedback, and share it with Pauly and Karime. I also emailed a copy to Karime. Pauly was in the shop when I gave Matt a printed version. He reviewed the chapter titles and, in all seriousness, pointed to "Mispld" and said, "Hey bud, you misspelled something." Matt and I nearly came to tears laughing, with Pauly catching up and laughing along with us.

There was fun involved, but the fact that a selective representation of their lives will remain fastened to the page long after publication implicates these people in a degree of risk they otherwise wouldn't experience. It's a frightening thing to inscribe people into a book. This is partly because the reader may (wrongly) conclude that what's been described in it is uniquely bad.

I often conjured a folk saying to buffer against this fear while writing: "If you look at anything too close, you're gonna find shit."

This helped because, of course, I reveal people making mistakes, working near or just past the edge of their skill, and drinking too much. I only hope the reader will assume that a few years spent among nearly any group will show them and their scene to be characterized by the less-admirable contours of everyday life.

The stakes wouldn't be so high if this book used pseudonyms. It is standard ethnographic practice to employ pseudonyms at every turn. Believe me, I often approached this practice as an out-of-reach luxury. Those most directly involved in this story didn't want me to use pseudonyms, so I didn't use them. Many of those interviewed or otherwise featured didn't want their names in the book, so you instead find descriptions like "A tattooer of ___ years." Some preferred pseudonyms because, in the life and times of a tattooer, reputation matters.

In my case, tattooers like those I've written about rely on a steady clientele, and their clientele is amassed or disbanded with fluctuations in reputation. For those who didn't want the pseudonyms, publishing the book can strain their reputation, which is a risk to their livelihoods.

This risk is instructive, teaching us that the ethical conditions of ethnographic writing are shaped by the economic conditions of the field and its people.

This economic logic of reputation applies for whole shops. In tattooing, where stepping outside conventions can inspire reputation-smashing campaigns by fellow tattooers, Matt and Premium are opened to the potential of economic hardship because of this book. For one, it exposes what many tattooers work to obscure—the fact that tattooing is way harder than it seems. While some tattooers may be flattered, they'll also know that the emotional and physical labor they do to conjure the glamour spell for clients could be threatened.

Of course, the book could grant heightened visibility to those within it. This may actually inspire an increase in business for those involved. The problem here is that some especially critical readers may suppose this to be the plan all along, as though the work was actually a creative marketing scheme. It was an early suspicion from the institutional review board of my PhD-granting institution, anyway.

I only felt glad to be aboveboard with Matt as a researcher, as I don't know how I could've handled being covert with him—not telling him about

the research project and instead pursuing an apprenticeship as though no research was happening. Ashley Mears describes the anxiety that stemmed from such covert research while working as a fashion model.[7] She only revealed her sociological aims late in the project.

The surprising thing for Mears was that no one seemed offended. Some were fascinated and quickly offered their own sociology of the fashion world. She had been racked by anxiety due to the deception but also because she feared "coming out" as a researcher would change the situations around her. She wanted to study life as it generally happens.

I likewise wondered if my presence as a researcher at Premium would impact what people said and did. It might have at the beginning, but the subtle effect of my presence didn't seem to last.

Many ethnographers have shared that their presence in the field didn't seem to matter at all.[8] As Mitchell Duneier argues, social processes have a "structure that comes close to insuring that a certain set of situations will arise over time"—that is, that a researcher's presence won't override the "pressures, obligations, and possible sanctions in the settings."[9]

The idea here is that ongoing social situations—such as the daily happenings in a tattoo shop—have an inertia that doesn't yield to the presence of a researcher.

It's also the case that people embedded in a mode of living, working, arguing, and so forth won't know what an ethnographer might find most interesting. Indeed, the point of hanging around with people all day for years is to understand what they take for granted. This requires the researcher to identify and describe how these people experience their world, and every detail counts.

Consider this: Matthew Desmond spends precious words describing how wildland firefighters get dirty. The fact that firefighters get dirty could hardly be more obvious, but he isolates this observation and transforms it into a vehicle of sociology.

Desmond anticipates the reader's potential displeasure with such a finding and assures us that a firefighter's comfort with dirt is "not a trivial point." He argues it's rather a source of the "practical knowledge" that explains their relationship to work, risk, the self, and others. That they're cool with being filthy—that they celebrate it, even—is a big deal, and he lets us in on it.[10]

People generally don't approach their taken-for-granted experiences as worthy of concentrated time and attention. Indeed, a firefighter critiques Desmond's work for describing what seems obvious.[11] People might also have a hard time describing what they'd otherwise consider to be a commonsensical approach to life. Prompting them into conversation about what they take for granted can be tricky and embarrassing.

I asked Matt all sorts of "obvious" questions to try and tease out his basic assumptions about tattooers and their work. Questions like, "What if tattoos didn't last forever?" seemed, at least when I asked them, like dumb questions. I'd ask tattooers I just met if they ever get scared before a big project. They would look at me as though I was trying to trick them into something, not because they were offended but because it was just so damn obvious. Of course people would experience fear before giving someone a complicated tattoo. What of it?

Matt appreciated my attempt to make sense of common sense. Not all readers will understand what I've tried to do, though. In fact, audiences produce their own meanings of what they encounter. They (we) place weight on some things and not others.

Broadly speaking, the more ethical features of ethnographic writing add context to the ethical conditions of research itself. I interviewed and talked with folks, sure, but I also tattooed strangers for money. I did so because I wanted to become a good tattooer, but I was also there for another reason. To echo Michael Herr's point on observing the Vietnam War, *I was there to watch*.

Ethics of Research

There are risks associated with doing field research that are particular to the kind of embodied ethnography I've done here. Those risks can be a bit difficult to communicate, especially, perhaps, when drawing on so much Erving Goffman in the text. This is because Goffman's dramaturgical sociology can, regrettably, paint the social world as a big show—a stage on which we exist as mere players.

Goffman himself describes that all the "language of the stage" he uses, including "performers and audiences" and even "backstage," is intended to be read as a "scaffold."[12] The scaffold, he suggests, should be taken down after

it's fulfilled the duty of propping something else up. The stage is a metaphor. Goffman uses it to produce a more direct take on the "structure of social encounters," a key facet of which involves the task of maintaining a definition of the situation.

Keeping the definition afloat—whatever it happens to involve—requires a great deal of performance. The people who do this performance, all of us, employ similar techniques as stage actors. We follow cues, manage impressions, and wield our bodies toward the task. To be sure, there's a significant difference between the theater and the social world. The social world, with all its performative characteristics, is full of real consequences.

An actor who fails in a performance onstage may indeed face a challenge—say, to their ability to work as an actor—but that consequence doesn't change so much if the actor fails to perform the role of doctor or line cook. The social world is different. A failed performance might cost you your job . . . or it might even get you killed. In the context of tattooing, it might mean you misspell the word *pendeja* on the inside of a stranger's lip. Or maybe you touch all the wrong things in the wrong order and give someone a terrible staph infection. Maybe you give yourself Hep C along the way.

Just as people perform in social situations, ethnographers conjure their own performance when diving into a new social scene as observing participants. But, because they're *not* on the stage, they can risk messing things up and for real when they do.

Some ethnographers buffer against these risks through previous training in what they did *as researchers* later on. Mathew Desmond was a firefighter before becoming a researcher-firefighter. Ashley Mears was a fashion model before becoming a researcher-model. In each case, the researcher came into the scene schooled-up and therefore didn't expose themselves and others to new daily hazards.

I was trained as an apprentice, of course, and I wouldn't have started just tattooing people out of my house (as a researcher) like many wannabe tattooers do. But I still had to learn how to tattoo people through direct experience, because tattooers gain most of their skill, and especially their technical skill, while tattooing. While I was able to tattoo Matt, Pauly, Karime, my friends, and myself first, every tattooer has to leave that nest at some point, and of course I did.

There's a tattoo from the early days that still shakes my nerves. The client

came in near closing time. We were actually preparing to play Dungeons & Dragons, which meant the shop probably smelled like weed. The guy asked for a piece along his rib cage. He wanted the name of his wife, beginning with a "K" near his back and ending with a "y" near his chest. A seasoned tattooer was available, one who could do the job well and one who needed the money more than I did.

The problem was that it was my turn. I'd been around all day without doing a tattoo, while this other tattooer had recently arrived. I'd also begun the conversation with the client if only because I was near the door when he walked in. I didn't want to do it because I knew the other tattooer could've done it better. But I knew it would be inappropriate to hand the project over.

The tattooer would've been very surprised, and while Matt might've understood, he would've been disappointed. It was my turn, my client, and my chance to make a buck. Everyone knew I could do the tattoo well-enough, so it wasn't like cases I had faced before—ones where my lack of skill in a particular technique allowed everyone to comfortably prevent me from trying to do it. Any street-shop tattooer I ever met would've jumped on the project. They would've been expected to do so. And wasn't I a street-shop tattooer?

So, I did the piece. I had a good time with the client, and the tattoo came out all right. We took pictures, and he gave me a decent tip. He sent those pictures directly to his wife, and he gave me a hug. I cringe while looking at the photo, though, because I know the piece would've been better if it had been done by the other tattooer. I knew that things like this happen in tattoo shops all the time, but the difference was that I was also a researcher.

While I often disclosed my research to clients, and especially those who booked appointments for more stylistic work, I didn't tell everyone about it. My clients weren't my research subjects; the tattooers were. But, of course, the client was the medium through which any tattooing could be made possible. I needed them, and, in some sense, I used them. *All* ethnographers, journalists, memoirists, and so forth use people and scenes to accomplish their goals.

I told Matt about this dilemma one afternoon. We rarely discussed the research project, as he asked that we didn't, but I sometimes brought it up anyway. I told him I thought I was in tattooing "for the wrong reasons." He laughed and said, "What the fuck are the right reasons, then?" He reminded me that people tattoo for money and that everyone wanted *something else*

as tattooers. My "something else" was understanding and a book. His was a livelihood. I wasn't sure he was right, but I took his approach as a form of permission.

In some important respects, the ethical conditions of this research clarified the broader moral character of tattoo labor. It helped me understand the fact that many tattooers find themselves in situations that can feel morally ambiguous or even troubling. I only hope to have communicated that ambiguity such that it can be experienced by those who might read about it.

There are readers that will be skeptical of what I've done because they may think tattooing for research is a shady enterprise, or they may think that all I've done is publish a series of journal entries. The scientism of my peers promotes skepticism of "I" statements, in particular. This skepticism is rooted in good reason; they want to know that what they've been reading is an outcome of legitimate research. They want to know it was produced through a process meant to buffer against bias, as much as they know that some bias will always permeate attempts at truth-telling.

I respect the skepticism, especially in the face of the creeping piles of false truth lying around in books, articles, podcasts, and news stories. We should be critics of what we encounter. I hope to satisfy at least some of the suspicion through a quick description of data collection and analysis.

Some Nuts and Bolts on Data and Analysis

Like most works of sociology, this book was born from the process of transforming a set of social experiences (data) into a vehicle of explanation. I did this with help from social theory, methodology (the study of method), and the process of peer review.

The book mostly draws from firsthand experience of becoming a tattooer and, especially, from the fieldnotes I took to capture that experience. These notes include free-form moments of personal reflection. They contain lists, charts, and drafted exercises through which I explored a number of sociological concepts and theories. I tried to ensure I contextualized the notes I took down—adding information about the scene so that I could know what the little details amounted to when I reviewed them later on. Although I was always exhausted after eight-plus hours at the shop, I only missed a few evenings of notetaking while working as a tattooer.

These fieldnotes also include hundreds of statements made by tattooers, mostly Matt and others at Premium. I used my phone to record these statements verbatim, often typing them just after the statement was made.

The act of grabbing a phone to take notes in the tattoo shop was far less awkward than you may expect. When not actively tattooing, tattooers are on their phones all day. Those around me didn't seem to even notice that I was typing furiously throughout our time together.

I would also go to the bathroom and otherwise make myself unseen while taking notes in situ. I spent some real time in that bathroom typing fervently. When I couldn't capture these statements as they occurred, I would repeat them to myself (often while tattooing) so as to remember and record them later.

Although I took notes at Premium, I recorded the majority of them while on the go. I usually did so while commuting between my three jobs. I used a voice-to-text feature on my phone and, once I figured this out, talked at the phone every day for years. I did so while in the car, taking walks, exercising, cleaning, and lying in bed. I transferred the notes into a Word document on my computer a few times a week. I cleaned them up and labeled them by date. I conjured up rough themes as I went along, and I clarified those themes through a process of qualitative data analysis.

I tried to capture everything, from what I thought was "important" to what proved to be surprisingly important only later on. I wrote about the weather, about the music we listened to, about what we ate, and about our D&D campaigns. The wide-net approach paid off.

This note, for instance, didn't seem immediately relevant to my project when I took it down: "It is an interesting thing to touch people's bodies in the shop." I recorded it more than six months before I ever thought to study touch. Actually, I chose to focus on touch and embodiment because comments like this began popping up in my notes.

I also gathered hundreds of photos and videos of people working at Premium. They feature people doing tattoos, Matt teaching me how to tattoo, and other aspects of the shop in motion. I also photographed tattoo shops I visited, if the people inside said it was cool. I organized these artifacts into folders on my phone and moved ones that seemed especially relevant onto my computer for later review. I backed everything up on a password-protected external hard drive.

The videos proved essential in my writing and analysis, jolting my memory and encouraging me to take the aesthetics of space seriously. They allowed me to rehash experiences with a vivid quality unavailable in the written notes. But this book is the product of much more than my own note-taking.

I began talking with tattooers across the Bay Area while writing an article for the San Francisco Museum of Modern Art.[13] The article explores the "tattoo school" struggle involving Matt and his shop. I identified the prominent people of this struggle and interviewed them. I asked these initial contacts if they knew a tattooer that I should talk with. That is, I employed a "snowball" sampling strategy, and this was a good idea.

It was a good idea because a lot of tattooers know each other, or at least *of* each other, and because they're often suspicious of curious outsiders. Gaining a recommendation from a trusted source allowed me access to people who might otherwise have refused to speak with me.

I broadened this initial sample by walking into any tattoo shop I passed. I talked with people inside, mostly tattooers but also those working the counter and a few apprentices. The majority of these encounters were thirty-minute conversations, but I had some that lasted more than an hour. On two occasions I stayed after the shop closed, talking and generally hanging out.

It became much easier to talk with tattooers once I became one myself. The guardrails on our conversations would fall away, and we spent good time sharing deep inside baseball information. We compared machines and techniques, and we learned from one another. We complained about our clients and laughed, if nervously, while repeating stories about mistakes and projects that otherwise had gone wrong. We talked about playing the part for our clients and for ourselves. We were strangers with a lot in common.

I also became rather close with some tattooers by having them give me a tattoo. I got ten pieces by people I wanted to meet, which means I talked with these people for at least two hours. It was an incredible way to meet tattooers, but it was far too expensive to keep up. They often gave me a steep discount—being that I was another tattooer—but still. I had *no* funding, and here I was paying more than a hundred dollars per interview.

Geographically, I spoke (in English) with tattooers in Los Angeles, New York, Paris, Zagreb, and Mexico City. I generally stuck close to home, though, in the Bay Area cities of San Francisco, Oakland, and Berkeley. The

Bay Area is a special place. Many tattooers call it "the mecca of tattooing" because some of the best tattooers work there and because it's the site of some key developments in US tattoo history.

For example, it was Ed Hardy in San Francisco who opened up the country's first "private studio," wherein those getting tattooed have to make appointments. Hardy was among the first to do "custom" tattoos—designing original images for each client rather than relying on flash designs. He was influenced by the art world, having gone to art school himself, and by the tattoo practices of people in Japan, a country he visited for decades. The legacy of Ed Hardy and other influential tattooers lives on in the Bay Area.

My location also means I spoke with a few very successful people. They had been in magazines and on TV. They made $5,000 a week, owned million-dollar homes, and drove nice cars.

But I never wanted this project to reflect just their lives, the ones who'd found great success as tattooers. We at Premium were *not* famous, and those I spent most of my time with didn't land on magazine covers. They instead carved out a decent living by doing tattoos five or six days a week. I spoke with apprentices, too, who were unknown and broke.

While I often gleaned more from casual conversation than I did from formal interviews, it's important to note that I did twenty-three recorded interviews. I created a team of three research assistants to help transcribe and analyze the recordings.

The majority of those who sat for interviews identified as women, queer, or trans, which is yet another site-specific, San Francisco Bay Area feature of my experience. Most interviews were more than an hour long. While two of them were done over the phone and one occurred in a coffee shop, the rest took place in or just outside a tattoo shop.

These interviews opened the potential to write a book about queer tattoo culture. That book, though, wasn't mine to write. Importantly, too, its related questions and concerns weren't the things that kept me up at night. I tried to trust that the story most important to me would be the one I could tell best.

So, the story isn't about queer tattooing, nor is it about the tough-white-guy tattoo world. Many people who responded to drafts wanted it to be just that, or rather a take-down of bro white-dude tattoo culture. I occasionally wanted to write that book, especially after talking with people who had been harassed and otherwise shunned by men in tattooing.

But many white, tough-looking men declined conversation. For instance, I once entered a tough tattoo shop in San Francisco to find a big man with big folded arms telling me, "You're lucky you can walk in here and ask me that question." I had asked if any tattooers could talk with me, another tattooer, who was writing a book.

Granted. I wasn't dressed for the occasion. I wore a wide brimmed hat, a silk scarf, and colorful sneakers. I stood out as suspect in the hypermasculine scene. I wasn't offering to pay for their time, either, and I may have just stumbled on someone else's bad day. But it wasn't just that guy. Many men gave me the cold shoulder, and their refusal was interesting on its own.

In addition to the hundreds of hours I spent tattooing in a shop, the many casual conversations, and the formal interviews, I drew from secondary sources. These sources included academic publications, many of which are cited throughout this book, as well as more popular types of material.[14] I took notes while on my third pass of Ed Hardy's memoir, and I devoured magazines, including *Tattoo Time*, *Machinegun Magazine*, and the contemporary *TTTISM*.[15]

I contextualized these sources with material from podcasts, including *Books Closed* by Andrew Stortz. My research assistants and I combed through the episodes and organized them by theme, and I referenced the themes while writing. I was able to interview Andrew and get a tattoo from him, and we upheld light correspondence.

I also drew from material featured in museum exhibitions about tattooing. These exhibitions included a 2019 show at the Contemporary Jewish Museum in San Francisco titled *Lew the Jew and His Circle: Origins of American Tattoo*, a 2019 show at San Francisco's Asian Art Museum titled *Tattoos in Japanese Prints*, and a 2019 show at the DeYoung Museum in San Francisco titled *Ed Hardy: Deeper Than Skin*.

I learned a great deal by connecting with tattooers over Instagram. I built up my own humble presence on the platform, accumulating roughly three thousand followers, and I kept up with those who had major influence. I also paid attention to more social-justice-oriented conversations that took place across the platform between the years of 2018 and 2021.

I read thousands of posts, watched hundreds of videos, and took screenshots of many to analyze later on. I also followed local tattooers and commented on their posts, and they did the same for me. It was out of this

process that I did a couple of "trades" with other tattooers, giving them a piece in exchange for one by them. I even invited a tattooer out from the East Coast to do a guest spot at Premium through this process.

All this to say I did some research. I observed, participated, and ultimately threw my whole self at the matter. It didn't provide a whole picture of tattooing, in part because such a whole picture might never make it into a single frame. I wanted to dive deep, and I did. The process gave me what I needed to write, edit, and write again with confidence.

I ultimately hope to have captured my story and theirs—to have described what they think, feel, and do while navigating the intersection of people, bodies, and money. I hope to have learned and explained what it's like to try and do good by the client while still doing good by yourself. That is, I hope to have explained their world, their work, and their lives.

NOTES

Introduction

1. While the metaphor of "streams" is useful in the analysis of policy making, I do not mean to reference or attend to that area of scholarship, even as the metaphor is used in a similarly productive way. See Howlett, McConnell, and Pearl (2014).

2. Goffman (1959, 106–40).

3. Goffman (1959, 3–9).

4. Goffman (1959).

5. Rotary machines employ a rotating motor to drive the needle up and down, somewhat like the machines people build in prison from cassette tape motors but much better. These rotary machines can't be easily customized, tuned, or otherwise altered like coil machines can, as coil machines have adjustable springs and many moving parts that can be adjusted to meet particular demands of the job. Those who rely on coil machines will have particular machines set up for shading or for lining, moving between two (or three, or four!) machines during the making of a single tattoo.

6. Friedman (2015).

7. Mears (2011, 5).

8. Goffman (1959).

9. I use these terms in a way similar to Mears (2011, 108).

10. See, e.g., on manicurists (Kang 2010), hairstylists (Gimlin 1996; Barber 2016), massage therapists (Oerton 2004; Purcell 2013), sex workers (Wesley 2003; Barton 2006; Deshotels and Forsyth 2007; Wolkowitz, Cohen, Sanders, and Hardy 2013), surgeons (Bosk 2003), elderly care providers (Twigg and Atkin 2000), therapeutic spa workers (Little 2012), and nightclub bouncers (Monaghan 2002).

11. On the concept of *body labor*, see Kang (2010, 18–21).

12. See Barber (2016); Craig (2002).

13. Purcell (2013, 181).

14. DeMello (2000, 61); Thompson (2015, 128, 132).

15. Steward (1990, 127–29).

16. There are great resources that explain aspects of the tattooer's experience and answer a burning question: Why do people get tattoos? Some of this work focuses on women with tattoos and the ongoing struggle for bodily autonomy. See, e.g., Atkinson (2002, 2003); Braunberger (2000); DeMello (2000); Kang and Jones (2007);

Kosut (2003); Mifflin (2001); Pitts (2003); Roberts (2016); Santos (2009); Sullivan (2001); Thomas (2014); Thomas, Cole, and Douglas (2005); and Thompson (2015). Research on tattooers also contributes insight on the question of why people get tattoos. See, e.g., Lane (2020); and Sanders (1989).

17. Like boxing, for instance. See Wacquant (2004).

18. Tattooers use *section* to describe the spaces between lines. Most tattoo designs have many sections, and most of these sections require some sort of action—whether it be filling the section solid with ink (filling) or pulling ink from one side of the open space toward another to create an effect of texture, shadow, or transition (shading).

19. On tattooers, see especially Sanders (1989) and Lane (2020). On fashion models, see Mears (2011); and on jazz musicians, see Becker (1982).

20. On the characteristics of a craft world, see Becker (1983, 272–76).

21. Williams (1983, 40–43).

22. Kosut (2014).

23. For Becker (1982), conventions are the "agreements that have become part of the conventional way of doing things" (29). For Biggart and Beamish (2003), they're "habits, customs, routines, and standard practices" (443). Conventions of tattooing are like the "rules of the game," explored by Lane (2020): a "set of core practices, ideas, and values" (4, 13, 119).

24. Stortz (2021b).

25. Weber ([1905] 1958, 17).

26. See Burns (2009).

Chapter 1

1. Durkheim ([1912] 1965, xli).

2. Barber (2016, 75).

3. Archer (2005).

4. See, e.g., Berg, Linden, and Schultz (2020); and Paap (2006).

5. The Solid Waste Division of Alameda County's Department of Environmental Health regulated tattoo shops in Alameda County, including Premium. It oversaw a 2009 "Body Art Ordinance" until the "Safe Body Art Act" of 2012. The act mandated fees from tattooers and required shops to have "Infection Prevention and Control Plans" (Department of Environmental Health 2020). California regulation requires tattooers and apprentices to attain a "Bloodborne Pathogens Certificate" each year.

6. The speed of the needles will vary given different configurations of voltage and machine build. Tattooers generally use higher voltage (higher speed) for linework than they do for shading.

7. Hughes (1962).

8. See Kosut (2006); and Thompson (2015, 21–35).

9. Hardy (2013, 71–73).

10. A "rinse cup" is used while tattooing multicolored pieces. It's a small plastic cup filled with distilled water. The tattooer rinses the needles in the cup before transitioning between differently colored inks. We would press a little Vaseline-like jelly

to the bottom of the cup so that it would become anchored to the surface on which it was placed. While cleaning, you poured some specialized powder into the cup to solidify the liquid so as to avoid any spillage.

11. This was until 2021, when the county began making tattooers submit video documentation of their effort to prevent cross contamination. The onset of this requirement prompted some tattooers to fear an increased intrusion into their lives by the state. Many tattooers I met, and before this new requirement, would whisper that one of these days, the state will come for us all.

12. Lane (2020, 70–86) constructs a similar typology between "formal" and "casual" apprenticeships.

13. Andrew Stortz captures this worry across several episodes in his podcast *Books Closed*. See Stortz (2019a, 2019b).

14. Sanders and Vail (2008, 176), for instance, cite "blatantly unethical and disrespectful behavior" as rooted in "the decline of the traditional apprenticeship system."

15. Hardy (2013, 56).

16. Lane (2020, 178).

17. Private tattoo schools are among other models of training that occasionally change the tattoo world. Tattooers in Oregon were required to obtain certification from a "licensed tattoo career school" before tattooing (Oregon Health Authority 2020), prompting organized response by tattooers seeking input and influence in the process such as "Reform Oregon Tattooing." Some art schools bring tattooing into their curricula (see Westphall 2019; Stortz 2019b).

18. Mabry (2018).

19. Lane (2020, 84).

20. KPIX (2017).

21. Lane (2020) suggests tattooers "view tattoo schools as financial scams" that "defraud fledgling tattooists" (84).

22. Lane (2020) adds that critics view schools as allowing anyone with "time and money to call themselves a tattooist" (84).

23. Goffman (1963).

24. Mabry (2018).

Chapter 2

1. Thompson (2017).

2. Hochschild (1979; 1983, 56–76).

3. The feelings make up part of what is described as the "definition of the situation" or a shared understanding of a local setting and its related expectations. See Goffman (1959).

4. Ahmed (2014, 202).

5. The lifetime is a projected temporal dimension of experience, part of what Tavory and Eliasoph (2013) call a "temporal landscape" that provides "overarching temporal orientations" presumed natural (909; see also Tavory 2018).

6. Bordo ([1993] 2003, xvi–xvii).

Chapter 3

1. Bourdieu (1986).

2. Loïc Wacquant, for instance, describes a process through which the wannabe boxer is transformed—through activity in the gym—such that they take on the *pugilistic habitus*, or "the specific set of bodily and mental schemata that define the competent boxer" (Wacquant 2004, 16). Matthew Desmond uses *habitus* to describe a "fundamental sense of self" among wildland firefighters who seem predisposed to a shared understanding of the world that allows them to succeed in their work (see Desmond 2007). He suggests a change can occur when someone's "general habitus" is molded into a "specific habitus" reflective of their occupational, social, and environmental setting.

3. See Bourdieu (1986); Wacquant (2004, 127–49).

Chapter 4

1. Sanders, Cohen, and Hardy (2013).

2. Smith and Kleinman (1989).

3. See Giuffre and Williams (2000); Smith and Kleinman (1989); Starr (1982).

4. Barber (2016, 119).

5. Merian (2018).

6. Watkins (2022).

7. Merian (2018).

8. Little (2012).

9. Little (2012, 42–43). Guided by a paradigm of wellness, workers who pamper aim to induce emotional bodily experiences that might reduce the stress of their clients.

10. Little (2012, 5).

11. That is, unless the people offering the treatments work (and touch) in a way that ensures men don't feel feminized. See Barber (2016).

12. "Orientalist tropes of Asian women's inborn affinity with body services," Kang (2010) argues, "naturalizes their work in nail salons." It's as if they are good at nails owing to some "inherent biological or cultural traits" (140).

13. Jo Little reminds us that people who go to spas "are seeking 'time out' from busy lives." See Little (2012, 7).

14. Stortz (2021a).

15. See Barber (2016) once again on the role of touch in the masculinization of upscale salon patrons who are men.

16. Obrador-Pons (2008, 123); see also Urbain (2003).

Chapter 5

1. Jablonski (2006, 2).

2. Byrd and Tharps (2014).

3. See Faber (2019); Massy and Denton (1993).

4. See Craig (2002); Norwood (2014).

5. See Craig (2002); Glenn (2009); Hunter (2005); Norwood (2014).

6. Menand (2001, 97–117).

7. For a discussion of Linnaeus's categories, see West (2002, esp. 56–57). Angela Saini argues that more recent science supportive of racial classification is produced by eugenicists and those studying intelligence, human biodiversity, and/or population genetics (Saini 2019, 228–79).

8. Saini (2019, 27).

9. Lombroso ([1876] 2006, 58).

10. See Bennett and Plaut (2018); Yancy (2017, xxix–1).

11. Boyer and King (2019).

12. Lane (2020, 129–30).

13. Mead ([1934] 1972, 261).

14. Bonilla-Silva (2006).

15. Norwood (2014, 4).

16. This can be described as an aspect of their "sensory socialization." See Friedman (2015).

17. See Ruiz (2020); Salvalaggio (2020).

18. Aran (2015).

19. Sanders (1989, 135).

20. Trepany (2020).

Chapter 6

1. Kluger (2014, e46).

2. See Du Bois ([1903] 2007); James ([1890] 1950); and Mead ([1934] 1972, 136, 152–63).

Chapter 7

1. Breton (2014).

2. For starters, see Healy (2006); Ho (2009); Quinn (2008); Zelizer (2005b); and Zaloom (2006).

3. See Ho (2009); MacKinzie and Millo (2003); and Zelizer (1981).

4. As sociologist Derek Roberts explains, tattooers are like everyone else. They know that a highly visible piece can prevent someone from getting a good job, especially if that job involves front-stage work. See Roberts (2016).

5. Sanders (1989, 175).

6. Lane (2020).

7. They develop and work in what Fine (2006) calls "shopfloor cultures."

8. Scholars make this assumption, too. Sanders (1989) refers to the benefits of the apprenticeship when underlining how important the passing of "institutional memory" from "teacher to apprentice" is in the reproduction of the tattoo world.

9. Dewey ([1922] 2001, 42 [emphasis in original], 75).

10. Biggart and Beamish (2003) argue that conventions "involve social accountability" and that they ultimately "provide a basis for judging the appropriateness of acts" (444).

11. See Atkinson (2002, 2003); and Mifflin (2001).

12. See Bythewood (2015); Leven (2015).

13. Goffman (1959, 142).

14. Sociologists who study autonomy among professionals can teach us about tattooers. See, e.g., Eyal (2006).

Conclusion

1. Mears (2011, 249–61).

2. See, e.g., Geertz (1973a–c); and Malinowski (1922). On this notion of field in history, see Desmond (2007, 283–85); and Iverson (2009).

3. Desmond (2007) and Mears (2011) studied the people of their own language, nation, background, and aesthetic taste. Moreover, Mears was a fashion model before she studied fashion modeling, and Desmond was a wildland firefighter before he studied wildland firefighting. Desmond had previously worked with those he later studied, such that they knew him as "primarily a firefighter and secondarily an ethnographer" (2007, 284).

4. Hochschild (1983).

Appendix

1. Nelson (2015, 102).

2. See, e.g., Czerniawski (2015); Desmond (2006); Mears (2011); and Wacquant (2004). For the record, Mears and Desmond had already been these things before studying them. They reasserted themselves as sociologists later on.

3. Wacquant (2015).

4. Pitts-Taylor (2015).

5. See Desmond (2007, 296–97); and Hughes (1971).

6. Febos (2022).

7. Mears (2011).

8. See, e.g., Mears (2011, 263–65).

9. Duneier (1999, 338, 340).

10. Desmond (2006, 406–8).

11. Unger (2007).

12. Goffman (1959, 254).

13. Mabry (2018).

14. Notable academic research includes Atkinson (2002, 2003); Braunberger (2000); DeMello (2000); Kosut (2003, 2006, 2014); Lane (2020); Mifflin (2001); Pitts (2003); Sanders (1989); Sullivan (2001); Thompson (2015); and Vail (2000).

15. Hardy (2013); see also https://tttism.com/about.

REFERENCES

Ahmed, Sara. 2004. *The Cultural Politics of Emotion*. Edinburgh: University of Edinburgh Press.

Aran, Isha. 2015. "Why Do Some Tattoo Artists Balk at Dark Skin?" *Splinter News*. https://splinternews.com/why-do-some-tattoo-artists-balk-at-dark-skin-1793853050.

Archer, John. 2005. "Social Theory of Space: Architecture and the Production of Self, Culture, and Society." *Journal of the Society of Architectural Historians.* 64 (4): 430–33.

Atkinson, Michael. 2002. "Pretty in Ink: Conformity, Resistance, and Negotiation in Women's Tattooing." *Sex Roles* 47 (5): 219–35.

———. 2003. *Tattooed: The Sociogenesis of a Body Art*. Toronto: University of Toronto Press.

Barber, Kristen. 2016. *Styling Masculinity: Gender, Class, and Inequality in the Men's Grooming Industry*. New Brunswick, NJ: Rutgers University Press.

Barton, Bernadette. 2006. *Stripped: Inside the Lives of Exotic Dancers*. New York: New York University Press.

Becker, Howard S. 1982. *Art Worlds*. Berkeley: University of California Press.

Bennett, Mark W., and Victoria C. Plaut. 2018. "Looking Criminal and the Presumption of Dangerousness: Afrocentric Facial Features, Skin Tone, and Criminal Justice." *UC Davis Law Review* 51 (3): 745–803.

Berg, Adam, Andrew D. Linden, and Jamie Schultz. 2020. "Manning Up: Modern Manhood, Rudimentary Pugilistic Capital, and Esquire Network's White Collar Brawlers." *Journal of Sport and Social Issues* 44 (1): 70–92.

Berger, Peter L., and Thomas Luckmann. 1967. *The Social Construction of Reality: A Treatise in the Sociology of Knowledge*. New York: Anchor.

Biggart, Nicole Woolsey, and Thomas Beamish. 2003. "The Economic Sociology of Conventions: Habit, Custom, Practice, and Routine in Market Order." *Annual Review of Sociology* 29:443–64.

Bonilla-Silva, Edwardo. 2006. *Racism without Racists: Color-Blind Racism and the Persistence of Racial Inequality in the United States*. 2nd ed. Lanham, MD: Rowman & Littlefield.

Bordo, Susan. (1993) 2003. *Unbearable Weight: Feminism, Western Culture, and the Body*. Berkeley: University of California Press.

Bosk, Charles L. 2003. *Forgive and Remember: Managing Medical Failure.* 2nd ed. Chicago: University of Chicago Press.

Bourdieu, Pierre. 1984. *Distinction: A Social Critique of the Judgment of Taste.* Cambridge, MA: Harvard University Press.

———. 1986. "The Forms of Capital." In *Handbook of Theory and Research for the Sociology of Education*, edited by John G. Richardson, 241–58. New York: Greenwood Press.

Bowyer, Kevin, and Michael King. 2019. "Why Face Recognition Accuracy Varies due to Race." *Biometric Technology Today*, no. 8, 8–11.

Braunberger, Christine. 2000. "Revolting Bodies: The Monster Beauty of the Tattooed Woman." *NWSA Journal* 12 (2): 1–23.

Breton, David Le. 2014. "From Disfigurement to Facial Transplant: Identity Insights." *Body & Society* 21 (4): 3–23.

Burns, Craig. 2009. *Skin & Bones: Tattoos in the Life of the American Sailor.* Philadelphia: Independence Seaport Museum.

Byrd, Ayana, and Lori Tharps. 2014. *Hair Story: Untangling the Roots of Black Hair in America.* New York: St. Martin's.

Bythewood, Dan. 2015. "No, You Can't Get a Fucking Neck Tattoo, Jane Marie." www.facebook.com/notes/tattoos-by-myttooscom/no-you-cant-get-a-fucking -neck-tattoo-jane-marie/10153328624497459?fref=nf.

Cohen, Rachel Lara, Kate Hardy, Teela Sanders, and Carol Wolkowitz. 2013. "The Body/Sex/Work Nexus: A Critical Perspective on Body Work and Sex Work." In Wolkowitz et al., 3–28.

Craig, Maxine. 2002. *Ain't I a Beauty Queen? Black Women, Beauty, and the Politics of Race.* Oxford: Oxford University Press.

Crane, Diana. 1992. *The Production of Culture.* Newbury Park, CA: Sage.

Czerniawski, Amanda M. 2015. *Fashioning Fat: Inside Plus-Size Modeling.* New York: New York University Press.

DeMello, Margo. 2000. *Bodies of Inscription: A Cultural History of the Modern Tattoo Community.* Durham, NC: Duke University Press.

Department of Environmental Health. 2020. "Body Art Program." https://deh.acgov .org/solidwaste/body-art.page?.

Deshotels, Tina H., and Craig J. Forsyth. 2007. "Sex Rules: The Edicts of Income in Exotic Dancing." *Deviant Behavior* 29 (5): 484–500.

Desmond, Matthew. 2006. "Becoming a Firefighter." *Ethnography* 7 (4): 387–421.

———. 2007. *On the Fire Line: Living and Dying with Wildland Firefighters.* Chicago: University of Chicago Press.

Dewey, John. (1922) 2001. *Human Nature and Conduct: An Introduction to Social Psychology.* Mineola, NY: Dover.

Du Bois, W. E. B. (1903) 2007. *The Souls of Black Folk.* Oxford: Oxford University Press.

Duneier, Mitchell. 1999. *Sidewalk.* New York: Farrar, Straus and Giroux.

Durkheim, Emile. (1912) 1965. *The Elementary Forms of Religious Life.* Translated by Karen E. Fields. New York: Free Press.

———. (1914) 1973. *On Morality and Society*. Edited by Robert N. Bellah. Chicago: University of Chicago Press.

Eyal, Gil. 2006. *The Disenchantment of the Orient: Expertise in Arab Affairs and the Israeli State*. Stanford, CA: Stanford University Press.

Faber, Jacob William. 2019. "Segregation and the Cost of Money: Race, Poverty, and the Prevalence of Alternative Financial Institutions." *Social Forces* 98 (2): 819–48.

Febos, Melissa. 2022. *Body Work: The Radical Power of Personal Narrative*. New York: Catapult.

Fine, Gary Allen. 2006. "Shopfloor Cultures: The Idioculture of Production in Operational Meteorology." *Sociological Quarterly* 47 (1): 1–19.

Förster, Till. 2022. "Bodily Ethnography: Some Epistemological Challenges of Participation." *Ethnography*, Feb. 4, https://doi.org/10.1177/14661381211067452.

Friedman, Asia M. 2015. "Perceptual Construction: Rereading *The Social Construction of Reality* through the Sociology of the Senses." *Cultural Sociology* 10 (1): 77–92.

Geertz, Clifford. 1973a. "Deep Play: Notes on the Balinese Cockfight." In Geertz 1973b, 412–54.

———. 1973b. *The Interpretation of Cultures*. New York: Basic Books.

———. 1973c. "Thick Description: Toward an Interpretive Theory of Culture." In Geertz 1973b, 3–33.

Gieryn, Thomas F. 1983. "Boundary Work and the Demarcation of Science from Non-science: Strains and Interests in Professional Ideologies of Scientists." *American Sociological Review* 48:781–95.

Gimlin, Debra. 1996. "Pamela's Place: Power and Negotiation in the Hair Salon." *Gender and Society* 10 (5): 505–26.

Giuffre, Patti A., and Christine L. Williams. 2000. "NOT JUST BODIES: Strategies for Desexualizing the Physical Examination of Patients." *Gender and Society* 14 (3): 457–82.

Glenn, Evelyn Nakano, ed. 2009. *Shades of Difference: Why Skin Color Matters*. Stanford, CA: Stanford University Press.

Goffman, Erving. 1959. *The Presentation of Self in Everyday Life*. New York: Doubleday.

———. 1963. *Stigma: Notes on the Management of Spoiled Identity*. Englewood Cliffs, NJ: Prentice-Hall.

Granovetter, Mark. 1985. "Economic Action and Social Structure: The Problem of Embeddedness." *American Journal of Sociology* 91:481–510.

Hardy, Ed. 2013. *Wear Your Dreams: My Life in Tattoos*. New York: Thomas Dunne.

Ho, Karen. 2009. *Liquidated: An Ethnography of Wall Street*. Durham, NC: Duke University Press.

Hochschild, Arlie Russell. 1979. "Emotion Work, Feeling Rules, and Social Structure." *American Journal of Sociology* 85 (3): 551–75.

———. 1983. *The Managed Heart: Commercialization of Human Feelings*. Berkeley: University of California Press.

Howlett, Michael, Allan McConnell, and Anthony Perl. 2014. "Streams and Stages:

Reconciling Kingdon and Policy Process Theory." *European Journal of Political Research* 54 (3): 419–34.

Hughes, Everett. 1962. "Good People and Dirty Work." *Social Problems* 10 (1): 3–11.

———. 1971. "Sociologists and the Public." In *The Sociological Eye: Selected Papers on Work, Self, and the Study of Society*, edited by Everett Hughes, 455–63. Chicago: Aldine Atherton.

Hunter, Margaret L. 2005. *Race, Gender, and the Politics of Skin Tone*. New York: Routledge.

Iverson, Roberta. 2009. "'Getting Out' in Ethnography: A Seldom-Told Story." *Qualitative Social Work* 8 (1): 9–26.

Jablonski, Nina G. 2006. *Skin: A Natural History*. Berkeley: University of California Press.

James, William. (1890) 1950. *The Principles of Psychology*. Vol. 1. New York: Dover.

Kang, Miliann. 2010. *The Managed Hand: Race, Gender, and the Body in Beauty Service Work*. Berkeley: University of California Press.

Kang, Miliann, and Katherine Jones. 2007. "Why Do People Get Tattoos?" *Contexts* 6 (1): 42–47.

Keere, Kobe De 2022. "Evaluating Self-Presentation: Gatekeeping Recognition Work in Hiring." *Cultural Sociology* 16 (1): 86–110.

Kluger, Nicolas. 2014. "Blurry Halos around Tattoos: A New Case of 'Tattoo Blow-Out.'" *International Journal of Dermatology* 53 (1): e44–46. doi: 10.1111/j.1365-46 32.2012.05724.x.

Kosut, Mary. 2003. "An Ironic Fad: The Commodification and Consumption of Tattoos." *Journal of Popular Culture* 39 (6): 1035–48.

———. 2006. "Mad Artists and Tattooed Perverts: Deviant Discourse and the Social Construction of Cultural Categories." *Deviant Behavior* 27:73–95.

———. 2014. "The Artification of Tattoo: Transformations within a Cultural Field." *Cultural Sociology* 8 (2): 142–58.

KPIX. 2017. "New Tattoo School Makes Waves as It Prepares to Open in Oakland." CBS News. March 2. https://sanfrancisco.cbslocal.com/2017/03/02/new-tattoo -school-makes-waves-as-it-prepares-to-open-in-oakland.

Lane, David C. 2020. *The Other End of the Needle: Continuity and Change among Tattoo Workers*. New Brunswick, NJ: Rutgers University Press.

Leidner, Robin. 2010. "Work Cultures." In *Handbook of Cultural Sociology*, edited by John R. Hall, Laura Grindstaff, and Ming-Chen Lo, 419–28. London: Routledge.

Lena, Jennifer C. 2019. *Entitled: Discriminating Tastes and the Expansion of the Arts*. Princeton, NJ: Princeton University Press.

Levin, Lori. 2015. "Here's What I Have to Say about Your F***ing Neck Tattoo." *Huff-Post*, July 6. www.huffpost.com/entry/heres-what-i-have-to-say-_b_7701856.

Lewis, Rachel Charlene. 2019. "You Can't Be an Ink Master If You Only Tattoo White Skin." BitchMedia, Sept. 12. www.bitchmedia.org/article/whiteness-of-tattoos.

Little, Jo. 2012. "Pampering, Well-Being and Women's Bodies in the Therapeutic Spaces of the Spa." *Social and Cultural Geography* 14 (1): 41–58.

Lombroso, Cesare. (1876) 2006. *Criminal Man*. Translated by Mary Gibson and Nicole Hahn Rafter. Durham, NC: Duke University Press.

Mabry, Dustin. 2018. "Plenty of Skin." Open Space, SFMOMA. May 10. https://openspace.sfmoma.org/2018/05/plenty-of-skin.

MacKinzie, Donald, and Yuval Millo. 2003. "Constructing a Market, Performing Theory: The Historical Sociology of a Financial Derivatives Exchange." *American Journal of Sociology* 109:107–45.

Malinowski, Bronislaw. 1922. *Argonauts of the Western Pacific*. London: Routledge & Kegan Paul.

Massey, Douglas S., and Nancy A. Denton. 1993. *American Apartheid: Segregation and the Making of the Underclass*. Cambridge, MA: Harvard University Press.

Mead, George Herbert. (1934) 1972. *Mind, Self, and Society: From the Standpoint of a Social Behaviorist*. Edited by Charles W. Morris. Chicago: University of Chicago Press.

Mears, Ashley. 2011. *Pricing Beauty: The Making of a Fashion Model*. Berkeley: University of California Press.

Menand, Louis. 2001. *The Metaphysical Club: A Story of Ideas in America*. New York: Farrar, Straus and Giroux.

Merian, Anna. 2018. "The Tattoo Industry Is Having Its Own Wrenching, Revelatory #MeToo Moment." *Jezebel: A Supposedly Feminist Website*. https://jezebel.com/the-tattoo-industry-is-having-its-own-wrenching-revela-1822026779.

Mifflin, Margot. 2001. *Bodies of Subversion: A Secret History of Women and Tattoo*. New York: Juno.

Monaghan, Lee F. 2002. "Hard Men, Shop Boys and Others: Embodying Competence in a Masculinist Occupation." *Sociological Review* 50 (3): 334–53.

Moore, Sarah E. H. 2010. "Is the Healthy Body Gendered? Toward a Feminist Critique of the New Paradigm of Health." *Body & Society* 16 (2): 95–118.

Nelson, Maggie. 2015. *The Argonauts*. Minneapolis: Graywolf.

Norwood, Kimberly Jade, ed. 2014. *Color Matters: Skin Tone Bias and the Myth of a Post-Racial America*. New York: Routledge.

Obrador-Pons, Pau. 2008. "A Haptic Geography of the Beach: Naked Bodies, Vision and Touch." *Social and Cultural Geography* 8 (1): 123–41.

Oerton, Sarah. 2004. "Bodywork Boundaries: Power, Politics and Professionalism in Therapeutic Massage." *Gender, Work & Organisation* 11 (5): 544–65.

Oregon Health Authority. 2020. "Board of Electrologists and Body Art Practitioners—Tattoo Artists—License Information." www.oregon.gov/oha/PH/HLO/Pages/Board-Body-Art-Practitioners-Tattoo-Artists-License.aspx.

Paap, Kris. 2006. *Working Construction: Why White Working-Class Men Put Themselves—and the Labor Movement—in Harm's Way*. Ithaca, NY: Cornell University Press.

Peterson, Richard A., and N. Anand. 2004. "The Production of Culture Perspective." *Annual Review in Sociology* 30:311–34.

Pitts, Victoria L. 2003. *In the Flesh: The Cultural Politics of Body Modification*. New York: Palgrave Macmillan.

Pitts-Taylor, Victoria. 2015. "A Feminist Carnal Sociology? Embodiment in Sociology, Feminism, and Naturalized Philosophy." *Qualitative Sociology* 38:19–25.

Purcell, Carrie. 2013. "Touch in Holistic Massage: Ambiguities and Boundaries." In Wolkowitz et al., 175–90.

Ribeiro, Nuno F. 2017. "Boxing Culture and Serious Leisure among North-American Youth: An Embodied Ethnography." *Qualitative Report* 22 (6): 1622–36.

Roberts, Derek. 2016. "Using Dramaturgy to Better Understand Contemporary Western Tattoos." *Sociology Compass* 10 (9): 795–804.

Ruiz, Angelina. 2020. "The Black Lives Matter Movement Will Change the Future of Tattooing." *Allure*, Sept. 8. www.allure.com/story/black-lives-matter-tattoo-industry.

Saini, Angela. 2019. *Superior: The Return of Race Science.* Boston: Beacon.

Salvalaggio, Erica. 2020. "Tann Parker, Founder of Ink the Diaspora, on Racism in the Tattoo Industry—And How to Combat It." *Inside Out*, Feb. 17. https://readinsideout.com/artists/profiles/tann-parker-ink-the-diaspora-profile.

Sanders, Clinton R. 1989. *Customizing the Body: The Art and Culture of Tattooing.* Philadelphia: Temple University Press.

Sanders, Clinton R., and D. Angus Vail. 2008. *Customizing the Body: The Art and Culture of Tattooing.* Rev. and exp. ed. Philadelphia: Temple University Press.

Sanders, Teela, Rachel Lara Cohen, and Kate Hardy. 2013. "Hairdressing/Undressing: Comparing Labour Relations in Self-Employed Body Work." In Wolkowitz et al., 110–35.

Santos, Xuan. 2009. "The Chicana Canvas: Doing Class, Gender, Race, and Sexuality through Tattooing in East Los Angeles." *NWSA Journal* 21 (3): 91–120.

Smith, Allen, and Sherryl Kleinman. 1989. "Managing Emotions in Medical School: Students' Contacts with the Living and the Dead." *Social Psychology Quarterly* 52 (1): 56–69.

Spillman, Lyn, ed. 2002. *Cultural Sociology.* Malden, MA: Blackwell.

Starr, Paul. 1982. *The Social Transformation of American Medicine.* New York: Basic Books.

Stortz, Andrew. 2019a. "EPISODE 027: LIVE in San Francisco!" *Books Closed*, Nov. 18. https://booksclosedpodcast.com/episodes-1/live-in-sf.

———. 2019b. "EPISODE 030: Tattoo Diploma-cy." *Books Closed*, Dec. 16. https://booksclosedpodcast.com/episodes-1/disruptive-tattooing-77hzg-x6gnl-7fm2w.

———. 2021a. "EPISODE 039: Paul Dobleman & Austin Maples" *Books Closed*, Jan. 27. https://booksclosedpodcast.com/episodes-1/dobleman-maples.

———. 2021b. "EPISODE 040: Faith (@Americanflesh)" *Books Closed*, Feb. 3. https://booksclosedpodcast.com/episodes-1/faith.

Sullivan, Nikki. 2001. *Tattooed Bodies: Subjectivity, Textuality, Ethics, and Pleasure.* Westport, CT: Praeger.

Tavory, Iddo. 2018. "Between Situations: Anticipation, Rhythms, and the Theory of Interaction." *Sociological Theory* 36 (2): 117–33.

Tavory, Iddo, and Nina Eliasoph. 2013. "Coordinating Futures: Towards a Theory of Anticipation." *American Journal of Sociology* 118 (4): 908–42.

Thomas, Nicolas. 2014. *Body Art*. London: Thames & Hudson.

Thomas, Nicolas, Anna Cole, and Bronwen Douglas, eds. 2005. *Tattoo: Bodies, Art and Exchange in the Pacific and the West*. London: Reaktion.

Thompson, Beverly Yuen. 2015. *Covered in Ink: Tattoos, Women and the Politics of the Body*. New York: New York University Press.

Thompson, Sara. 2017. *Tattoos in Japanese Prints*. Boston, MA: MFA Prints.

Trepany, Charles. 2020. "Oliver Peck Leaves 'Ink Master' after Blackface Controversy; Paramount Network Weighs In." *USA Today*, Jan. 7. www.usatoday.com /story/entertainment/tv/2020/01/07/oliver-peck-says-goodbye-ink-master-after -blackface-photos-emerge/2838903001.

Twigg, Julia, and Karl Atkin. 2000. "Carework as a Form of Bodywork." *Ageing and Society* 20:389–411.

Unger, Zac. 2007. "Review: A Firefighter Reviews 'On the Fireline' by Matthew Desmond." *SF Gate*, Nov. 16. www.sfgate.com/books/article/Review-A-firefighter-re views-On-the-Fireline-3235898.php.

Urbain, Jean-Didier. 2003. *At the Beach*. Minneapolis: University of Minnesota Press.

Vail, Angus D. 2000. "Slingin' Ink or Scratching Skin? Producing Culture and Claiming Legitimacy among Fine Art Tattooists." In *Unusual Occupations*, edited by H. Z. Lopata and K. D. Henson, 55–73. Stamford, CT: JAI Press.

Wacquant, Loïc. 2004. *Body & Soul: Notebooks of an Apprentice Boxer*. Oxford: Oxford University Press.

———. 2015. "For a Sociology of Flesh and Blood." *Qualitative Sociology* 38:1–11.

Watkins, Ali. 2022. "'A Monster in Our Midst': How a Tattoo Industry #MeToo Case Collapsed." *New York Times*, May 4. www.nytimes.com/2022/05/04/nyregion/ toothtaker-isaiah-camacho-sexual-assault.html.

Weber, Max. (1905) 1958. *The Protestant Ethic and the Spirit of Capitalism*. New York: Scribner.

Wesley, Jennifer K. 2003. "'Where Am I Going To Stop?' Exotic Dancing, Fluid Body Boundaries, and Effects on Identity." *Deviant behavior* 24 (5): 483–503.

West, Cornel. 2002. *Prophesy Deliverance! An Afro-American Revolutionary Christianity*. Louisville, KY: Westminster John Knox Press.

Westphall, Kimber 2019. "Booker T. Washington Alum Creates Tattoo Artist Internship for High Schoolers." *Dallas Observer*, May 9. www.dallasobserver.com/arts/ booker-t-alum-creates-tattoo-artist-internship-for-high-schoolers-11659381.

Wilkis, Ariel 2017. *The Moral Power of Money: Morality and Economy in the Life of the Poor*. Stanford, CA: Stanford University Press.

Wolkowitz, Carol. 2006. *Bodies at Work*. London: Sage.

Wolkowitz, Carol, Rachel Lara Cohen, Teela Sanders, and Kate Hardy, eds. 2013. *Body/Sex/Work: Intimate, Embodied, and Sexualized Labour*. London: Palgrave Macmillan.

Yancy, George. 2017. *Black Bodies, White Gazes: The Continuing Significance of Race in America*. 2nd ed. New York: Rowman & Littlefield.

Zelizer, Viviana. 1981. "The Price and Value of Children: The Case of Children's Insurance." *American Journal of Sociology* 85 (5): 1036–56.

———. 2005a. "Circuits within Capitalism." In *The Economic Sociology of Capitalism*, edited by Victor Nee and Richard Swedberg, 289–322. Princeton, NJ: Princeton University Press.

———. 2005b. *The Purchase of Intimacy*. Princeton, NJ: Princeton University Press.

INDEX